THE·MODEL·WIFE

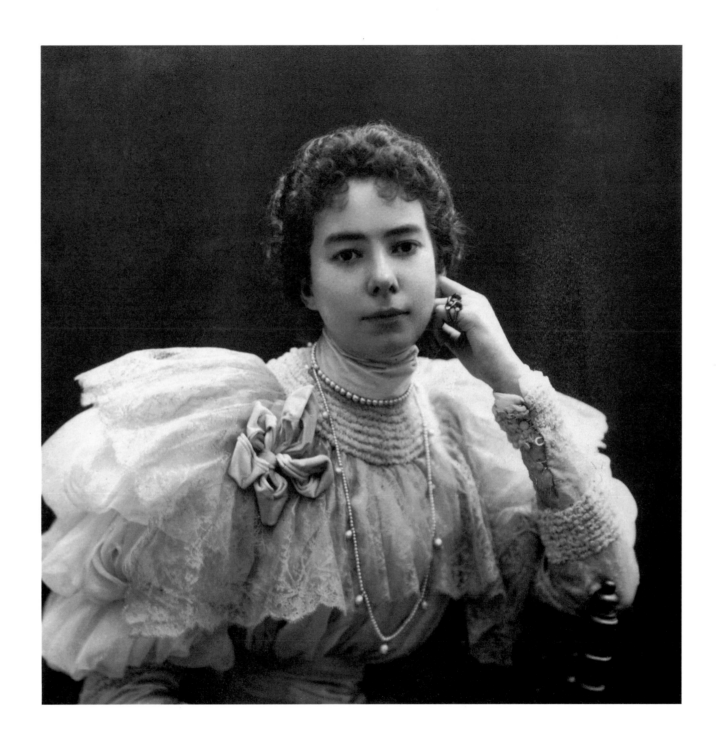

Adolph de Meyer, *Olga de Meyer,* ca. 1898

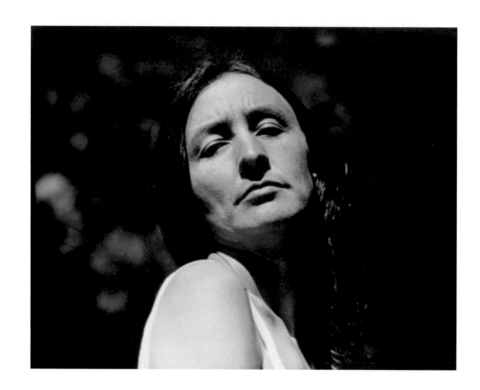

Alfred Stieglitz, *Georgia O'Keeffe: A Portrait,* 1923

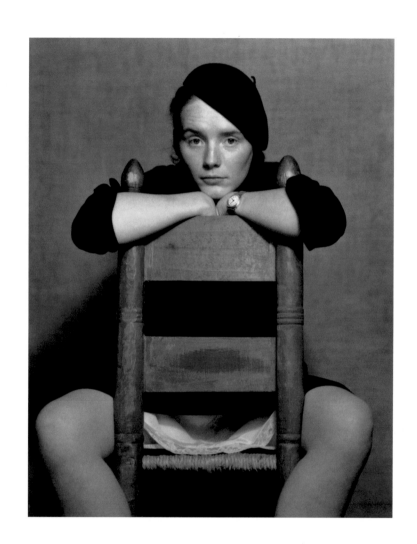

Edward Weston, *Charis Weston*, 1935

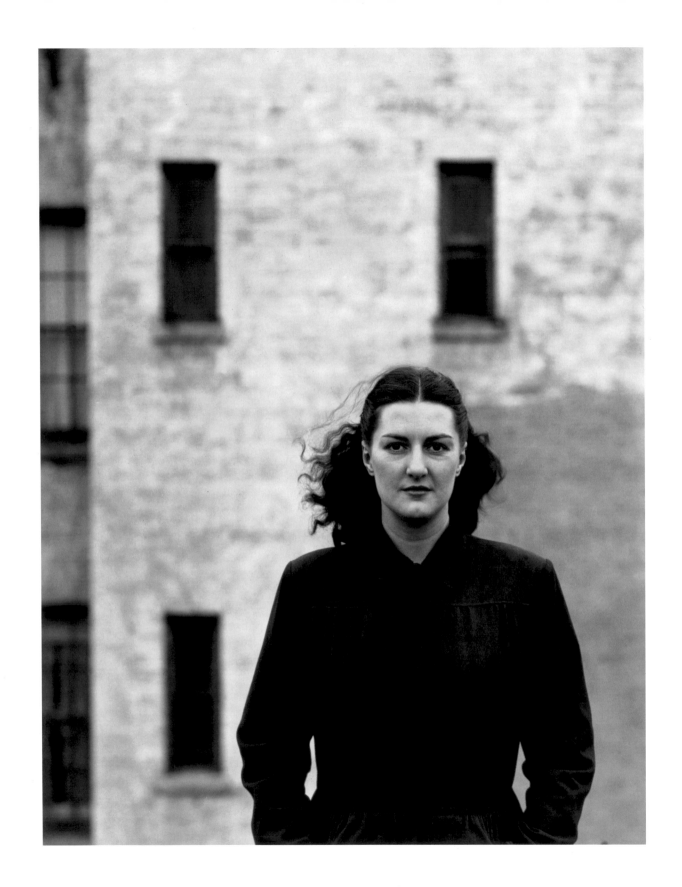

Harry Callahan, *Eleanor, New York,* 1945

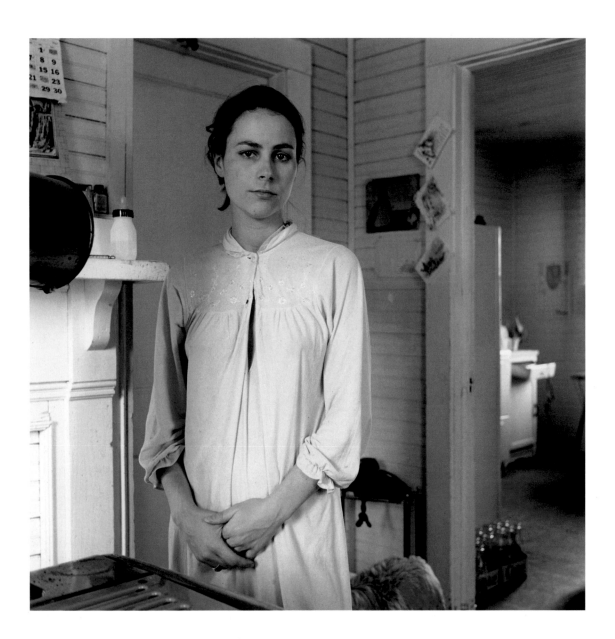

Emmet Gowin, *Edith, Danville, Virginia*, 1969

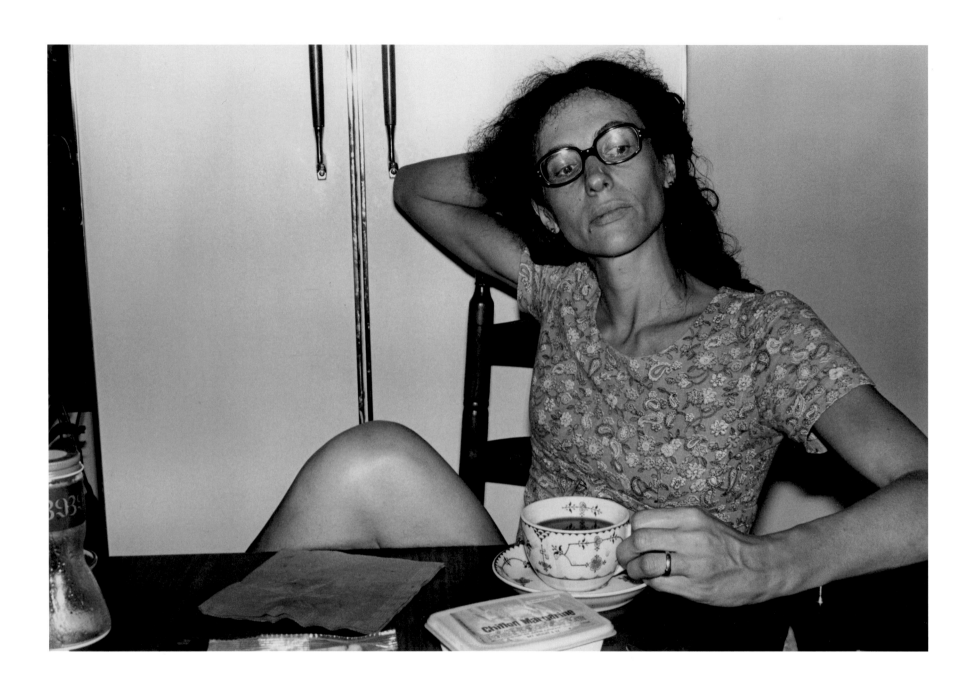

Lee Friedlander, *Maria*, 1970

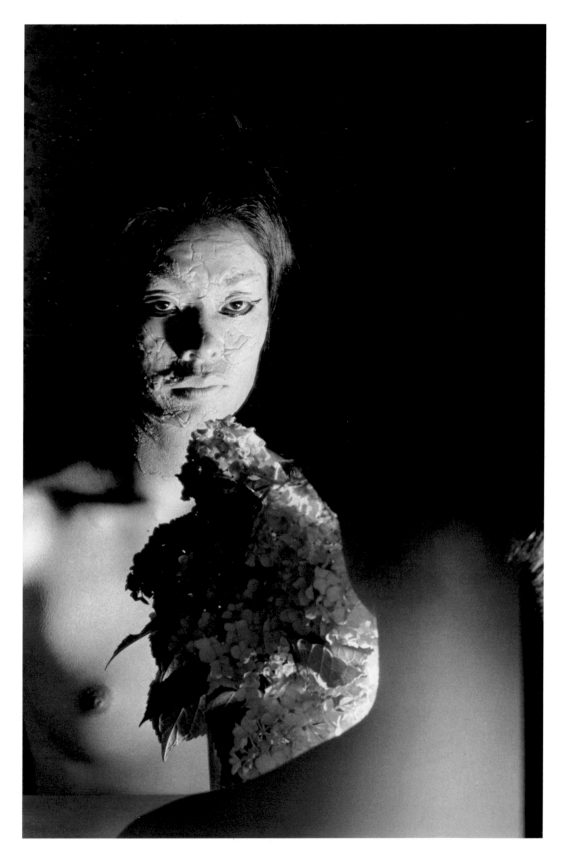

Masahisa Fukase, *Matsubara Apartment*, 1968

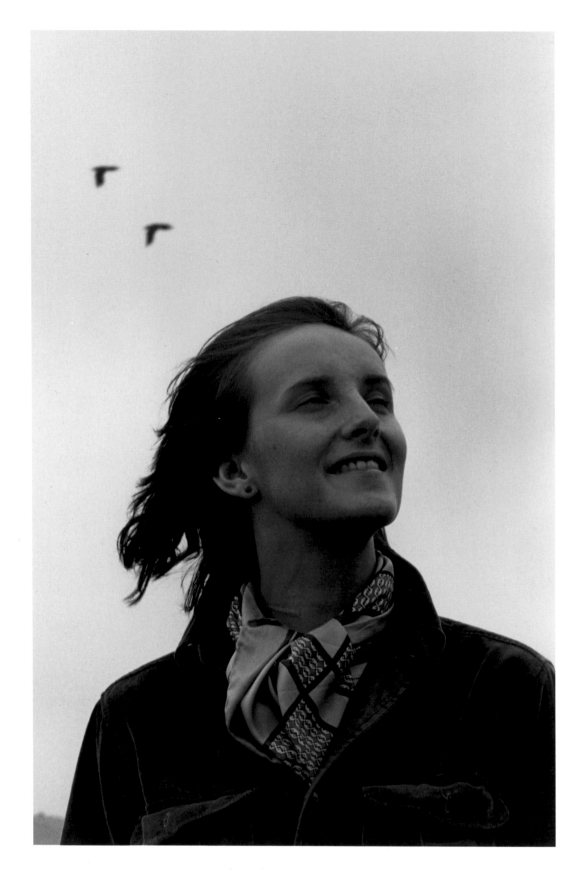

Seiichi Furuya, *78/8*, 1978

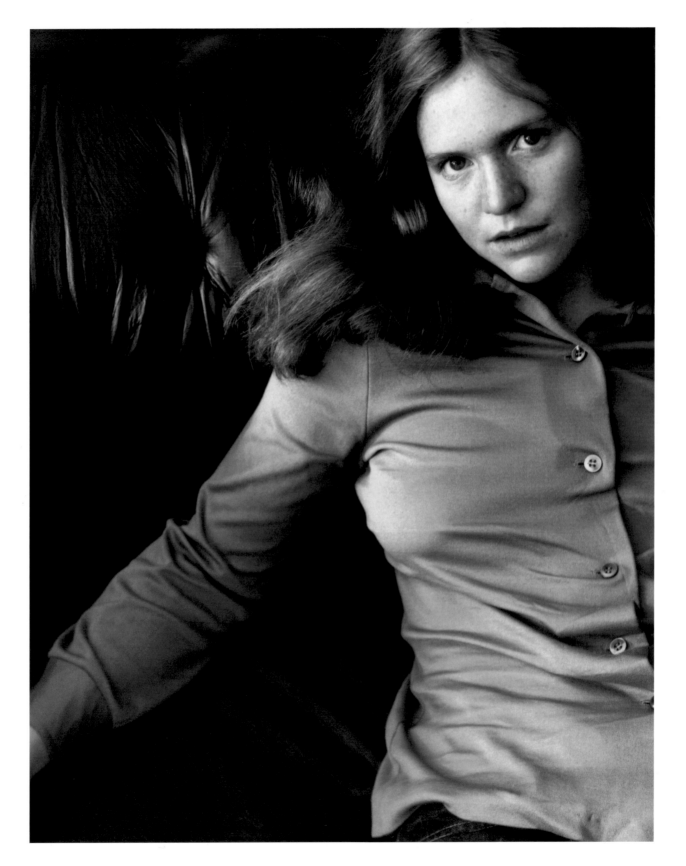

Nicholas Nixon, *Aspen*, 1970

THE·MODEL·WIFE

PHOTOGRAPHS BY

BARON ADOLPH DE MEYER · ALFRED STIEGLITZ · EDWARD WESTON · HARRY CALLAHAN
EMMET GOWIN · LEE FRIEDLANDER · MASAHISA FUKASE · SEIICHI FURUYA · NICHOLAS NIXON

ARTHUR OLLMAN

A BULFINCH PRESS BOOK / LITTLE, BROWN AND COMPANY

BOSTON NEW YORK LONDON

PUBLISHED IN ASSOCIATION WITH THE MUSEUM OF PHOTOGRAPHIC ARTS, SAN DIEGO

Copyright © 1999 by The Museum of Photographic Arts

All rights reserved. No part of this book may be reproduced in any form or by any electronic or mechanical means, including information storage and retrieval systems, without permission in writing from the publisher, except by a reviewer who may quote brief passages in a review.

First Edition

For additional copyright information see List of Plates and Credits on pages 219-222.

Library of Congress Cataloging-in-Publication Data

The model wife / [compiled by] Arthur Ollman ; photographs by Adolph de Meyer . . . [et al.]. — 1st ed.
 p. cm.
"A Bulfinch Press book."
Exhibition held Fall 2000 at Museum of Photographic Arts, San Diego.
Includes bibliographical references (p.).
ISBN 0-8212-2170-1 (hardcover)
1. Photography of women — Exhibitions. 2. Women — Portraits — Exhibitions.
3. Photographers' spouses — Portraits — Exhibitions. 4. Portrait photography —
Exhibitions. 5. De Meyer, Adolph, Baron, 1868–1949. 6. Stieglitz, Alfred,
1864–1946. 7. Weston, Edward, 1886–1958. 8. Callahan, Harry, 1912–1999.
9. Gowin, Emmet, 1941– . 10. Friedlander, Lee, 1934– . 11. Fukase, Masahisa,
1934 – . 12. Furuya, Seiichi, 1950– . 13. Nixon, Nicholas, 1947– . I. Ollman, Arthur.
II. Museum of Photographic Arts (San Diego, Calif.)
TR681.W6M63 1999
779'.24 — dc21 99-17301

Designed by Alex Castro

Duotone separations by Robert Hennessey

Printed and bound by Amilcare Pizzi, Milan, Italy

Bulfinch Press is an imprint and trademark of Little, Brown and Company (Inc.)

PRINTED IN ITALY

To my children, Ariel and Jonah,
for their honesty, clarity, and their need to express

To Leah, my beloved,
whose mysterious and continual alchemy
set the course for this digression

To my mother and father,
who introduced me to the myriad ways of being
a balanced, nourishing, and loving couple

CONTENTS

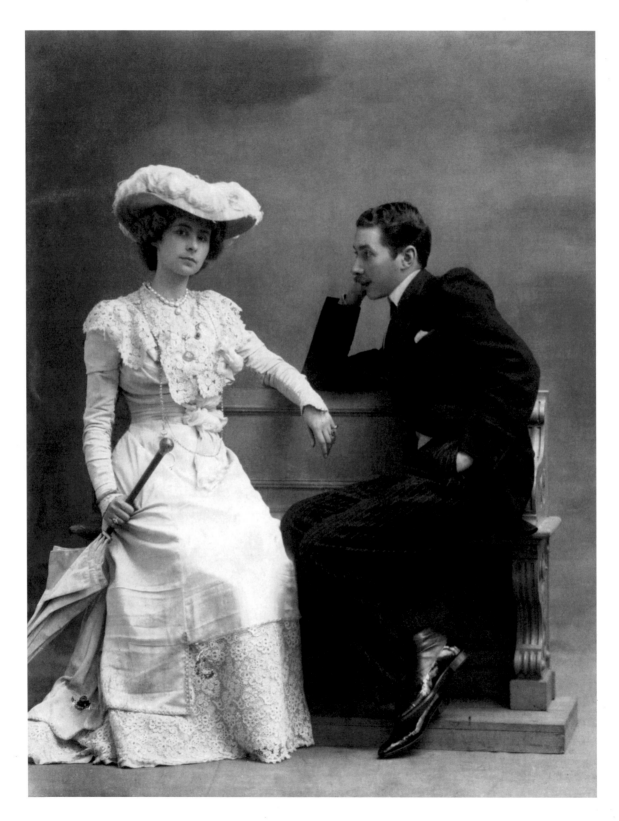

Adolph de Meyer, *Adolph and Olga de Meyer*, ca. 1900

INTRODUCTION

IT'S A SIMPLE IDEA. THERE ARE NINE PHOTOGRAPHERS and they all photographed their wives. Each has done so for a long time and created a large number of pictures, which form a major part of their life's work. Collectively, they span a full century. And these projects all interlock by chronology as well as the powerful influences that the earlier ones supplied for the later. As a group they might be examined to identify a variety of changing views, over time, of marriage and the image of wife. It's a simple idea, which has varied applications.

The intricate and delicate web of human relationships is rarely more complex, more fraught with contradiction, more difficult to understand or decipher than in the institution of marriage. Generalizations are common; the ceremonies of marriage themselves are constructed of them. Yet photographs are specific. There are, perhaps, as many forms of partnering as there are partners — and as a society, we seem continually to be mutating new ones. Perhaps by examining a group of fine photographers and their efforts over the past one hundred years, we can learn something about male perceptions. How is the wife depicted differently than other portrait subjects? Have changes in the culture altered male perceptions over the past century? Do the women photographed exercise collaborative influence over the resulting art? The portfolios that we examine here identify some of the most intimate and personal art that these important photographers ever made. Did this intimacy stimulate deeper photographic responses?

Considering works by Baron Adolph de Meyer, Alfred Stieglitz, Edward Weston, Harry Callahan, Emmet Gowin, Lee Friedlander, Masahisa Fukase, Seiichi Furuya, and Nicholas Nixon, we may observe the development of a photographic tradition that has parallels in other media.

Artists throughout history have observed love's mysterious manifestations in others and in their own lives. The heterosexual male's visual attraction to females is one of art's principal generators. Most art made by men depicting women is based on casual or commercial acquaintance, or even none at all. Fashion photography, nudes, most portraits, and street photography do not necessarily involve intimate knowledge of the subject. The same is true in similar genres in other media. How is the portrait affected when the model is the artist's wife, when both parties are known intimately to the other and the relationship is one of unique complexity and depth? In such relationships, each partner has emotional commitments to nourish. Each has needs and dependencies at risk. Each controls more than the art. With a hired model, the artist is a stranger, one whose persona is masked in the task at hand and the small necessary conversation required for the enterprise. With a spouse as model, both participants are exposed, equally aware of the other's strengths, shortcomings, vulnerabilities — both equally naked in the light of the relationship. Neither can hide, each has a controlling role. Many artists have made a few studies of their partners; few have extended this sort of work for many years of a relationship. The photographers described here have done so for one, two, three decades and even more.

Intimate relationships based upon mutual responsibilities engender a weave of interlocking dependencies and compromises. Delicate balances of selflessness and need struggle daily through thickets of desire and ego. Career and financial pressures, children, health issues, aging, extended family, and societal expectations test us all. Among these nine families, one finds a platonic chaste marriage, couples with vast age and career imbalances, prolonged separations, divorce, mental illness, sub-

stance abuse, and suicide. There are also lifelong marriages, which by most standards, would appear fulfilling and resolved. Being an artist provides neither immunity nor a shortcut to wisdom on any of these concerns. Nor does it predict disaster. The nature of relationships is that they are dynamic. It is unnecessary to attempt to fix an identity too tightly upon any of these relationships.

This group of photographers is not encyclopedic, but rather representative. One knowledgeable in the field might identify Paul Strand's strained portraits of Rebecca; Alexander Rodchenko's playful experiments with Varvara or Man Ray's with Juliet; Irving Penn's elegant fashion works of his wife, Lisa Fonssagrives; Nobuyoshi Araki's early sweet and respectful images of the life and death of Yoko; Bernard Plossu's poetically diaristic notations of Françoise and their two stunningly beautiful children; or the outsider artist from Milwaukee, Eugene Von Bruenchenhein, who repeatedly dressed his wife up in silly homemade exotica, which somehow rarely covered her breasts, and a few others, whose work is not discussed here. Each would certainly bring new perspective to the subject. Those who are examined at length in the portfolios that follow present a series of ideas that this viewer found too compelling to ignore. It is also intriguing to place these bodies of work within the broader art historical tradition, which will be the goal of a later part of this discussion.

The interlocking flow of these nine extended portrayals begins with the work of the Baron Adolph de Meyer (1868–1946), who produced much of the finest early fashion photography for *Vanity Fair, Vogue,* and *Harper's Bazaar.* He wrote fashion and style editorials and was generally considered a tastemaker on both sides of the Atlantic between 1913 and 1932. His wife, Olga, was one of the great doyennes of high society, a confidante to Prince Edward (later King Edward VII), and one of the most fashionable women of her era. The baron's photographs of her are the perfect reflection of their role in the world of wealth and style.

Through his association with pictorialist photography organizations, the baron befriended Alfred Stieglitz (1864–1946). Stieglitz was the great eminence and impresario, whose pronouncements, as much as his galleries, publications, and photographs, were keystones of early Modernism in America. His photographs of his second wife, Georgia O'Keeffe, remain among the greatest icons of photography and represent much of his finest work. These portraits began in 1917 and continued for nearly twenty years.

In 1934 the photographer Edward Weston (1886–1958) met Charis Wilson, who would soon become his lover, wife, and principal model for the next eleven years. Charis was an intellectually curious free spirit whom he photographed both as a nude figure, like many of his previous models, and as a real character, with a personality and a context in his life. Weston was quite aware of the Stieglitz images of O'Keeffe, which he had seen while visiting Stieglitz in New York. Many of his finest photographs were of Charis, including his important nudes on the dunes at Oceana, California, in 1936. The photographs of Charis ended in 1945 when she divorced Weston.

Harry Callahan (1912–1999) began photographing Eleanor Callahan in 1945. As one of the great innovators of Modernism, Callahan was a constant experimenter and needed a continuing stimulant and model at the ready. Eleanor was an eager participant in much of his innovation, as was their young daughter, Barbara, until 1961. The spirit of play and the wide menu of formal explorations evidenced during those years demonstrate how productive their partnership was. In 1961 Callahan's student, Emmet Gowin (b. 1941), made his first photographs of his wife, Edith. These images were deeply influenced by Harry Callahan and by Gowin's study of Alfred Stieglitz. Dedicated to finding his subject matter in his own life, Gowin made loving and poetic observations about his family and the essentiality of Edith to him. They have not stopped making these photographs.

In 1959 Lee Friedlander (b. 1934) photographed Maria Friedlander for the first time. These casual yet insightful portraits appear, initially, to fit seemlessly into the artist's oeuvre. Like all the rest of his work, they are moments snatched from the stream of daily life, yet they are not the dramatic crescendos of a Cartier-Bresson, nor are they as inflected with angst or humor as the photographs of Robert Frank or Garry Winogrand. It is the abundant respect, tenderness, and affection that separate them from many of his more anonymous images. Friedlander, who is generally reticent on personal matters, portrays what he may be unable to state verbally: that he is dependent on Maria for the stability that he requires in his life and in order to do his work.

Masahisa Fukase (b. 1934) was also expressive in his work of the influence of the photographs of Harry Callahan and Lee Friedlander. His central subject during their marriage (1963 to 1976) was his wife, Yoko. This couple of highly creative artists (Yoko was trained as a dancer) was absorbed by the chaotic and overindulgent lifestyle of Tokyo's 1960s art scene. Heavy drinking, wild orgiastic parties, and extreme experimentation in art made for an unstable life. It also produced remarkable photographs. Eventually such existence can be exhausting and even dangerous. Yoko left him in 1976.

The journalist and photographer Seiichi Furuya (b. 1950) met Christine Gössler in 1978 in Graz, Austria. For the next seven years they were nearly inseparable, and together they produced hundreds of photographs. These diaristic and situational images trace a marriage that begins playfully, develops into loving and affectionate portrayal, marks the birth of Komyo, their son, and finally describes Christine's painful decline into severe emotional disorder. Ultimately, their entire life together is pictured, including Christine's death in 1985.

In 1970 Nicholas Nixon (b. 1947) began to make portraits of Bebe Brown, whom he married the next year. He continues photographing her at present. This bright, proudly interdependent couple has continually attempted to represent their collaborative life in photographs. Their children have been beautifully integrated into the photographs, as has the very passage of time. Their willingness to portray Bebe's aging as explicitly as possible is a refreshment as well as a testament to their pleasure at all parts of a well-examined life. This portfolio is now nearly thirty years old and continues to grow.

The work of each of these photographers will be explored in depth in the individual chapters that follow. This introductory essay will identify a number of the issues that are particular to such work and also examine how artists in other media have approached the portrayal of a wife. Few areas of study can be more politically charged than that of male perception of women. For some the discussion need never be addressed; men's views about women have dominated the discourse for too long. For others, the act of viewing is itself related to objectification, a form of violation. This text will address the differences that permission, cooperation, and collaboration impart to the art-making process and to the meaning of the art.

It is often said of portraits that they show three things. They illustrate the model. They announce the concerns of the artist. And they explore the relationship between the two people; usually this relationship is of short duration. Much is made of the techniques of the great portrait artists: how they prepare for a sitting with a celebrity; what clever ice-breaking banter they develop.

Richard Avedon once wrote, "A portrait photographer depends upon another person to complete his picture. The subject imagined, which in a sense is me, must be discovered in someone else willing to take part in a fiction he cannot possibly know about. My concerns are not his. We have separate ambitions for the image. His need to plead his case probably goes as deep as my need to plead mine, but the control is with me."[1] This argument is at the core of Avedon's work. He has an archive full of such confrontations, many of them stunning, most powerful and tense. Vicki

Goldberg has written, "Whoever controls the image holds the other's vanity for ransom."[2] When a photographer turns his camera toward a loved one, the stakes are different and each partner has complex reasons for a generous spirit.

In this sort of ongoing portrayal it is the relationship which takes on greater weight. Each of the artists in this selection has made other portraits of people imperfectly known to them. Some of those efforts are more clever than wise. Some are quite brilliant. Edward Weston compellingly photographed dozens of his acquaintances among the Mexican and American art scenes, and Lee Friedlander's portraits of musicians have a spontaneous jazz hipness. But within these portfolios it is difficult to locate images that approach the depth, solidity, and transcendence of the extended descriptions of the photographer's partner. Obviously, the sheer quantity of images made over years may identify many aspects and moods, but far more than numbers, intensity and deeper life knowledge yield greater insight and wisdom. Both partners share responsibility and its corollary, vulnerability. That, perhaps, is why so few artists engage in this sort of depiction. Only the most secure or brazen persist in the long-term portrayal of their spouse. This balance of relations identifies why such projects may fail. If the relationship's power is fully one-sided or there is no mutuality of responsibility, it will likely be obvious in the art.

Andrew Wyeth's Helga pictures illustrate the difference between the wife and the model. Wyeth's neighbor sat secretly for fifteen years, nude and clothed, for a series of drawn and painted portraits. Helga was a toy to be brought out for sexual play, for looking at, for lust. In the paintings, she is never personified — she patiently sits, lies, or stands while she is scrutinized. Artist and model don't share children, insurance, or car payments. They have no responsibility toward one another except the silence between them. And that silence is the palpable atmosphere of these works.

Interestingly, Andrew Wyeth has commented in interviews about his drawings and paintings of Helga, who is from Germany, that he could never have gotten an "American girl" to model in this way — tirelessly and fully manipulable — continually willing to pose absolutely as he wanted. He depicts her as inert, un-alive, always with the same expression. Sitting, standing, kneeling, or lying down, her poses identify no activity, no interaction with the environment or other people. She betrays no interests, no concerns, no occupations, no ideas. She shows no creative involvement in the collaboration; a thing in a box, with no personality except an icy ability to withdraw into inscrutability, she lends only her body to the project. This was not a partner, wife, or even a real, animated person. His passion seems predicated on her reticence.

Photography, it seems, is redefining ideas that have surfaced for centuries in other media. The notion of depicting one's spouse repeatedly is seen nowhere more famously than in Rembrandt's paintings of Saskia, and after her death, Hendrikye. His wives as biblical or mythological figures alternate with straight and direct portraits of them which, alongside his many self-portraits, are among his most common motifs.

Art historian and critic Linda Nochlin in her article "Cézanne, Studies in Contrast" in *Art in America* in June of 1996 wrote:

> Artists' wives get bad press in the 19th and early 20th century hagiography of the artist. Many of the heroes of individual genius are, of course, understood to be just that: unfettered free spirits. . . . Delacroix, Géricault, Courbet, Degas, Van Gogh, and Seurat never married; Manet's wife is often denigrated, despite the fact that he continued to live with her, write to her, and paint her throughout his life (she was fat, an added negative); Mme. Pissarro was a demanding, ignorant shrew; Gauguin shucked off his Scandinavian spouse as an inconvenience fairly early in his career, Picasso, succumbing momentarily to bourgeoisification during his marriage to Olga, retaliates by transforming her into a castrating monster on canvas — and so it goes. Only Cézanne, the lone-wolf master of Aix, paints his wife so often, with such attentiveness . . . she is recognizable and always dignified. As a pictorial object, if not as a human companion, Cézanne lavished attention on her; she is always different in her many manifestations, posed and dressed in an interesting variety of ways.[3]

The late nineteenth and twentieth centuries — the period coinciding with the work of these photographers — are particularly rich in extended depictions of wives.

Pierre Bonnard (1867–1941) painted his wife, Marthe, for nearly thirty years. His principal motif showed her bathing. An abundance of varied poses and compositions suggest that he was fixated on the image of the nude tending to her toilet. While he undoubtedly was intrigued by watching her, she was known to have a neurotic fixation on cleanliness and spent numerous hours every day bathing and in odd ritual ablutions. As Marthe aged, Bonnard's images of her continually referred to her in her younger form, reflecting either his idealization, his fantasy, or hers. Though he often employed a close vantage point, she seemed never to look at him and appears unaware of his presence. Perhaps his idealizations suited their marriage, for her psychological imbalances caused her to mistrust nearly everyone and forced them to live in near isolation. A too true depiction would perhaps have been unnecessarily cruel. Such portraits, which take considerable care and attention on behalf of both participants, generally become important elements in the couple's dialogue with each other.

In George Grosz's paintings and drawings from the late 1920s and up into the 1940s, sex is presented with passionate ambivalence. His voluptuous wife, Eva, and her sister, Lotte, share in grotesque escapades, cavort with sleazy, bestial men, and carefully examine their own genitalia. The critic Alf Erdmann Ziegler of Berlin wrote, "What Grosz constantly sought was a maternal yet arousing female form, and that is the form that appears throughout his work, in both the language of love and the language of hate."[4] His use of sexual allegory and political metaphor conceal the real Eva, but they reveal the real George Grosz; a man caught between Germany and America, between two worlds, the teeming sophistication of metropolitan Berlin and suburban Long Island. The artist, by controlling the portrait enterprise, may simply employ his wife as an actor in a drama that ultimately does not refer to her at all.

Pablo Picasso made hundreds of works depicting the women in his life. The October 1996 exhibition at the Museum of Modern Art "Picasso and Portraiture" was entirely devoted to the daunting task of unraveling the Gordian knot of his prodigious love life. His art at first idealized each lover and generally in the end attacked, insulted, and degraded her. The art may refer to the women in his life, but ultimately the subject of so much of Picasso's work is Picasso and his passions. While the products of the camera are so powerfully linked to the subject of the photograph, it is also true that the photographer is present in each image and is often its real subject. Throughout much of the 1950s and 1960s Alberto Giacometti painted and drew his wife, Annette, in his typical fashion, an armature of nervous line and crosshatching. He often sculpted busts of her as well. In each, she sits facing forward, a head and torso with full eye contact. Little can be gleaned from them about her, but clearly she was useful to him as he worked on a variety of formal pursuits. The art is about him but it refers to her.

From the late 1950s through the 1990s, painter Alex Katz has made dignified, reductive, and reticent portraits of his wife, Ada. With minimal context, she is portrayed singularly or among other friends in the well-heeled Manhattan art world. Beautifully coiffured, smartly dressed, Ada, like everyone else in his repertoire, is seen as she might be seen in a casual snapshot: content, involved only in the light requirements of a day at the shore, a casual café soirée, or an afternoon reading, briefly interrupted for a quick depiction. Katz presents his wife with no more personal information than one might obtain from simply seeing her in public. As may be the case in photography, depiction may not be revelation.

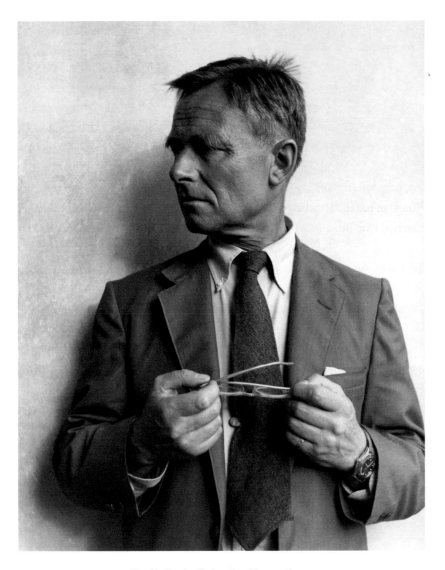

Don Bachardy, *Christopher Isherwood*, 1957

Don Bachardy, *Christopher Isherwood*, 1986

While the artists and issues examined here identify heterosexual relationships, many of the same dynamics appear in homosexual couples. The artist Donald Bachardy drew portraits of his lifelong partner, writer Christopher Isherwood, for many years. They traveled in the Orient in 1957 and each made beautiful and sensitive photographs of the other, a couple newly in love. Nearly thirty years later, in the months leading up to January 1986, Bachardy repeatedly drew the dying Isherwood. The drawings were generally signed by both participants to indicate that the labor was shared and the model claimed some of the authorship. Composed of hundreds of drawings of his partner, from robust if sober studies to deep

meditations on transformation, this final episode in their lives together is based on devolution unto death and, in fact, beyond. On January 4, 1986, Bachardy made eleven drawings in the seven hours after Isherwood's death. "I have had my death encounter with Chris. I have had that body all to myself all afternoon. . . . I feel sort of ghoulish, but also like an artist, and like a pioneer in the further reaches of the land of feeling. I was able to identify with him to such an extent that I felt I was sharing his dying, just as I had shared so many other experiences with him."[5]

Photography has long claimed the business of postmortem recording and largely displaced painters and the ceramic death mask fabricators in

this work. Few photographers, however, have publically exhibited images made of a dead spouse. The Japanese photographer Araki produced a book about his dying wife, Yoko, which included her funeral and cremation, and Masahisa Fukase did a similar series on the death of his father. And, as we will see, the death of Christine Gössler was photographed by Seiichi Furuya.

Between 1978 and 1981, Jim Dine made a series of twenty-five etchings of his wife, Nancy, collectively titled *Nancy Outside in July*. Technically each is a complicated variant with layers of inks requiring the use of several plates. Many bear extensive handwork. Nancy Dine's role in them was to sit facing the artist with a neutral expression. Little is revealed of Ms. Dine: who she is, what her husband feels for her, what their life together is about. Jim Dine has not offered this information and might well wonder why we cared to know. By contrast, most of the photographers we consider here have whetted our appetites for such inquiry. The private lives of the nine couples in this photographic survey, to varying degrees, intrigue their audiences, in some instances the relationships overshadowing the art. So much intimate detail is offered to the viewer, especially with those couples working in the last twenty years, that we feel invited by the photographers into their lives. We come to know their homes, their children, even their nude bodies. Particularly for Gowin, Friedlander, Furuya, and Nixon, the subject is not simply their spouses, it is rather their lives together.

Nancy Dine provides a welcome insight from the perspective of a wife who has been a model. In her lovely essay for the catalog of the series *Nancy Outside in July,* she writes: "I once read about Annette Giacometti, sitting in a cafe and asking her husband 'Why are you staring at me?' and being extremely puzzled by the answer 'because I haven't seen you all day' as she had, in fact, been sitting for him all that day . . . perhaps that is one tiny clue to the complicated relationship between artist and model." She goes on to identify her inability to divorce herself from the image of herself. "Even though it's not a mirror, somehow you can't help thinking it is. Then, too, there is a moment when you are aware that the artist is concentrating on your left cheek bone . . . you can actually feel the brush or pencil on your face . . . it is at that moment that it begins to itch." [6]

These photographers describe pieces of very complex lives and relationships over long stretches of time. While they eloquently reveal some of the variability of twentieth-century coupling and several distinctive views of it, they may obscure more than they uncover. They illustrate highly edited fragments of lives. Here, the artist and model need to commence each session with knowledge of where the last efforts ended. The

married couple who engage repeatedly in a committed collaborative portrayal have a deep responsibility to nourish. They are interdependent. Each has needs and dependencies at risk. Each artist has very particular needs of his wife and far more limited needs of his model. At moments these roles intersect and occasionally are congruent. The person central to his life may be his muse, his object of sexual desire, his ideal of virtue or strength, or a tantalizing unfathomable mystery, the mother to his children, a convenient partner in the laboratory of invention, and the guardian of his legacy. The camera may be the erotic tool of foreplay, an abstracting intermediary, a shield, a microscope, or a container of preserving amber.

Essentially, these are the portfolios of the photographers, not the spouses. The power over the images — over when and how to shoot, of printing, editing, presentation, and the resultant responsibility for promoting and representing these photographs — rests with the husbands and explicitly not with their wives. The wives also exercised a variety of controls. They gave permission, they were as physically and emotionally open as they wished to be. To judge whether the relationships represented here were coercive, one must carefully listen to the participants and view the results. While some wives have placed certain photographs off-limits, insisting that some images not be shown, most deferred to the artist to make such judgments. These couples never allow the photographs to define the meaning of their marriage.

Photography is the ideal tool to use to lie to oneself. It is the tool of choice for those who would construct make-believe worlds that require "evidence," of the most seamless sort, to support them. The shutter activates an amplifier, by declaring the significance of the selected moment. The frame is a dissecting scalpel, which by its precise and surgical excision emphasizes what it encloses. The photograph's crystal clarity is the perfect foil for its mendacity. The camera has been used to fool audiences since the first — did we think we could escape its necromancy?

Roberta McGrath in her article "Re-reading Edward Weston: On Feminism, Photography, and Psychoanalysis," in *TEN*-8, states, "We know they are only flimsy scraps of paper but we overinvest them with meanings. Moreover, photographs come to stand in for the missing object. The condition of the photograph is precisely the absence of the real object." [7] That is why the desires of the viewer are so carefully linked to photographs.

Prior to photography, the actual subject of an art piece was always a central and dominating problem for the artist. The subject could be transcribed, translated, transformed by the artist but never exactly duplicated. Art seemed necessarily metaphor — and metaphors, like transla-

tions, are inherently wrong: that is to say, they are not the original thing. With the invention of photography the artist could capture and subjugate the subject; could obtain it whole and bring it back "exactly." The artist was, then, irrefutably dominant — and this act was accomplished relatively easily. So easily that the process was thought not to be art at all, but to be science and technology. Now, however, we understand that the subject was not retrieved. It was altered, it survived our best efforts to make it a captive.

Instead, we now trust the *image* of the subject as though it were the reality — the *image* is ours, it is the captive. The subject, being as elusive as ever, is still beyond our reach and increasingly, therefore, in our media-centered world, it is beyond our interest. It is still at large. It was merely interpreted and represented.

An assumption underlying such work is that a subject may be known better by a variety of glimpses of it. It is the premise behind much photographic work. A long life together is a series of intricate dances of power, negotiations, responsibilities, agreements, changes of plan. Images do not fully describe these marriages — but they do describe something. A perception of essences, flavors — like all photographs they are true but not full truths — they are lies but not full lies; they only go so far.

It is troublesome to read these series in reverse chronology. As Kierkegaard stated, "It's perfectly true, as philosophers say, that life must be understood backward. But they forget the other proposition, that it must be lived forward." To know that Furuya's spouse was a suicide informs our view of the first photos presented of her. It causes us to mistrust her happiness or, unnecessarily early, to fear for the welfare of her son. Our knowledge of women's issues surely inflects our sense of the O'Keeffe-Stieglitz marriage, and knowing of Olga de Meyer's addiction to drugs and drink makes of her dress-up posturing a particularly poignant charade. Such readings of the images are, on one hand, not true to the moments of their making and, on the other, inevitable. The relationships will be judged by the later knowledge, but it is useful to distinguish what we know from the photographs and what we glean from biography.

Photographs in a series may provide a greater understanding of a subject, but they also elicit new questions as well. What was said and understood between the images? What sparks ignited these inspired moments? What interactions interleaved the early images of an intensely staring Christine Gössler and the later, profoundly distraught and suicidal one? What transpired in the Stieglitz-O'Keeffe relationship between exposures? The exposure time is insignificantly short. What of the rest of the time? Further, what did the images themselves precipitate? Serving as

symbols, notes on a relationship, love poems, flights of fantasy, idealizations, moments of conspiracy, collaboration, erotic foreplay, and diaristic tracings, these photographs allowed couples to momentarily assess their situations. Inevitably, they identify a few islands in the stream of a marriage, and while they do not define the totality of any relationship, they provide enough vantage points to map much of the territory while making more mysterious still the unexplored and invisible places.

That is what these photographers are doing: showing us various insights about their love and about their loved one. They illustrate for us what it is about their partner that absorbs them. They attempt, through multiple efforts, to identify more of the whole person. What of these limbs, these torsos, these scenes of quotidian domesticity, these elegant displays of fashionable excess and performance, these images of change and mutability, of multiple personalities within an individual, these angry or flirtatious or girlish or impatient or openly seductive expressions? They are all aspects of these women as they were seen and adored by their photographer spouses — they are also the fantasy projections of the photographers. They seem at times among the most honest of their works and occasionally may be among the most deluded.

If one carefully examines the oeuvres of these nine photographers, the seriousness, depth, articulation, and the sheer quantity of the spousal portraits underline their significance. It is, moreover, the affection, the sexuality, and the collaborative playfulness that distinguish so much of the work. For an important period in each of these marriages, the wife/model is the muse.

Arlene Croce said in *The New Yorker* that "all Muses must possess two qualities, beauty and mystery, and of the two mystery is the greatest. Somehow or other, the woman must be able to impel the artist toward the goal of creation, she must be good for the art."

Croce stated, "Muses are passive, therefore passé. Most degradingly, Muses do not choose to be Muses; they are chosen. Since the 1970s modern feminism has based its appeal to women on the premise that all barriers to the dream of self-realization are political. The Muse is only a man speaking through a woman, not the woman herself. What male artists call Woman is a construct designed to keep real women in their place." In a real artistic collaboration, Croce observes, "It is not the man speaking through the woman, it is the woman speaking through the man."[8] That's partially the point of these collaborations. Each has a voice. The voices of husband and wife, however, are unequal.

Vera (née de Bosset) Stravinsky was Igor Stravinsky's second wife and only muse. Vera came to him around 1923 and remained with him until

he died in 1971 in New York (she died in 1982). He was her fourth husband. Croce wrote, "As for Vera, who was also a painter and had been an actress, the part of the Muse came easily, though even she found it necessary to set down some rules:

1. Force the artist to work, even with a stick.
2. Love his work no less than him.
3. Welcome every burst of creative energy. Kindle him with new ideas.
4. Keep the main works and the drawings, sketches, and caricatures in order. Know each work, its scheme and meaning.
5. Relate to new works as if they were surprising gifts.
6. Know how to look at a painting for hours on end.
7. Be physically perfect, and therefore his model forever." [9]

Though Vera Stravinsky clearly was able to apply great energy and humor to her role as muse, she understood her task was secondary, to inspire and prod, not to create. Croce wrrote, "Mention the Muse and people smile. We don't know who that is anymore, and we may never know." [10]

These bodies of work contain discussions of marriage, child-making and raising, and, yes, especially, sexual love. Some critics have drawn parallels between the more sexually explicit images in Stieglitz and Weston and pornography, pointing out that Stieglitz, in his early O'Keeffe sessions, encouraged Georgia to fondle her breasts for instance; however, neither of them made images as explicit as contemporaneous examples of Euro-American photographic prurience. The tides of puritanical and repressive impulses ebb and flow but never disappear. In pornography, the person, their context, their life, is of no importance; their perceived willingness, openness, desire, or their sexual performance is. For some, the boundary of pornography is crossed when the photographer and the anticipated audience exercise excessive power over a seemingly (or actually) unwilling model, when physical harm is involved, or a model is too young to provide informed consent. In these scenarios, power for the model is missing.

The effort of the couples in this selection is to invent, to locate new discourse, to identify meanings that are in fact sexual but also loving, responsible, transcendent, authentic.

Stieglitz and Weston perfected the isolated focus on a body part. The breast, the torso, the buttocks, as objects, are often considered separately from the person and the personality. These artists gave us the epicurean examination of a segment, much as poets had, but now the object could also become fetishized, disembodied, and loved — not because it was a loved one's breast but because it was a breast. Without its context it required no responsibility of a lover, of a spouse, no reciprocity, and could turn the sexual response of love, in all its complexity, to one of voyeurism and depersonalized masturbatory reflex. Photography, therefore, may provide the illusion of intimacy and the essential function of witness, but it may also be a perfect tool for substitution, surrogacy, and distancing.

The imagery of the artists collected here should not scandalize any well-adjusted individual or society. On the contrary, it stands distinctly apart from the more casual use of the hired model, with inherently little or no long-term commitment passing between the parties. Much the way long-term partners come to know each other's bodies and preferred pleasures, so a couple engaged in long-term depiction share a deepened understanding of their art-making process, and their responsibilities to one another.

As each couple has its unique balances, vacillations of power, dependency, surrendering, and taking, over long periods, so these bodies of work identify the aging, the mutation, the growth, the reformulation of these committed relationships. This unbroken progression of more than one hundred years parallels an extraordinary century of altering perceptions of women generally and of marriage in particular. Each couple is of its time. Each represents imperfectly the thinking, the ideals of its era. Each couple attempts to find its way through the thickets of life and love, the real and the ideal, with the camera as a close comrade — an insertion of our presence as viewers into the intimacy and messiness of a marriage.

Our own era is marked by much theorizing about gender, sexuality, relationship, and their representation. New and exciting inquiries evolve almost continually. The contemporary wives of this project are strong, eloquent, and politically aware women who have incorporated into their lives much of the feminist thinking of the late twentieth century. It must not be assumed by their inclusion here that homogenized inferences about their politics or their marriages might be drawn. That part of their lives that may be obliquely observed from photographs is small and does not fully define them. Just as the responsibility for the photographs rests principally with the photographers, so too do the meanings of those images. What we as audience are invited to see is the projection of the husband, largely filtered through the collective understanding of the couple.

A mystery arises. There are few well-known examples of a woman photographer portraying her husband over a similar long span of years. One would expect such pictures to exist. In the 1860s Julia Margaret

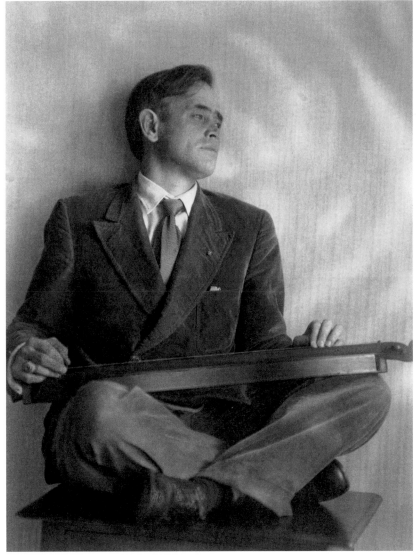

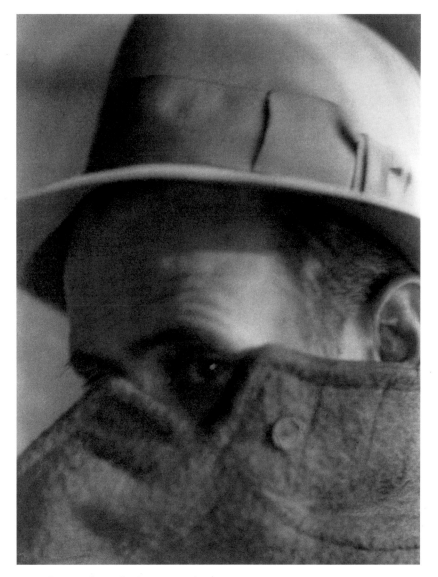

Doris Ulmann, *John Jacob Niles Seated Cross-Legged on Table with Dulcimer*, ca. 1927-1934

Doris Ulmann, *John Jacob Niles in Hat and Overcoat*, ca. 1927-1934

Cameron drafted many friends and neighbors into her photographic service as models, often in costume. Her husband, Charles Hay Cameron, was among them. Cameron generally photographed women as young and lovely, and men, old and wise. In her milieu, these were the supposed periods of their greatest respective powers.

In 1927 Dorothy Norman, a young intellectual of means, began a long and romantic relationship with Alfred Stieglitz. She was smitten by his art, his ideas, and his deep and serious attentiveness to her. She also gave financial support to his gallery, energy to his efforts, and as a poultice to his difficulties with O'Keeffe, he accepted her love. Ms. Norman even

began a rather self-conscious, yet sensitively rendered and affectionate, extended portrait of Stieglitz. She photographed him on his pillow, she pictured his hands clasped, his face lovingly close-up and full frame, and she pictured him full figure in his cloak. Norman's portrait motifs seem to have been lifted from the Stieglitz portraits of O'Keeffe. They offer a sweet double homage, both to the man and to his art.

Doris Ulmann photographed her paramour John Jacob Niles, the singer and folklorist, who was ten years her junior. Her wealth supported them and their adventures for several years. A clue to the mystery may be emergent here. Ulmann was socially in a position of greater power rela-

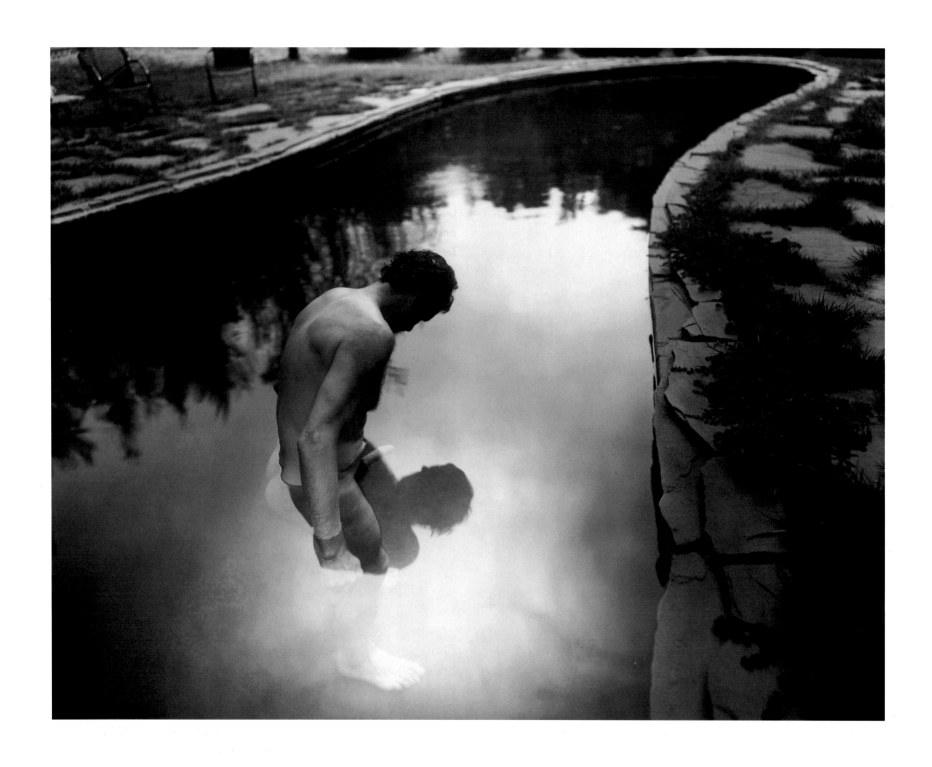

Sally Mann, *Untitled*, 1997

tive to her young man. He was a charismatically handsome and charming fellow. She, a driven and talented artist with an abiding passion for documentation and the rural South and particularly Black plantation life, relied on Niles to accompany her as she worked. A few others (such as Joanne Verberg, Judith Black, Jan Groover) made spousal pictures in the 1980s and 1990s, though they have not been widely seen or published. Jacqueline Livingston, in the 1960s, exhibited a series of images of her husband and son. Becky Cohen made a series of affectionate images of her then-husband, the computer artist Harold Cohen, in the early 1970s, which were praised for their tender sensuality.

Sally Mann, widely regarded for her family photographs, has only incidentally included her husband until recently, when she has begun to portray him. She has made a series of pictures of Larry Mann and herself, nude and sexually entangled. They are equally revealing to any of the Stieglitz or Gowin images, and they are far more sexually explicit. These photographs extend and amplify some of her earlier images of her children, by actualizing ideas that may have been suggested metaphorically in the earlier work. They have all of the seductive delectation she has exhibited throughout her career, and underline the depth of her sensuality. Romantic environments, brilliant slivers of light in shadowy rooms, twisted bedsheets, and lush fields under full trees are the sets for their luxurious activities. We are present at the beginnings of an epic poem of sexual devotion and affectionate play.

Beyond feeling compelled to make such images, one must also feel permitted to do so. Having power of one's own, in and outside the marriage, seems to be the sine qua non. Unfortunately, this is a scarce commodity still for many women artists in the twentieth century.

It also seems necessary to be able to objectify one's subject. The mental gymnastics required to do this have been ascribed most often to men. It is not simply a question of why women do not make such photographs more often. Men are also a party to this deficit. As Bebe Nixon states, "Men do not show themselves and their feelings as readily. They learn early on to be more hidden, to not exhibit themselves or their emotions. This is grossly generalized, but it is also sadly true."[11] Other researchers will, one day, have more tested hypotheses. We will see, one hopes, this genre find more of its female interpreters in the new millennium.

What changes are visible in the representation of wives over this span of time? Do we encounter increasingly powerful women? As art historian Svetlana Alpers questioned regarding Rembrandt, does the model have her own resources? Her own space, reality, her own focus, her own attitude in distinction to the artist? These women are never seen in the office or boardroom, nor on construction sites, in science labs, classrooms, or in a hang glider. They are instead pictured at home, in beds, in kitchens, handling the chores of child rearing, or posing outside or indoors, nude or clothed. They appear unashamed, returning our scrutiny. They perform. The Baroness Olga de Meyer was continually photographed in a state of such extreme polish that it seems safe to assume that the results were both predictable and pleasing to her. After the early years of the Stieglitz-O'Keeffe enterprise, O'Keeffe appears cooperative but also in a good deal of control. Eleanor Callahan is shown as a lover and a mother, but she was also unphotographed as a high-powered professional person and executive assistant to some very successful businessmen. Bebe Nixon is a filmmaker, a fact never announced in the photographs. Whatever effort these women have made to craft a professional life, except for O'Keeffe, often seen with her paintings, and Yoko Fukase, who is seen as a dancer in several of her husband's images, the visualizing of that part of life is not central to their husbands. Only Stieglitz's imagery was deeply enmeshed in his wife's professional persona. Not only did he photograph her with her paintings, but together they crafted a public persona for her career, first as a sexual libertine and then as a powerful, masculinized, square-jawed worker.

It is easy to assume that the professional lives of these wives is rarely portrayed because the husbands have little interest in that part of their wives' identity. This reading is too simplistic. The locale of most of their interactions is the home. The office or studio of the wife is not often the appropriate space for the husband's expression. Further, the wife, at work, would generally not be able to pay attention to the requirements of modeling. Only photographers who shoot spontaneously and casually, such as Friedlander and Furuya, would have been able to photograph their wives in their working environment. Maria Friedlander didn't hold a professional position in the years covered by these endeavors. Christine Gössler did, for a time, at a national radio station, and her husband made several pictures of her working there on one occasion. The Baroness de Meyer was photographed dressed in high style and perfectly coiffured — which was her profession as much as anything else. For Edith Gowin and Maria Friedlander, raising families was a full-time profession, which was abundantly photographed.

However, the absence of working images within this selection is troubling, in the end. One suspects that men simply refuse to retain an image of a wife who is not paying full attention to them. The time a woman spends on her profession is time during which the husband exercises no control. Her professional identity may carry little weight among the char-

acteristics with which he defines her. It is also a domain in her control that stands distinctly apart from these photographic episodes, where the photographer dominates. Bebe Nixon suggests that something deeper is taking place. The photographs are less about her and more about the relationship between them. "Nick is not looking for our identity through our jobs. He is examining how we are mysterious and unknowable. Can looking at things hard, as he tries to, unravel our mysteries? A man and a woman live together consensually for a long period of time. That the meaning of the relationship could be reduced to careers, that one might segregate aspects of a life and catalog them, is such small thinking. It embarrasses me to think of it. Things are so much deeper than that. These are pictures of people's lives. How dare anyone assume to reduce my life to categories." [12]

The women seen here have often described their pleasure at being photographed. It is unlikely that the Baroness de Meyer would have spent the prolonged periods of preparation necessary for her portraits if she did not enjoy either the process or the results. Eleanor Callahan enjoyed being of use to her husband. When friends asked the modest Mrs. Callahan how she felt revealed nude on gallery walls, she said she never felt the nudes were of her, so she didn't feel exposed. [13] Maria Friedlander responded similarly about seeing herself depicted in a book, though the photographs were not nudes. While her husband's photographic procedures are less intrusive than another photographer's might be, the publishing and exhibiting of them are not. Maria Friedlander is still a bit uncomfortable being at the center of the discussion. Her privacy seems, at least theoretically, at risk. [14] Charis Weston was flattered by Edward's attention and fascinated by how beautiful she was in his perception. She also loved watching Edward's animated, graceful operation of his large camera. [15] Not only has the time passed, but so too has the context of the making of the photographs. The woman in the mirror is no longer the one in the photograph, and the man in memory, who made the image, is nowhere to be found.

O'Keeffe was famously aggravated by forced stillness, in uncomfortable poses, but cooperated in modeling for the hundreds of photographs of virtually every inch of her body. She mugs, coyly flirts, exposes herself, squeezes her breasts in the early sessions. Over the course of several years, it became evident that O'Keeffe played an equal and at times dominant role in the enterprise of portrayal. A postural hauteur, a sarcastically raised eyebrow, or emotional inaccessibility mark many of the later pieces. Tellingly, as she took more power within their marriage, the posing slowed and then, finally, stopped altogether around 1936.

O'Keeffe also controlled the availability, the access, and the interpretation, in print, of Stieglitz's art after his death.

Then there is the work of Seiichi Furuya to consider, in which he seems to have trespassed beyond his wife's early pleasure and complicity in picture making, into more dangerous territory. Christine Gössler is shown on outings, at play, with friends, and clowning with her husband. But for an ominous scar on her neck, she seems, essentially, a happy young woman in love. Most of the early work is casual, situational, and diaristic. In a number of sessions, she poses dramatically, against dark backgrounds or mirrors or in the bath. Later in their marriage, toward the end of her life, when her emotional disintegration was rather evolved, he places us, as viewers, uncomfortably close to her, showing her in tears, in anger, lost in her own deep depression and self-destruction. He shows the scene of her suicide and her body immediately after. The camera is not, for him, a tool of art making but rather the organ of perception itself — the camera is his eye, the pictures are what he saw. The images attest to his impotence in stopping her inexorable decline (but also to his ability to keep her image alive). Was this troubled woman aware of what the photographs show? Could they illustrate something substantially different from the image in her mirror? Were they a form of preservation for her too? As a budding actress she often played to the camera. Did this dramatizing encourage her to lose her grasp of herself or was it a safe outlet for her instability? The sad and frightening photographs of Ms. Gössler, at her nadir, illustrate no anger or discomfort directed at the camera. Even the day before her suicide, she posed in a relaxed but formal pose with her son, Komyo. A number of well-known artists have experienced spousal suicide, none have made it so publicly graphic.

Though each of our nine couples manifest distinct views of marriage and family and each has its own peculiarities, there is a prevailing sense of marriage as identified by the photographers' expectations. They generally seem to identify the wife as homemaker, mother, and helpmate. She is cherished, protected, alone but for her husband. She is rarely seen in the company of others; occasionally with her relatives. She may be sexy, but almost never sexually engaged. She may be seen as an enigma, as distant or even as inaccessible, but never fully rejecting or angry at the photographer. Her emotional range (but for Gössler) is limited. While some of these relationships were subjected to great storms of anguish and disappointment, fury is never seen in the photographs. While no couple is obligated to cover this ground photographically, it is interesting to note that none has. The portfolios identify a kind of generous gentility, a romantic elevation; a sense that these families are not like our own,

which may experience a broader emotional spectrum and perhaps somewhat fewer epiphanies. Their enduring popularity may be due in part to their identification of societal values based on the traditional, some would say conservative, model of the family.

While some of these artists had several marriages, most had only one. Except for de Meyer and Fukase, each of the photographers had children. Where there were children, the father's identification with them was, at least photographically, strong. Of course, seeing one's wife tending to children underlines the domestic and, some would argue, the secondary role of the wife. It also allows the artist to publicly proclaim his virility. But in most cases, the interest in their children is genuine, and in several, these men seem to be exceptionally involved parents.

In public perception the artist is often a loner, has a character disorder, is a mumbler in strange tongues communicating principally with his materials. No doubt there are a few such individuals. The artist as family man, carpooler, PTA member, is perhaps a far more common yet virtually invisible manifestation. Stieglitz was father of a daughter but he was utterly absent and seemed little concerned, except financially, for her compromised welfare. Weston was famously the sire of four sons. He clearly enjoyed his role as a sort of scoutmaster, buddy, and role model. He photographed his sons with tenderness and sensitivity. He taught them and traveled with them, and worried about them. His sons adopted a variety of his interests and traits, including but not limited to the pursuit of photography and women.

Harry Callahan and Eleanor have a daughter, Barbara, born in 1950. She was lovingly anticipated in a well-known pregnancy photograph, and recorded neonatally many times. She joined the family seamlessly — one hardly noticed a transition. However she never appeared in Callahan's work after 1957. He indicates that when she went to school full-time she was no longer either interested or available. At this point Eleanor went back to work, and Harry spent more time on the streets photographing.

Family for Emmet Gowin is the central motif in his early work and it remains important. A tangle of his wife's relatives, young and old, populate the early Danville, Virginia, work. When Edith became pregnant, Emmet's fascinated consideration was plain. The pictures in the late sixties and early seventies are so tender and loving that one is tempted to believe that the pregnancies were caused by picture making.

As the glorious, absurd drama of pregnancy overtook the Gowins, they both seem amazed and amused. Evidence of life with children emerges — Edith Gowin presiding over a room obscenely filled with the derivatives of Christmas — their son Elijah is nearly invisible amidst the strewn wrappings. Elijah is not seen after the age of seven; the second son, Isaac, is shown in infancy and then disappears. Gowin seems to point his camera elsewhere, and increasingly at the landscape.

The Friedlanders have a son and a daughter who are much in evidence throughout his work. In the sixties and early seventies they are seen affectionately bundled together with their mother and occasionally their dad gets into the frame with them. His affection for his family reveals a touchingly sweet side to an artist who seems, at times, to raise ambivalence to a high art. It is almost as though the pictures reveal affections for which he has no other vocabulary. These pictures are warm. They identify an artist who experiences a sense of well-being in his family setting. But he is clearly not the primary caretaker. He is curious about his children's existence, proud of them, pleased with his wife's steadfast regard for the children, and as with most things, Friedlander stands off to the side, on the edge, to engage his perspective.

Photographic evidence of caring is not the same as active caring. It is easy to idealize and fictionalize a functional, well-balanced family in photographs where none exists. Whatever the involvement of these photographer/fathers, they are at least actively present with their families and paying close attention for the purposes of image making. Beyond that, the full truth of each household can never be known from the photographs.

In Nick Nixon's work, intimacy is the central theme. While his wife's body is not sexually presented, he comes in close to examine her skin, her freckles, her wounds, and other important minutiae. When the babies — one boy and one girl — appear, they are the subject of several of the finest baby pictures ever made. In dozens of images Nixon identifies his curiosity and astonishment about his children and their ties to Bebe Nixon. In one image Sam, twelve years old, sleeps and fills one side of the photograph while a close-up Bebe is seen on the left, lying face up, staring at the ceiling. We are left to guess at her ruminations, but anyone who has raised children has lain awake, contemplating and fearing for the fate of that sweet life that they produced and yet control so little. It is important to remember that the photographer was also awake and staring in wonder.

Seiichi Furuya and Christine Gössler never stopped to discuss whether a photograph could or should be made at any time. Seiichi constantly made images; the camera was always present. When their son, Komyo, was born, the same rhythm was maintained. Whether there was a stroll in the garden, bathing, family visits, emotional turmoil, fierce anger and tears, institutionalization, and finally suicide, the camera was a participant. Furuya was the constant in young Komyo's life. The boy's

mother was too erratic to be fully responsible. Subsequent to Christine's death, Seiichi has been a single father, raising his son with the help of his mother-in-law. The images of his son are tender and caring but quite matter-of-fact.

The making of images in the service of love is not, as Jung might have it, a sublimated or indirect form of love. It is essential to identifying love — it is the way that love manifests the other in one's life. By creating the image one takes action with the object of one's love. One does something about it. The artist does not simply fantasize or toss about ideas — he interacts with and becomes productive with the partner. These images then, truly are procreative. The vast majority of family photographs depend on their residing within the context of the family, which give them their meaning. If they leave the family, they may become the heartbreaking, anonymous contents of shoe boxes at flea markets. The photographs considered here, because of their quality, their pedigrees, their visibility within art discourse, and their residence in major museums and private collections, have come to represent "The Wife" and the family, for a much larger family — a worldwide audience.

As much as these efforts illustrate a man watching his wife go through the passages of a lifetime, they are also about a man watching himself go through them, about his identifying and scrutinizing his own mortality. For who but our life partner is our closest mirror, the one whom we look to for response to our questions, to provide evidence of our own experience, to be our memory of past events. These artists whose love evolved into long marriages, close, monogamous, supportive, deep relationships (far beyond sex and parenting), are men looking into their own barometers, mirrors, lenses, to see themselves and their wives passing through the life they have jointly constructed. Their art is inextricable from their life.

It is noteworthy that none of these wives have been photographed as old women yet. It will be up to Friedlander, Gowin, or Nixon to do so. As for all the other women involved, it is no longer possible. It will be interesting to see if traditional imaging conventions of youthful beauty may be realigned as these couples age. These three artists have announced a willingness, so far, to appreciate their spouses' maturing. Nixon has not turned away from the textural exactitude of his rendering and is, it seems, more attracted than ever to the visual vocabulary of aging. Similarly for Gowin and Friedlander, an aging spouse seems to provide new opportunities for portrait invention.

"To take a photograph is to participate in another person's mortality, vulnerability, mutability," states Susan Sontag in *On Photography.*

"Precisely by slicing out this moment and freezing it, all photographs testify to time's relentless melt."[16] Only de Meyer, among the artists in this discussion, attempted to resist the mutability of time. Olga remains artfully and artificially young for many years. In this battle, costume, make-up, lighting, and pose are the principal weapons. Her husband, at her side, is the ultimate collaborator and alchemist. To believe fully in illusion and the reality of images, is after all, to have belief.

The artists in this survey whose wives predeceased them or otherwise departed seem to have suffered most romantic manifestations of loss. The muse is no less a muse for being physically absent. The Baroness de Meyer died in 1931. The baron worshiped her in an inexplicably intense way till the last. He referred to her as a paragon of perfection in all things. When O'Keeffe increasingly left Stieglitz for her beloved dry country, he would, by all accounts, rave, curse, and cry for her; that is, until he located a surrogate in the body and spirit of Dorothy Norman. But his emotional turmoil over O'Keeffe has been debated and gossiped over as often as have his photographs. After Charis left Edward Weston, the quality of his life weakened quickly. Importantly, his Parkinson's disease was diagnosed at the same time and his level of activity diminished. His friends found him despondent, morose, and unable to work. Masahisa Fukase fell into deep depressions, drunkenness, and prolonged illness when his wife, Yoko, departed. He made two books which dealt with Yoko and his anger. A third, *The Solitude of Ravens,* identifies his cosmic aloneness in the most unendurably anguished vocabulary. Seiichi Furuya has spent nearly twenty years working and reworking the "Christine" pictures. Obsession is not too strong a term to describe his need to continually present her as a loved and deeply troubled woman, one whose legacy and memory is his central photographic production.

The photographer generally has the power to fix forever the history he wants, in spite of whatever reality the world creates for itself. De Meyer, Fukase, and Furuya each enveloped themselves in their photographic memories as a poultice against their loss. It is only after time has acquainted us with death that we realize how embalming a photograph may be.

These photographers seem remarkably undone by the loss of their partners, who had been not only wives but also colleagues in the pursuit of image making. They have lost an intimate domestic partner and, moreover, they have lost an image of the ideal, one who could help extract inspired visions, who could understand the vicissitudes of creation, a comrade in the trenches, a recipient of intimate visual attention, and one

who provided, for their husbands, a door to a different vocabulary of picture making, of a character they would never find again.

In all works of art there is at least some fiction — all art is metaphor at some level — but for Stieglitz, Weston, Gowin, Friedlander, Furuya, Nixon, Fukase, even de Meyer and Callahan, this work is very close to the unalloyed truth. This is their real life. These pictures show their lives coming together, loving and occasionally coming undone. It is highly personal reality — not only art.

These husbands made these images to direct, control, name, and hold that which cannot, in fact, be directed, controlled, named, and held. And while this task is, in one context, futile, in another it is essential, heroic, memorializing; an attempt to forge a one-way bridge across an infinite chasm. By making this effort as interesting and creative as possible, these nine artists solve the problem identified by Balzac when he stated, "Marriage must incessantly contend with a monster that devours everything: familiarity."

We are all essentially tourists in these nine marriages. The couples show us what they have agreed to let us see. Complex dynamics underlie each couple's decision to reveal these intimate moments. Career, honesty, love, devotion, passion for an idea, art and ambition. Each couple feels a certain distancing from the people pictured in the photographs, a certain remove from the image of themselves, as the image is of another time and they themselves have moved on. As O'Keeffe stated in 1978 at the age of ninety, "When I look over the photographs Stieglitz took of me, some more than sixty years ago, I wonder who that person is."[17]

Millions of words have been written about the subjects of marriage, love, commitment, collaboration, and their relation to art. It is not the goal of this writing and selection of photographs to attempt to redefine these topics. Those who do so, as scholars, are entitled to their efforts, rewards, and bruises. Artists have forever sought to communicate their passions and photographers no less so. Here the successes and failures of the marriage are expressed. Much of their lives, responsibility, and ultimately vulnerability as people, not just artists, are inextricably linked to their spouses. Where would one look for more insight into an artist but where their greatest vulnerabilities are located? These nine artists have made, of both their relationships and their art, something enduring, something resilient. Their images, distilled, elemental, refracted particles of relationships, are bravely presented. Few have done it, and none better. These pieces represent some of the deepest, most passionate announcements the photographic lexicon allows. This work is about personal exposure. This is where the camera shoots in both directions.

Overleaf:
Baroness Olga de Meyer, Georgia O'Keeffe, Charis Wilson
Yoko Fukase, Edith Gowin, Bebe Nixon
Eleanor Callahan, Maria Friedlander, Christine Gössler

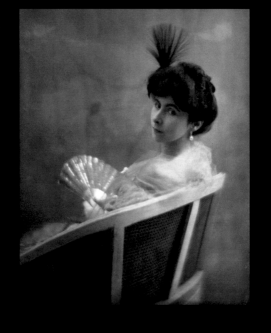
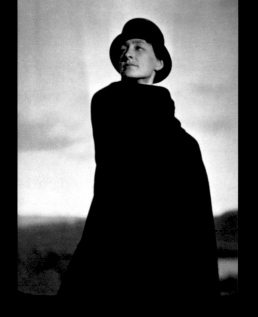
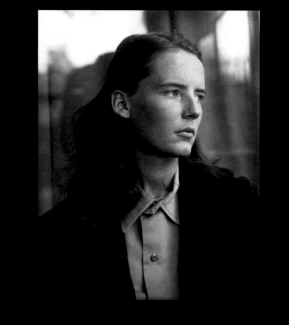

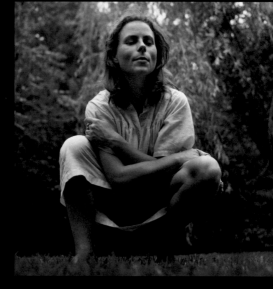

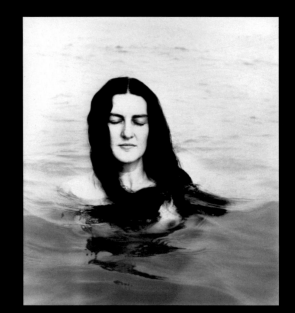
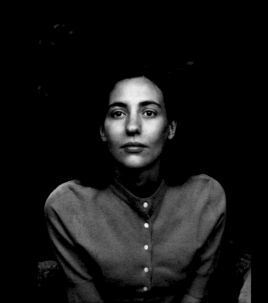

THE·MODEL·WIFE

Baron Adolph de Meyer Baroness Olga de Meyer

Alfred Stieglitz Georgia O'Keeffe

Edward Weston Charis Wilson

Harry Callahan Eleanor Callahan

Emmet Gowin Edith Gowin

Lee Friedlander Maria Friedlander

Masahisa Fukase Yoko Fukase

Seiichi Furuya Christine Gössler

Nicholas Nixon Bebe Nixon

BARON ADOLPH DE MEYER

A MAN WHO HAS MUCH TO CONCEAL lives by and for the image. He must be able to fabricate "truth" and that truth must be convincing. It must be so convincing that he comes to believe it himself.

As Anne Ehrenkranz has written in her monograph *De Meyer, A Singular Elegance,*[1] "Baron Adolph de Meyer fabricated most, if not all, of his biographical information; the facts must therefore be surmised obliquely, through scraps and documents, and through the biographies and memoirs of his acquaintances. From accounts of the period, we do know that he was, in all likelihood, half-Jewish, homosexual, and certainly German." Each of these three could be troublesome for him, so he fictionalized much of his life. It is also clear from his art that fiction and fabrication were among his greatest talents.

In 1896, the year de Meyer married, he no doubt was well aware of the 1895 trial of Oscar Wilde on charges of homosexuality. The Dreyfus case in Paris in 1894, involving false charges of espionage against a Jewish military man, was similarly infamous. De Meyer's marriage to Olga Caracciolo might have been precipitated by his need to distance himself from his own reality, resulting predictably in a life devoted to surface appearances.

Olga grew up in Dieppe, in Normandy, a destination of the fashionable intelligentsia and aristocracy and a relaxed domain of courtiers and artists. Henry James frequented this resort town, knew Olga and her mother, and is said to have based his central character in *What Maisie Knew* on Olga. Her mother was the Duchesse de Caracciolo, a popular figure in town, who had an air of mystery and numerous suitors. She never married and no one was quite sure who sired Olga. The Prince of Wales (later King Edward VII) was often thought to be her father, as he was regularly seen with the duchesse, and he presented Olga with the Villa Mystery, which became her home. Olga never denied that he was her father, and so speculation edged toward general knowledge.

Olga was particularly attractive and precociously bright. She modeled for a number of painters, including Whistler, and had a short-lived early marriage before she met de Meyer. "She was a young woman possessed of enough style, wit, and grace to succeed. She amused her godfather, the Prince — he was interested in the arts and well-informed, and she took good care not to bore him."[2] Olga frequented the salons and was one of their shining lights. She met Baron Adolph de Meyer at such a salon, for he was a regular also. They married in 1896, and their home became a center for spirited social activity. Anne Ehrenkranz comments: "It seems probable, however, that the couple's passions were fulfilled outside the marital bed: de Meyer was homosexual, and it was presumed that Olga had both lesbian and heterosexual liaisons."[3] It was said that they had a "*marriage blanche,*" a chaste marriage.

De Meyer's portraits of Olga are from 1897. His images of her reflect worship and platonic appreciation of her perfection. She seems confident in her poise and grace — well used as she was to being seen and admired. In photographs, their relationship is one of propriety, though one can read in them style, opulence, and decadence. Their private life, off camera, was infused with libertine and licentious qualities common to aristocracy. In high society, everything balances on appearances, a game in which the de Meyers were masterful and confident. Their close relationship with Edward VII was a perfect foil. The de Meyers both had style, but she had the better creden-

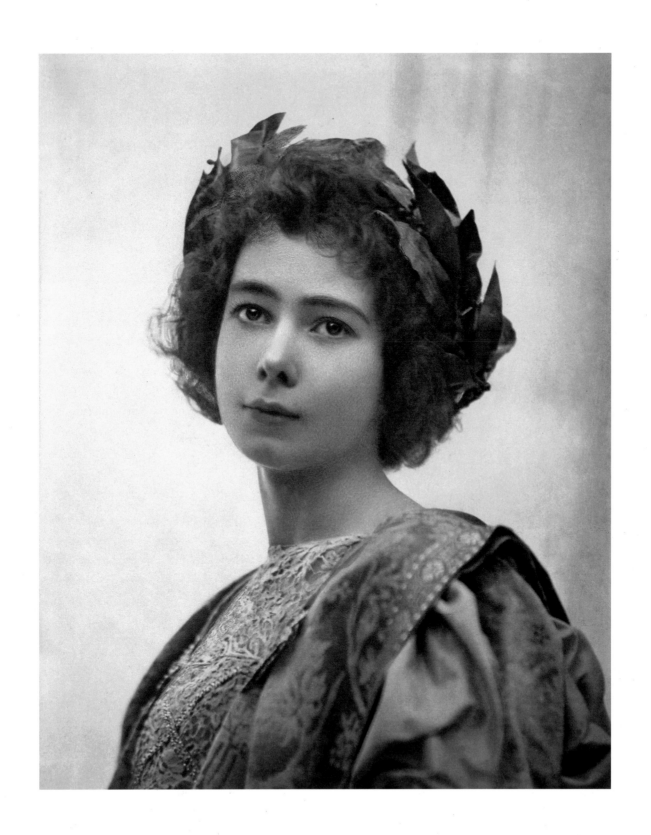

Adolph de Meyer, *Olga de Meyer*, ca. 1896

tials. It is likely that he worshipped her in part as his passport to credibility and social acceptability.

The pictorialist movement held high artistic aspirations for photography. Its stylistic vocabulary preferred generalized and romanticized subjects to specific, realistic ones. Eschewing photographic accuracy and detail, it tended to poeticize with soft focus and dreamy mythologies. The Brotherhood of the Linked Ring (a prestigious organization promoting pictorialist photography) in London required strict adherence to high pictorial standards. In 1898 Baron de Meyer joined the Brotherhood and through it met and befriended many American and British pictorialists, among them Edward Steichen, Alvin Langdon Coburn, George Seeley, Gertrude Kasebier, Francis Benjamin Johnson, and, by correspondence, Alfred Stieglitz. (Though de Meyer exhibited in 1907 at Stieglitz's Little Galleries of the Photo Secession and published in Stieglitz's magazine *Camera Work* in 1908, the two never met until 1909, in Munich.)

The baron and baroness led a glamorous existence; they traveled around the world in 1900, kept a villa in Venice, a home in Paris, one in London, another in Constantinople, and later lived in New York. Each year Diaghilev joined them in Venice. Their friends and contacts reached around the world, often at the highest levels of society. Their great guardian, King Edward, died in 1910, but by then de Meyer was propelling his own career as an arbiter of fashion. From 1913 to 1922 he worked as a staff photographer for *Vogue* and *Vanity Fair.* In 1915 he began also to write editorials in *Vogue.* Then, in 1922, he became the central figure at *Harper's Bazaar,* where for ten years his was the reigning voice determining what was stylish — in photo spreads, editorials, and fashion commentary.

De Meyer depicted women as lovely icons, porcelain dolls, and idle aristocrats, whose function was to be seen, to be lovely, witty if possible, and to spend money. The new American aristocracy of wealth and the European aristocracy of birth and position were his subjects and an important segment of his audience. Another element of his audience was women who could never hope to try on either those wardrobes or those lives, yet to some degree modeled their aspirations on both. In the first twenty years of the twentieth century women of social standing had no real occupation but for the slippery notion of "holding standards." Their wealth had relieved them of household and child-rearing requirements, and many were unwilling to put their reputations at risk over campaigns for suffrage and birth control. De Meyer's work gave them an identity and a sense of the rightness of their situation. He depicted them at ease with their wealth and position, confident and comfortable in their sable and silk. They were alluring without being overtly seductive. De Meyer, like later-generation portrait artists — Avedon, Penn,

Newman, Liebowitz — became the gilder of lilies, a definer and arbiter of celebrity. Those who desired visibility needed to be identified by one of the gatekeepers in order to attain it. Simple wealth and position were all that was required in de Meyer's time, while the sine qua non today generally is accomplishment. Being photographed by the baron ensured one's status in the New York and Newport social scene.

The baron made many elegant portraits of Olga that share several characteristics. In each, Olga is portrayed in opulent costume, perfectly coiffured and made up, posed carefully to show her in control of herself and her surroundings; her expressions are engaged but not spontaneous. Though they were extraordinarily busy and it is widely thought that drugs and drink played a great role in their lives from the middle 1920s to Olga's death in 1930, in no photo of her is there a sense of illness or decline or even of aging. She is never pictured by the baron with another person (except for one image of the baron and baroness together), never seen engaged in any activity save that of being seen. She gazes at the camera from the settee, from a throne, in a doorway, or she poses in profile in a sequence of gowns in lovely parlors. She is never seen functioning, never as sexual, never seen candidly, never really alive. Her portrayal is thoroughly superficial, her emotional range stiflingly narrow. The notion of superficiality, however, must not mask the fact that the photographs are strikingly beautiful tours de force and worshipfully graceful. Olga's luxurious trappings, however, appear to provide her with no pleasure or release. Alexandra Anderson-Spivy, one of de Meyer's historians, wrote that his photos idolize and distance Olga. They also protect her "from reality, from aging, from casual scrutiny, from disrespect." Who she is and what she is made of, what worried or obsessed her, is all quite a mystery in the end, as it was in her beginning. She was a much more potent force on the social scene and in her husband's life than the lovely bauble she appears to be in the photographs. As Ms. Anderson-Spivy states: "Beautiful as they are, these flawless portraits of Olga tell his love story, not hers."[4]

The baron is quoted as saying, "Real elegance is never amusing, it is perfect."[5] For de Meyer, Olga was a religious icon, an image of perfection, existing on a different plane, a transcendent goddess.

The Great Depression brought America up short — startling it into a grim realism that World War I, fought on foreign soil, failed to accomplish. The de Meyers were not prepared for such issues. Nor were they ready for the aesthetics of Modernism. So much of the modern world of art was concerned with challenging old styles, testing the boundaries of every medium, and the expectation that industry and mechanization would overthrow old societal hierarchies. In the casual America of the late 1920s, the high-society Edwardian couple seemed less adapted to an environment of emancipated

women of middle-class backgrounds. While the baron continued to play a role as arbiter of fashion, and as a couple they entertained at a lavish level, Olga had no real function.

Olga's health was delicate, and she sought cures at various spas in Europe. She also took spiritual advice from an Indian spiritualist. After Olga's death, in an Austrian clinic while undergoing treatment, Adolph returned from Europe to the United States. Eventually he took up residence in Hollywood, along with his lover, Ernest, whom he adopted in order to have a proper heir for his modest estate. He attracted a few friends and patrons, but his last years were quiet and lonely. He destroyed most of his original prints before he left Europe in 1938, saying in a letter to Stieglitz, "I destroyed all that was superfluous, it seemed to me a burden — all my photographic work especially."[6] As he never destroyed his images of Olga, he obviously felt they were anything but superfluous. He was able, in 1940, to amass only forty pieces for a small "retrospective" exhibition at the home of Edward G. Robinson. At his death, a trunk with a few of his possessions went to Ernest and eventually was passed to an antique dealer. Subsequently, in 1988, the photography dealer G. Ray Hawkins purchased this trunk and found within the Olga photographs. None had ever been exhibited, published, or been seen before. They are elegant illustrations of perfect style and form. They offer images of an era and a vocabulary of behaviors only incompletely understood now. Not only do we not understand what such calculated perfection meant, we no longer know why they cared to attempt it.

De Meyer seems to identify, for his milieu, the notion that one must believe absolutely in the image, far beyond one's capacity to believe in quotidian life, or the house of style falls around us. "In his life, as in his photographs, he was not concerned with the banalities of reality or fact. Instead, he implemented a way of seeing that transformed the people in front of his camera into fantastical figures, illustrations from picture books, princesses and princes."[7]

A fully platonic marriage can admit no imperfections. It is based on contemplation of the ideal, not consummation with it. It appreciates perception as a method of philosophical evolution up the ladder toward the sublime. But the object of Baron de Meyer's idealization was his wife, who must, for his needs, be perfect. As an aristocrat, he had little daily need of a helpmate, a procreator (as they were both uninterested in offspring), or an artistic partner. The baroness need not — no, she must not — ever come down from her pedestal. It is extraordinary to note that as the love of his life and his personification of perfection, Olga is always portrayed in the same manner as all the other society ladies in his portfolio. Though the images are stunningly complimentary and as beautiful as Olga herself was beautiful, she never emerges from the pack by more sensitive treatment, more poetic exposition, or more loving rendering.

For de Meyer, the secret cache of beautiful Olga photographs was an altar to her exquisite memory and a memorial shrine to his partner, best friend, and coconspirator. Poignantly, it also enshrined his longing for that moment of his essentiality at the highest levels of culture on both sides of the Atlantic.

The baron was left with the part he most coveted, a trunk full of photographs to worship. These may have been the most honest imagery of all; a fata morgana of beauty, grace, and dignity, frozen for all time in silver, to believe in in a manner that contemporary media commentators can only now understand. The image is the reality precisely because it lies so perfectly for us. De Meyer's pictures are the ideal repository for the couple's mutual secrets, safely locked away from our eyes, right on the surface of the photographs, for all to look at and none to see.

Modernism would demand deeper personal revelations from artists. De Meyer provides an interesting contrast to the photographers who follow, for whom intimacy, particularity, passion, and poetic exploration of a loved one are central to their art.

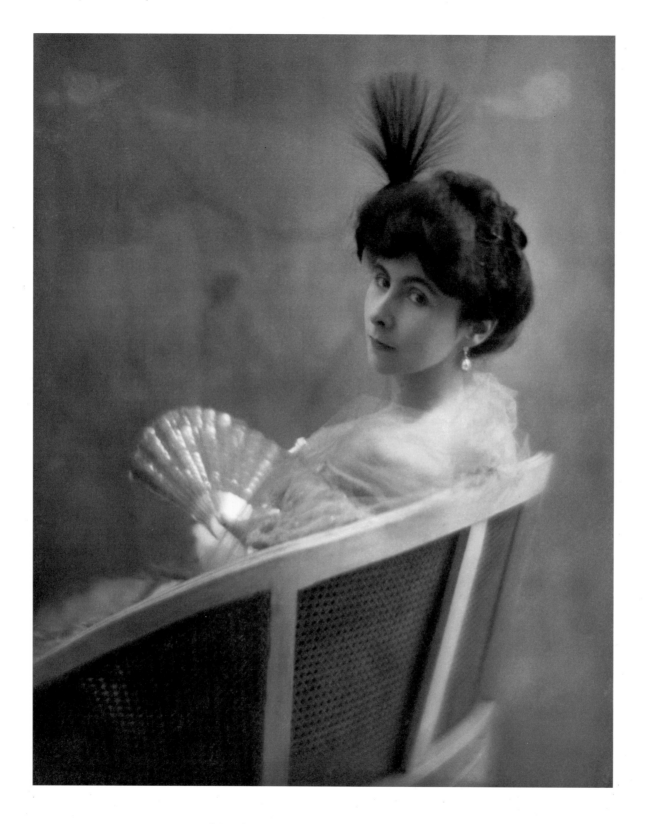

Adolph de Meyer, *Olga de Meyer on a Cane Settee,* ca. 1905

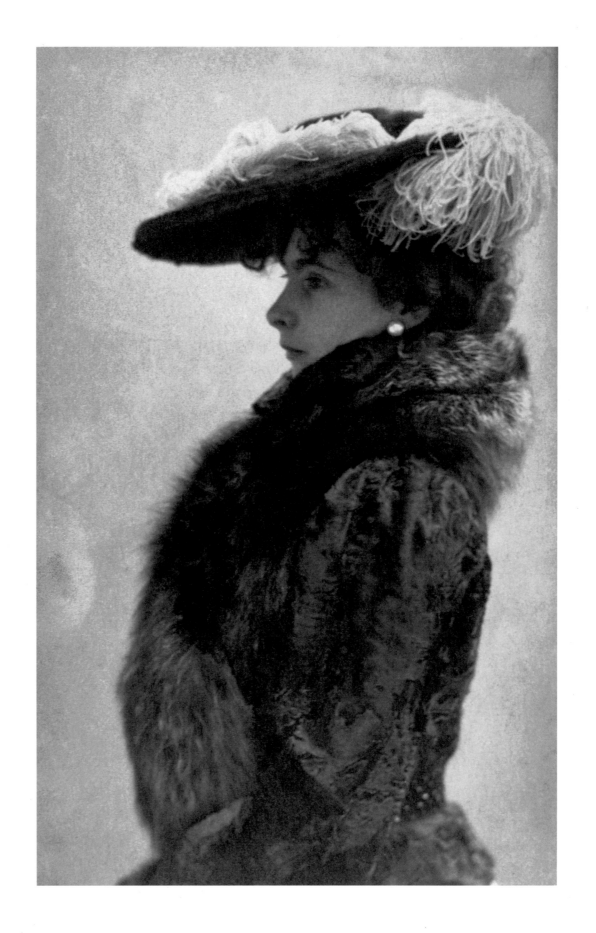

Adolph de Meyer, *Olga de Meyer,* ca. 1910

Adolph de Meyer, *Olga de Meyer,* ca. 1898

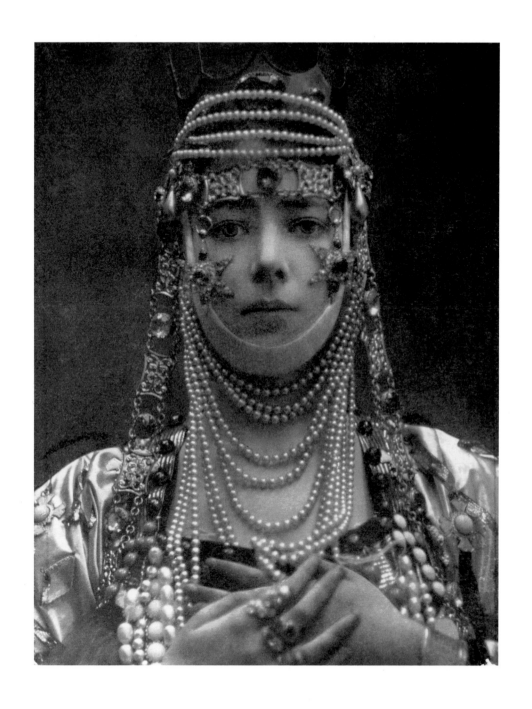

Adolph de Meyer, *Olga de Meyer*, ca. 1910

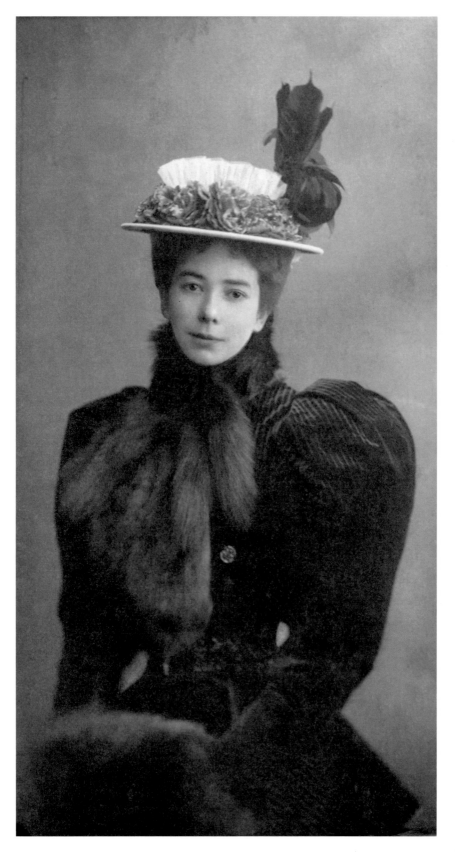

Adolph de Meyer, *Olga de Meyer*, ca. 1898

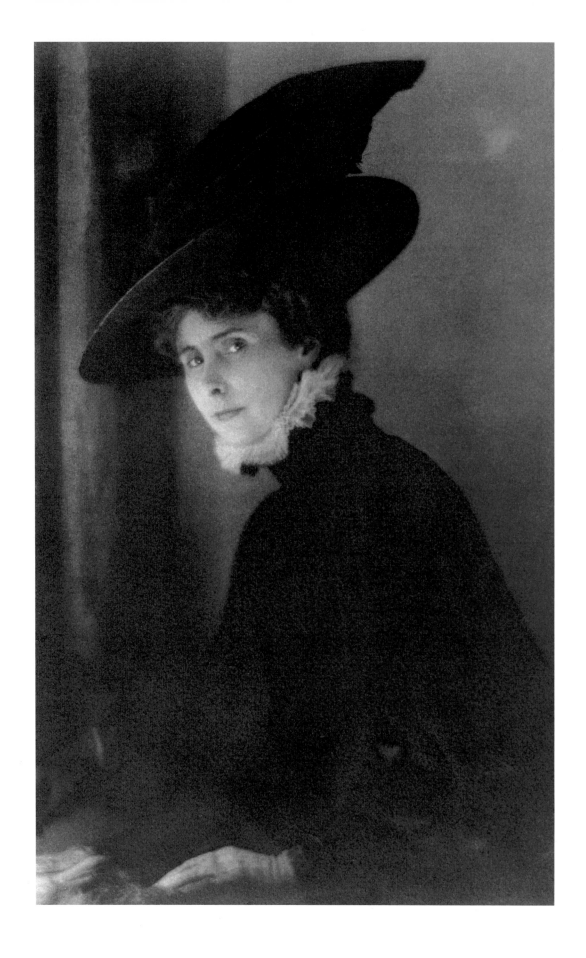

Adolph de Meyer, *Olga de Meyer*, 1910

Adolph de Meyer, *Olga de Meyer in a Garden*, ca. 1910

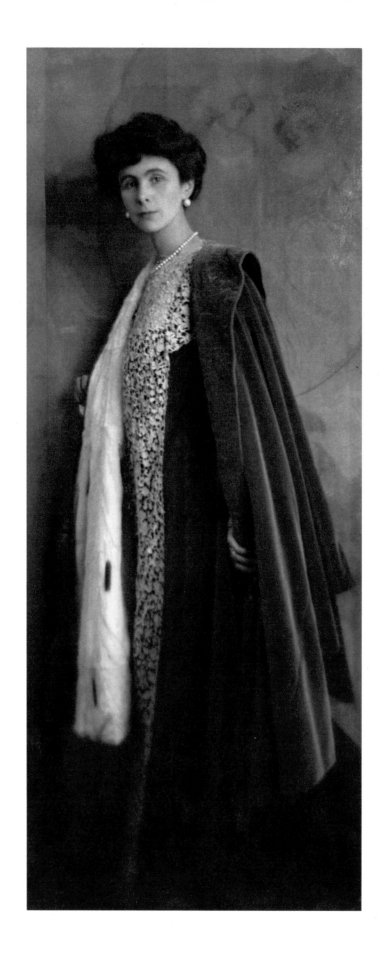

Adolph de Meyer, *Olga de Meyer*, 1915

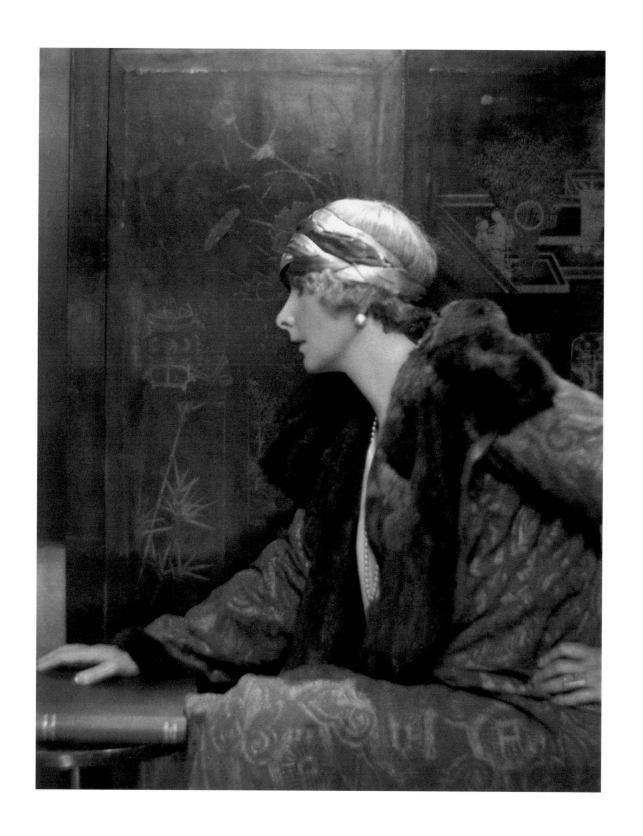

Adolph de Meyer, *Olga de Meyer*, 1920

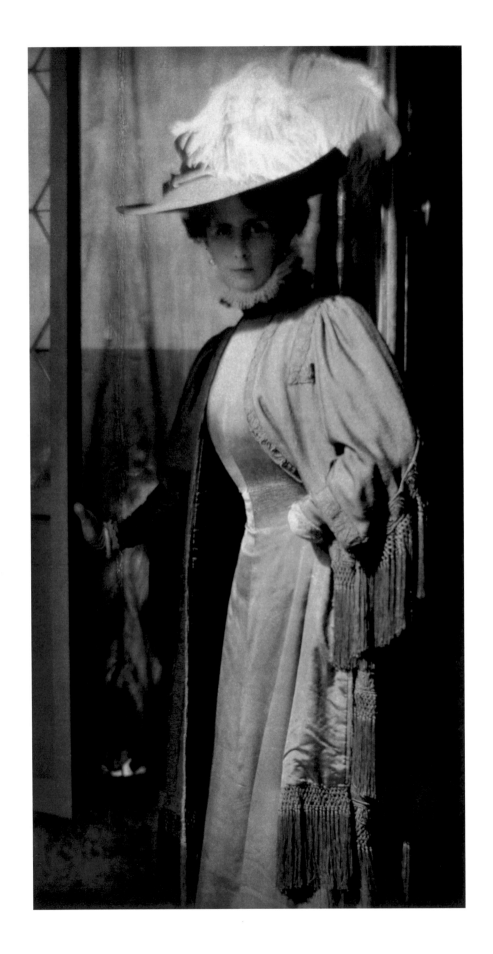

Adolph de Meyer, *Olga de Meyer*, ca. 1915

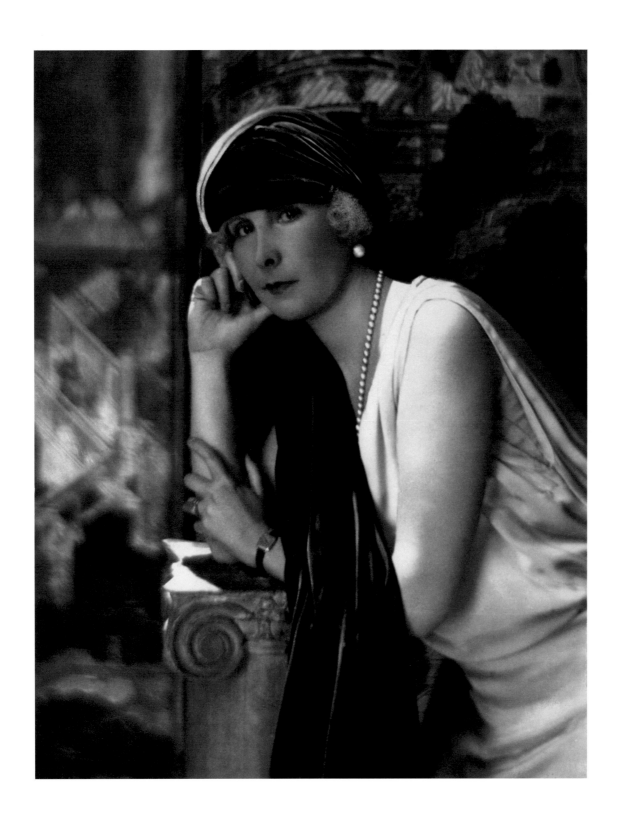

Adolph de Meyer, *Olga de Meyer*, ca. 1925

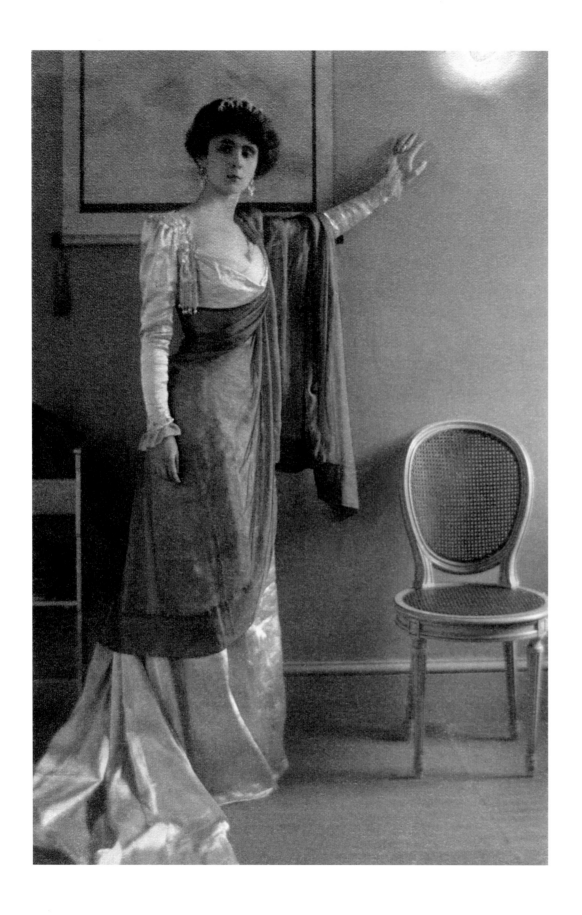

Adolph de Meyer, *Olga de Meyer,* ca. 1912

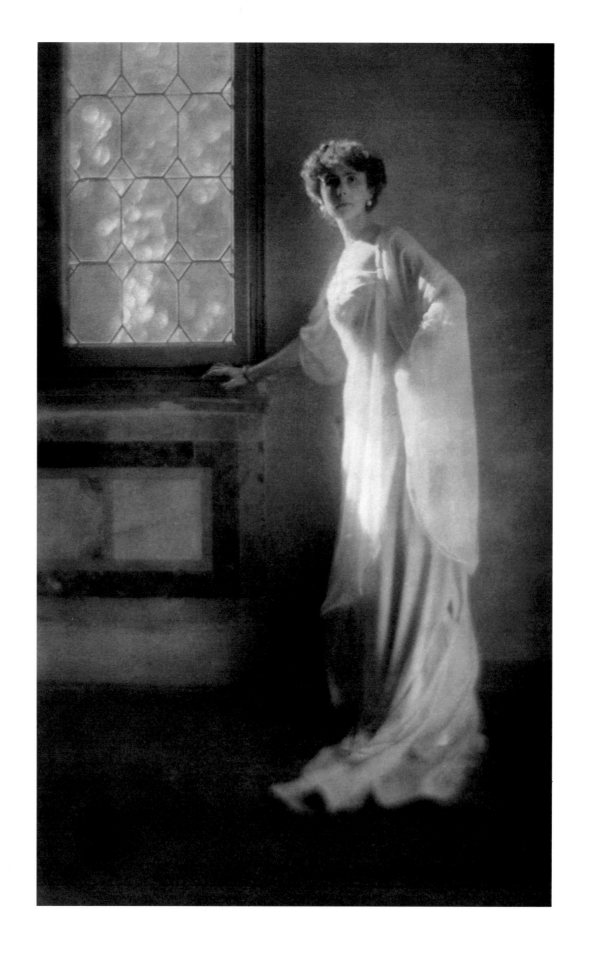

Adolph de Meyer, *Olga de Meyer,* ca. 1916

ALFRED STIEGLITZ

MANY COMMENTATORS HAVE DISCUSSED THE UTTERANCES AND LEGACY of Alfred Stieglitz. Every one of them must eventually address the impact on his life and his art of his second wife, Georgia O'Keeffe. Just so, scholars of O'Keeffe must consider Stieglitz's involvement in her life. The popular image of Stieglitz and O'Keeffe locked in mortal combat is inaccurate. They were sometimes combative but more often supportive, and cooperatively strategic about their careers.

O'Keeffe's art career virtually begins with Stieglitz, for he launched it. On the other hand, the control of his final legacy resided almost completely in her hands and, after her death, under the auspices of her estate. In this regard, each took great care of the other, and collaborated to create of their marriage an art world institution. Their collective power cannot be ignored in any discussion of early- to mid-twentieth-century American art.

Stieglitz was easy to disagree with and even easier to dislike, but many sought wisdom at his knee and heeded his every proclamation. And his ideas, unlike those of many intellectual gurus, have generally been supported by history as his legend has been amplified.

Stieglitz — the stern oracle; the pontificator; the showman; the star maker; the guardian of the highest gates of artistic purity; the bourgeois Jewish intellectual; the passionate lover; the writer of earnest and over-wrought poetry; the proud presenter of the talented, liberated new woman; the husband, inconsolable and distraught; the wise old lover of the young, doting, and wealthy Dorothy Norman — has remained a romantic leading man in the photographic pantheon.

Alfred Stieglitz was a masterful photographer whose art needs no aid from his overheated biography and who towers above most of his contemporaries. While his depiction of architecture, landscape, and portraiture is direct and distilled, and his luminous equivalents are poetic harbingers of Abstract Expressionism, it is his extended portrait of Georgia O'Keeffe that is his most profound photographic contribution to twentieth-century art.

Profundity came readily to Alfred Stieglitz but so did hyperbole. John Szarkowski, in his exhibition catalog *Stieglitz at Lake George,* claimed that "what Stieglitz did is greater than his explanations" and "that if the monument by which he is represented to the world is a little incoherent, it is not for that reason, a bad likeness." The economical elegance of the photographs was notoriously absent from the artist's passionate rhetoric.

The period prior to O'Keeffe's arrival in Stieglitz's life was difficult and frustrating. He was estranged from his wife, Emmeline, and their daughter. The outbreak and progress of World War I preoccupied the public; there was a diminished interest in art. Stieglitz himself, having spent years in Germany, couldn't at first take sides in the war. In 1917 there were only thirty-seven subscribers to his pride and joy, the magazine *Camera Work.* He had financial worries, was middle-aged, and the circle of followers eager to listen to him was dwindling. His artistic output had dramatically dimmed and he had made very few photographs in the previous ten years; then came Georgia O'Keeffe.

When Stieglitz first saw O'Keeffe's drawings he identified them as the "purest, finest, sincerest things that have entered 291 in a long while."[1] He exhibited her work in 1916, a year before their legendary meeting. He loved her work, she loved his power and intensity.

Stieglitz was rapturous about O'Keeffe and made no secret of it. Ironically, when Stieglitz's niece Elizabeth tried to persuade O'Keeffe, then teaching in Texas, to move to New York because she felt Uncle Alfred was in love with her, O'Keeffe wrote back, "He is probably more necessary

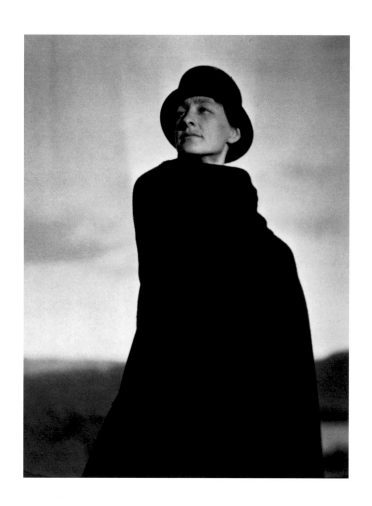

Alfred Stieglitz, *Georgia O'Keeffe: A Portrait*, 1920

to me than anyone I know, but I do not feel that I have to be near him. In fact, I think we are probably better apart."[2]

He photographed her first in June of 1917. He sensed her protean energy, her nonverbal assertiveness, her earthy strength, her physicality, and as he said, her "90 percent similarity" to himself. Such perceptions suggest an element of self-portrayal in his O'Keeffe pictures. He depicts her in the earliest photographs as open and vulnerable, like a little girl. A more sophisticated visual dialogue begins soon after. O'Keeffe moved to New York in June of 1918 and occupied Elizabeth's studio apartment. Within a month their romance was apparent to all who knew them. Between 1918 and 1923, Szarkowski says, they were "besotted" with each other.[3] In August of 1918 they went to the Stieglitz family retreat at Lake George, and everyone there commented on how his love affair had dispelled his depression.[4]

Stieglitz was about to turn an important corner as an artist. He was moving from a fallow period to a moment of great photographic insight and revelation. His emotional life had changed, and now his artistic life had to follow. Alfred Stieglitz suddenly faced his greatest challenge — how to depict his passions. If he was unable to depict this love, this erotic volcano, if he couldn't photograph this obsession with O'Keeffe, he was not only not a photographer, he was also not a poet or a philosopher. And alas, he would not be a lover, because in order to understand love, he needed to apprehend, to capture, to be able to express, what was causing this deep transformation. To be an artist he must be able to express the ultimate sensations, those things that meant the most to him. His core of wisdom, his grasp of reality, became shaky as he was being transformed. This was his test. Without his camera and its power of consecration, he was not a man. The camera was his phallus. Stieglitz himself declared, "Each time I photograph, I make love."[5] And now, who could doubt it?

In August 1918 they were making photographs virtually every day. She recalled: "We'd make love, afterwards he would take photographs of me."[6] Ultimately, 350 images of O'Keeffe resulted from their efforts together. Stieglitz's friend Paul Rosenfeld wrote in April 1921, "He has brought the lens close to the epidermis in order to photograph, and shown us the life of the pores, of the hairs along the shin-bone, of the veining of the pulse and the liquid moisture of the upper lip."[7] Following his vision around O'Keeffe's form, one feels his playful, erotic joy in her generous splendor. In his greatest test, Stieglitz was decidedly successful, going far beyond the directness and intimacy of his previous portraiture.

Stieglitz showed the O'Keeffe photographs first in 1921 at the Anderson Gallery. The show encompassed diverse works from 1896 to 1921 but about one-third of it was drawn from his extended portrait of O'Keeffe. Several of the portraits posed her with her art and were openly sexual. Many were nudes, and quite explicit at that. The most revealing nudes were not exhibited, as both felt that audiences were not ready for them. The show brought O'Keeffe to the public's attention. She became an overnight celebrity. As her art had not yet been widely seen, her early reception was as Stieglitz's model, his paramour, and an exemplar of the libidinous freedom of the brave "new woman."

The show became a cause célèbre, a scandal, a point of great debate. One of the Stieglitz pieces of O'Keeffe was priced at $5,000. In so pricing it, Stieglitz seemed to be equating his photographs with paintings. And by quantifying her "value," he made her more of an object of discussion. She belonged to him, it seemed to say, and his power, including his sexual power, was greater than it had ever been. After a decade of very little art making and declining influence, Alfred Stieglitz was back. People quickly became interested in O'Keeffe's art, and Stieglitz never missed an opportunity to promote it. By the late 1920s, O'Keeffe was among the most famous artists in America. Barbara Barholes Lynes in *O'Keeffe, Stieglitz, and the Critics, 1916-1929*, describes Stieglitz as a leader in advancing feminist ideas of the day. She calls him a "ground-breaking advocate of the most progressive attitude toward female artists to emerge in the teens; that it was possible for them [women] to become the equals of male artists."[8]

For her part, O'Keeffe was transformed in a few years, in front of the camera, from a shy, rather reserved young woman to an identifiable, widely viewed and discussed voluptuous nude model. Her portrayal alters also, from girlish and coy to brazen and haughty and then to masculine, assertive, and even taunting. O'Keeffe was identified, in public perception from 1921 on, as libidinous and sensual. Her art would always be defined in sexual terms and she, especially late in life, would continually and unsuccessfully deny it.

Even in her nineties, when feminists celebrated her liberated early sexual exploration and iconography, she would not cooperate with their exhibitions or research. While being publicly portrayed in the nude made her famous, her greater desire was to be taken seriously as an artist. Stieglitz had presented her in an openly sexual manner. She cooperated fully, not only in the making but also in the exhibiting of the photographs. And it enhanced her career. She had made a sort of deal with the devil. In order to focus her reputation more on her art, or at least to reduce the heat of her public image, she posed nude less often in the early and mid-1920s. By 1921 Stieglitz was producing close-up portraits of O'Keeffe that had strong masculine components. While the women's suffrage movement downplayed frilly femininity, there was little visual imagery available that could predict these sober,

Alfred Stieglitz, *Georgia O'Keeffe: A Portrait*, 1918

confident, asexual, chiseled portraits. They featured male clothing, eye-to-eye contact or a faraway stare, and, most powerfully, a visage so confident of its control of its own moment, that it had, at the time, to be read as male. Any previous art-historical antecedent would have been mythological, France at the battlements, Judith after decapitating Holofernes. But this was photography, with its perception of veracity. There was no chance that these photographs would be read mythologically. The portraits became more complex, dramatic, and ambiguous. We see powerful close-up faces, the delicate ballet of her hands, O'Keeffe wrapped monumentally in Stieglitz's black cape and shot from a low angle, O'Keeffe swimming nude except for a swimming cap. Stieglitz was drawn to her straining muscles, her long bony fingers, the exquisite definition of her clavicle, her stark profile, or her haughty, even icy, stare. These portraits, often tough and austere, bear little of the soft voluptuousness of the nudes and languid glances of 1918. Stieglitz and O'Keeffe were refocusing her identity, but also encountering greater complexity in their relationship.

O'Keeffe's final persona is one of strength and autonomous aloofness, one that she crafted in the images made of her in 1929 just after her return from New Mexico. She seems confident — looking down on the camera and Stieglitz. She doesn't give a great deal of herself to him, yet she does pose. She does not reject the photographic enterprise and thus she accepts Stieglitz, but she clearly does so on her terms.

O'Keeffe learned to separate herself from the images that Stieglitz made of her. As late as 1978 she said she could not relate to the young woman in the photographs, made some sixty years earlier. Her 1921 letter to Anita Politzer defined the point. "I feel somehow that the photographs had nothing to do with me personally. I never knew what I looked like or thought about it much. I was amazed to find my face was lean and structured. I'd always thought it was round."[9]

Her own sensuous imagery in her art pays little or no attention to male anatomical representation — either her husband's or anyone else's. Nor are there portraits. There are a few paintings wherein rigid protrusions penetrate spaces of void — and they are regularly discussed as sexually descriptive. In the end, the personal depiction in this sexually charged couple goes strictly in one direction. Stieglitz needed to portray O'Keeffe to prove that what mattered most in his life could be conveyed in his art. O'Keeffe had no such need of him. Her personal interest in sex and romance show up in a more abstracted yet equally passionate attachment to female anthropomorphic forms, pulsating colors, and the development of the persona of a mysterious, sexually liberated, art-world star. His success depended on his defining her; hers rest-

ed on an exploration of her vision as a liberated woman. Stieglitz, who had already helped shape the careers of many young artists, collaborated with O'Keeffe to create not only the finest photographic project of his career but also the brightest trajectory of any of his protégés. In the early twenties Alfred Stieglitz was in his glory. By the late twenties O'Keeffe was in hers.

Art historian Bram Dijkstra, in his book *Georgia O'Keeffe and the Eros of Place,* argues that O'Keeffe enjoyed Stieglitz's nude photographs of her and that the pictures helped her integrate her landscape painting with modernist ideas, which she had begun to absorb in 1905 while studying with John Vanderpoel at the Chicago Art Institute.[10] Vanderpoel, like Stieglitz, focused on form and volume rather than the particularities and specific details of a body. In Stieglitz's portrait studies, we see great attention to O'Keeffe's character and the specifics of mood and temperament, but in the nudes, line, form, and volume are the central concern. It is easy to see in O'Keeffe's art the manifestations of these influences.

It is difficult to imagine either Stieglitz or O'Keeffe in a domesticated situation. Their differences were as profound as was their love. According to Stieglitz's biographer Richard Whelan, "He was gregarious and she craved solitude. He wanted to get married, and she already felt too cramped by their present relationship."[11] However, they were married in 1924, an event of some discomfort and tension. Whelan relates that they were married by a justice of the peace in Cliffside, New Jersey. They were joined by friends John Marin and George Engelhard. Few other friends were ever told. O'Keeffe insisted on striking the promise to honor and obey Stieglitz from the vows. No rings were involved nor was there any celebration.

As O'Keeffe came into her power as a painter and as an art celebrity, Stieglitz aged and weakened. Each had numerous breakdowns and illnesses. These episodes took a greater toll on the aging Stieglitz. With O'Keeffe in the desert for much of the year, Stieglitz suffered from bouts of anxiety, loneliness, and jealousy over her romances and fear of his fading importance in the world and in his marriage.

In 1927 Dorothy Norman entered Stieglitz's *Intimate Gallery* on Park Avenue and his life. Though Norman and Stieglitz were both married, and four decades separated them, each filled voids for the other. There was still much substance in Stieglitz's marriage to O'Keeffe, but their prolonged separations insured that intimacy was, for them, rare and preserved principally in memory and in photographs. On issues of art and strategies for her career, Stieglitz and O'Keeffe remained confidants and coconspirators.

Dorothy Norman, however, found many ways to support Stieglitz. When the building housing Stieglitz's gallery was demolished, Dorothy Norman secured the money to open a new one on Park Avenue, called *An American*

Place. Here Stieglitz could hold forth until his last days. Their affair was not as improbable as it might at first seem. Stieglitz, a Jewish intellectual of European background, from a moderately wealthy family, believed in ideas as a poultice for a wounded world. He believed in art as an antidote to barbarism and in the perfectibility of man. He had fallen for O'Keeffe, the purely American Midwestern farm girl. O'Keeffe was not attracted by words or by ideas. Dorothy Norman, conversely, was a Jewish intellectual leftist of means. She came from his world but was of a younger generation. They shared a sense of social responsibility; they had a penchant for leadership, idealism, politics, and above all, devotion to the idea of affecting public thought. Norman was also young, lovely, open, and seductive at a time when O'Keeffe was none of these.

Dorothy Norman was not simply a young groupie. Her capacities were estimable. Between 1938 and 1948 she produced a literary magazine called *Twice A Year* in which she assembled a powerful group of the international intelligentsia, more than equal to Stieglitz's coterie at his various galleries — Franz Kafka, Sherwood Anderson, Anaïs Nin, André Malraux, Kenneth Patchen, Richard Wright, Thomas Mann, Stephen Spender, García Lorca, Albert Camus, Ignazio Silone. Stieglitz was vitalized by her magazine as he had been earlier by his own. It provided him with access to extraordinary people and ideas when his age alone might have marginalized him.

When finally weighed, Stieglitz's life as an artist and his influence as a promoter are mutually inextricable. His art and his ideas helped shape twentieth-century thinking, and no small part of this was his partnership with O'Keeffe. Nothing quite like their influence had been seen before. When his photographs of her became known, they were seen in dramatic contrast to the conventional images of the day, like those of Baron de Meyer. Photography critic A. D. Coleman has wisely noted, "The very premise of the project [the extended O'Keeffe portrait], once Stieglitz undertook it as such, was inherently Cubist: the apprehension of a subject by studying it from a variety of vantage points, and the montaging of those diverse observations into a single final work. Notably, he always referred to this project in the singular, calling it 'a portrait' rather than 'portraits' which suggests that he saw it as one multifaceted statement rather than many separate ones. For this viewer, at least, here is where Cubism in photography begins."[12]

The intensity, directness, openness, and pure sexuality of the O'Keeffe portraits was a revelation in its time. Indeed, it still is today. The large camera became an intimate observer, a surrogate for us as audience. In this extended portrait of O'Keeffe we literally see through Stieglitz's eyes, in full, even lascivious delectation, the deep hungry passion of their early years followed by a long and respectful, if pained, declination.

From the first O'Keeffe portraits in 1917 to the last in 1934, there is little in each frame but O'Keeffe. Often there is only a part of her, appreciated, savored. Many show a piece of her art, some a touch of their Lake George retreat, or a detail of her new automobile. It is clear that whenever O'Keeffe was around him, there was little room in Stieglitz's vision for anything else.

Their roles dramatically altered during their decades together. In their early days, Stieglitz was attracted by O'Keeffe's youth, naïveté, and vulnerability. He was eager to protect, nurture, and guide her. Later, as he aged, he sought her protection, security, and care. He required her dominance. It was, in the end, O'Keeffe who tended, with great care and unyielding opinions, the Stieglitz legacy for decades after his death.

Stieglitz's perception of O'Keeffe was closely aligned to his own needs. O'Keeffe young and in his thrall, O'Keeffe with her paintings, as his sexual stimulant and muse, as a masculine source of strength, as his ally, as his tease, his aloof tormentor, and elusive wife — Stieglitz used O'Keeffe as a model but the subject of his art was just as much the storms of his own psyche.

If a paradigm exists for the portrayal of a spouse, it was created by Stieglitz's images of O'Keeffe. After this body of photographs, it seems, anyone working in these fields must first read the trespass warnings. Each artist in this book, from De Meyer to Nixon, was ultimately aware of this work. Exploring the emotional terrain associated with a long-term partnership, these photographs identify a high point of honesty and revelation, belief and poetic dramatization in photography. They are as stunningly contemporary today as when they were made.

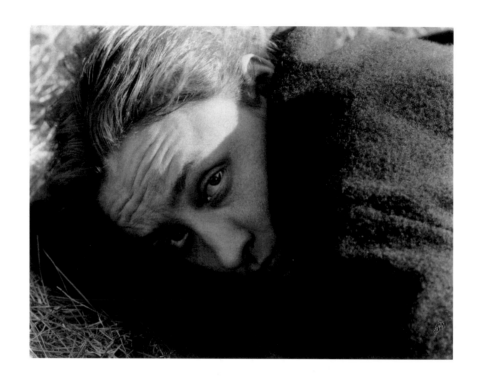

Alfred Stieglitz, *Georgia O'Keeffe: A Portrait*, 1918

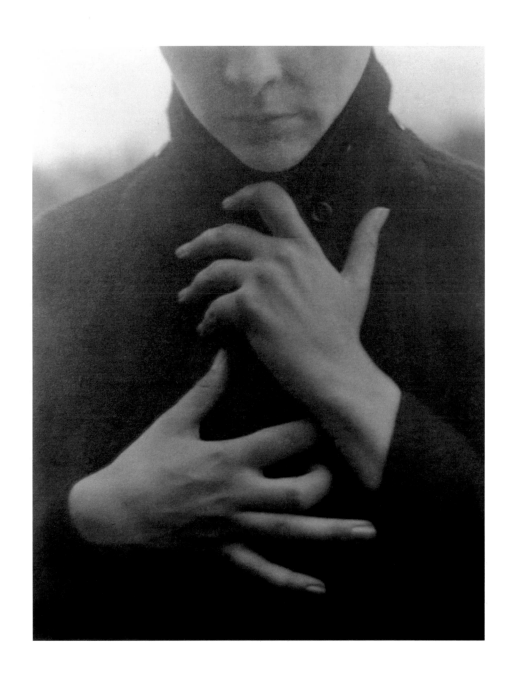

Alfred Stieglitz, *Georgia O'Keeffe: A Portrait*, 1918

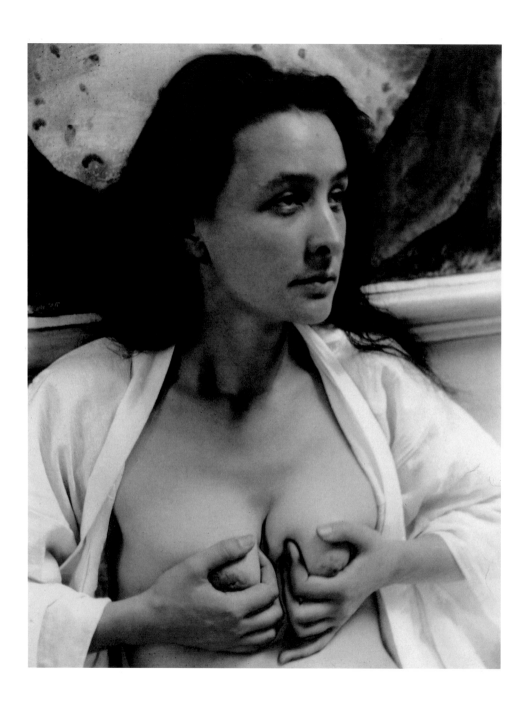

Alfred Stieglitz, *Georgia O'Keeffe: A Portrait*, 1918

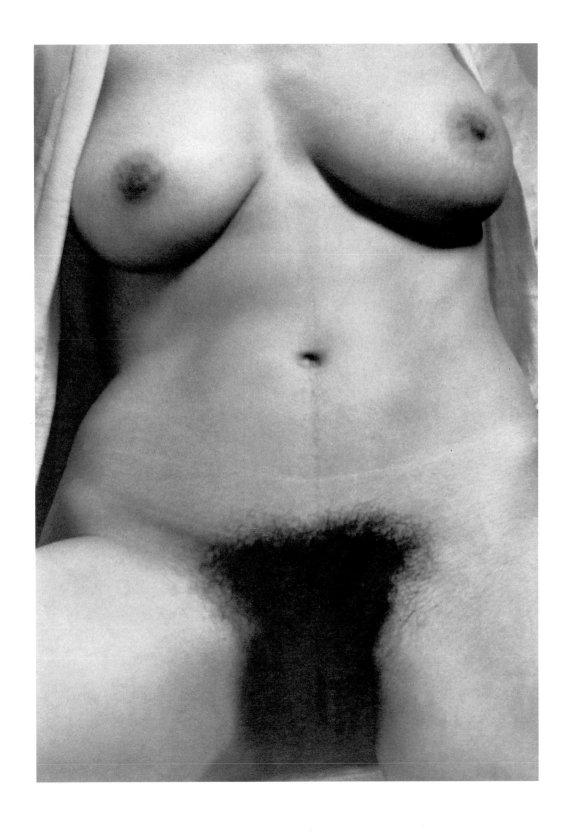

Alfred Stieglitz, *Georgia O'Keeffe: A Portrait*, 1918

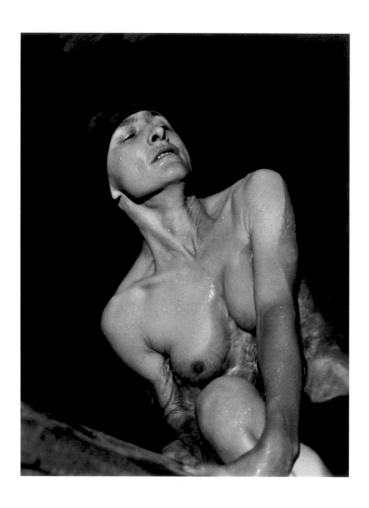

Alfred Stieglitz, *Georgia O'Keeffe: A Portrait*, 1924

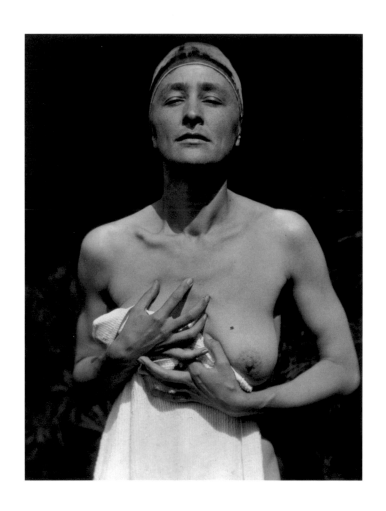

Alfred Stieglitz, *Georgia O'Keeffe: A Portrait*, 1921

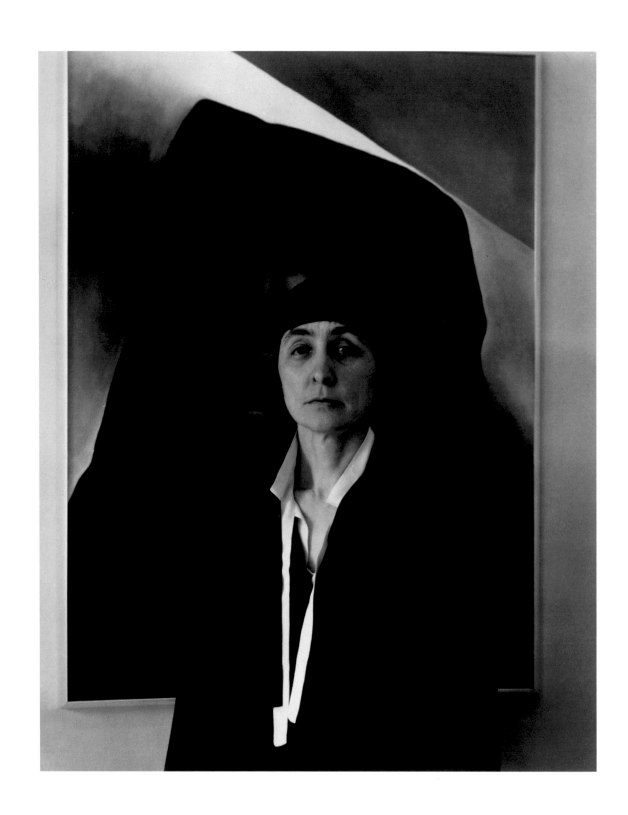

Alfred Stieglitz, *Georgia O'Keeffe: A Portrait*, 1930

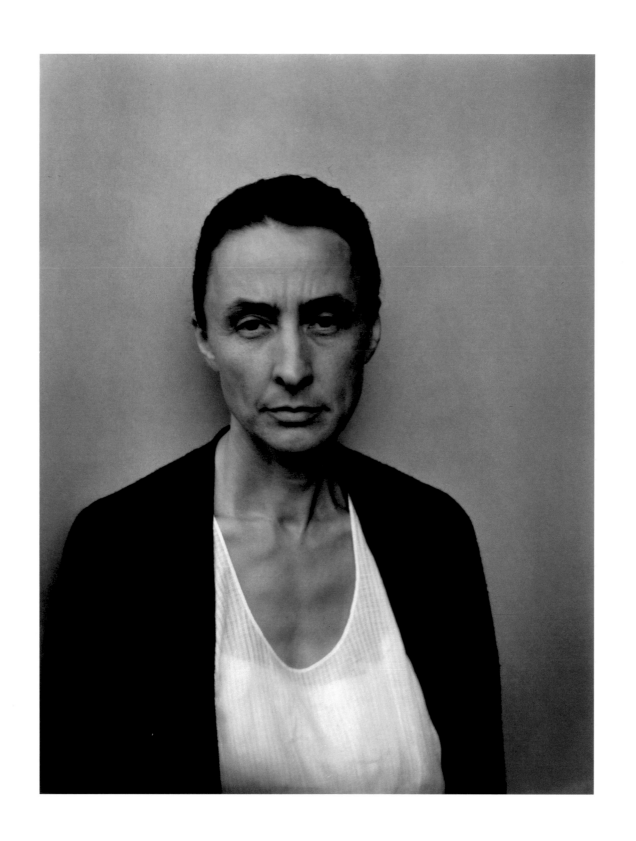

Alfred Stieglitz, *Georgia O'Keeffe: A Portrait*, 1932

Alfred Stieglitz, *Georgia O'Keeffe: A Portrait*, 1932

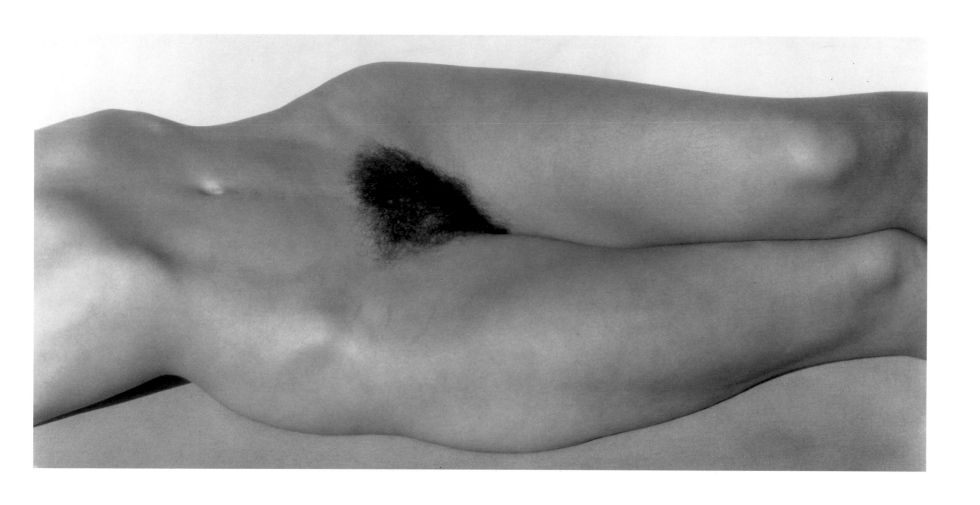

69

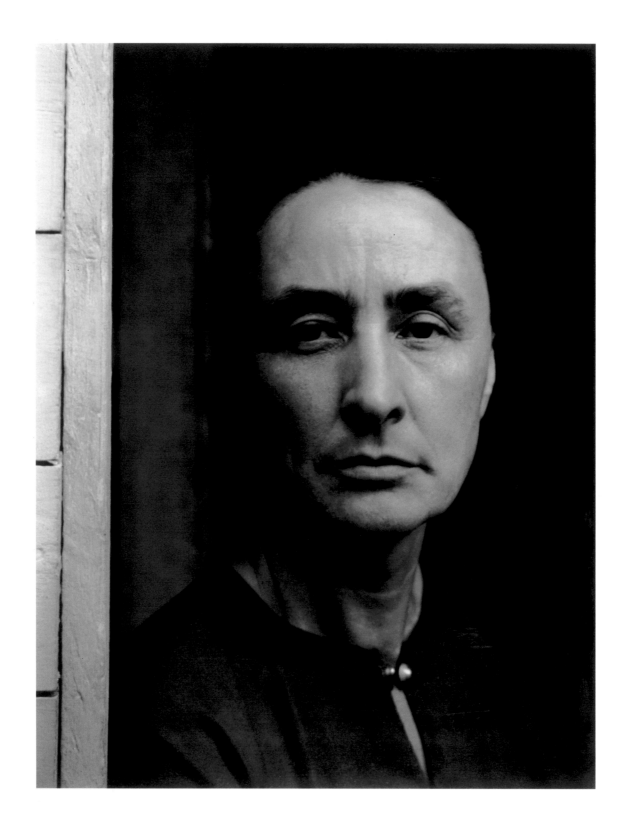

Alfred Stieglitz, *Georgia O'Keeffe: A Portrait*, 1933

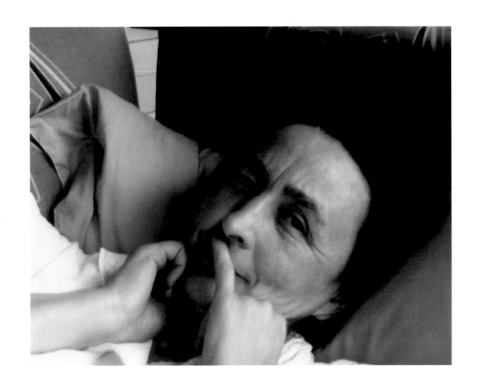

Alfred Stieglitz, *Georgia O'Keeffe: A Portrait*, 1933

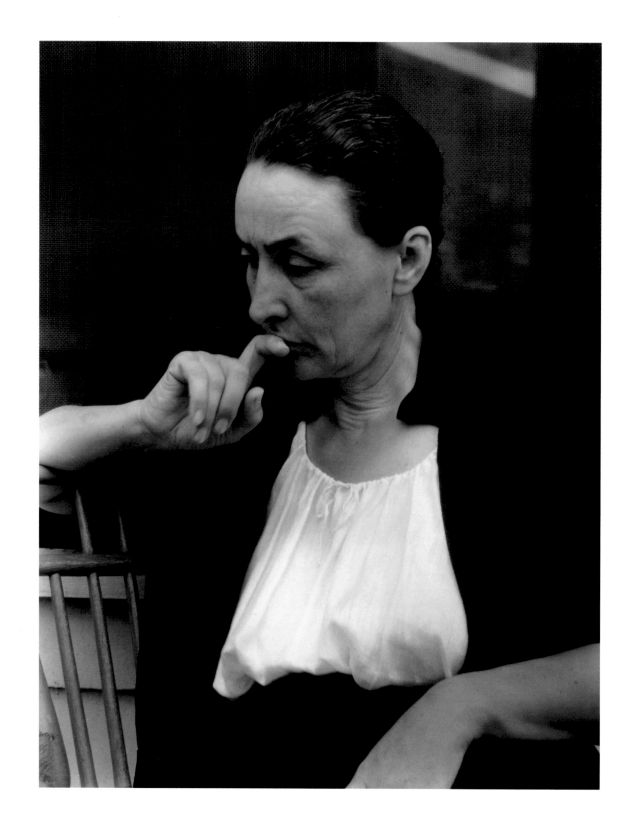

Alfred Stieglitz, *Georgia O'Keeffe: A Portrait*, 1933

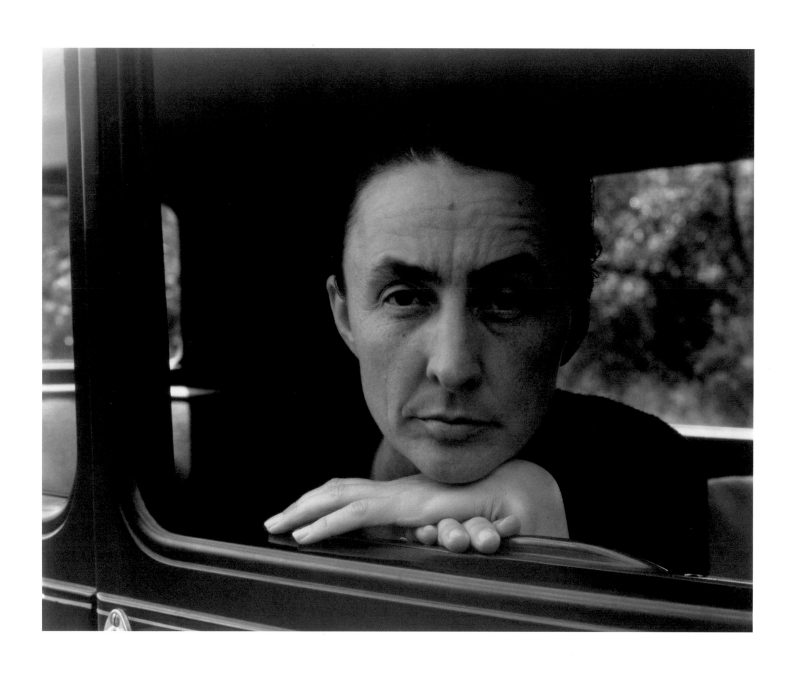

Alfred Stieglitz, *Georgia O'Keeffe: A Portrait*, 1932 or 1933

EDWARD WESTON

THE ROMANTIC IMAGE OF THE ARTIST ruled jointly by his passions and his discipline, struggling to survive economically and spiritually in a philistine world, is not solely a modernist invention. But it is alive and thriving in the twentieth century. Edward Weston is one of photography's best exemplars of the type. He stubbornly resisted compromising his art to commercial exigencies. He railed against those who did. After an early pictorialist period, he had a strict and unyielding belief in the use of simple, unalloyed tools and materials. He lived in poverty, he pursued many women, and he was pursued by many others. He described much of his thinking and perhaps too much of his experience, in his Daybooks. He left many friends, lovers, students, and four sons to carry his legend. And, of course, he left scores of brilliant photographs.

Weston's reputation rests on his elegant, reductive clarity. Rocks, sand, water, and trees, buildings, vegetables, folk art, faces, and bodies were his subjects. To describe his work this way is to say that Chopin's music is about notes. His real interest was the purity of natural forms.

Weston strove to reduce his statement to essences; to line, shadow, shape, and balance, while distilling its emotional intensity to an elixir of expressive power. The result is often an elegant and economic package — sensual, spare, and generous at once. In his prime, he may be said to have mastered his medium, if the term "mastery" can be used to describe the tight reining in of photography's abundant descriptive capacities. Especially in his portraits, nudes, and still lifes of the 1920s and 1930s, Weston's interest was the isolation of the salient feature and the reduction of background noise. Sensuous forms, light and texture, along with his own proclamations have encouraged sexual readings of much of his art.

For Weston, sexual seductivity and the chase were central motivating forces. His involvement with women has dominated his reputation. Gilles Mora has written of Weston "The women who formed the tapestry of EW's love life . . . were present at every major stage of his artistic career. Indeed, some were actively involved in its development. Between 1915 and 1923 Margarette Mather broadened Weston's cultural horizons: she posed for his first noteworthy nudes in 1923. Tina Modotti, the beautiful Italian revolutionary, was the photographic disciple and all-important mistress of his Mexican period. Sonya Noskowiak was his mistress and pupil during the years 1927 to 1935 in California, when Weston's aesthetic blossomed into maturity. And there was Charis Wilson, his traveling companion during the Guggenheim photographic expeditions of 1937 and later."[1]

Weston was nearing the end of his romance with Sonya Noskowiak when he met Charis Wilson. "At a concert in . . . January 1934 I saw a tall beautiful girl with a finely proportioned body, intelligent face, well-freckled, blue eyes, golden brown hair-to-shoulders, — and had to meet her."[2]

When Charis saw him, she was attracted by his appearance. He was short, lean, tan, had receding hair, intense brown eyes, and a playfully wicked expression. He was "twice as alive as anyone else in the room, and whose eyes most likely saw twice as much as anyone else's did. That they should look on me with obvious interest pleased me."[3] Charis Wilson was nineteen years old, the daughter of popular writer Harry Leon Wilson and Helen Cooke, a Carmel beauty who had been feverishly pursued by such luminaries as Sinclair Lewis, photographer Arnold Genthe, and poet William Rose Benét. The family was highly literate though not vigilant in

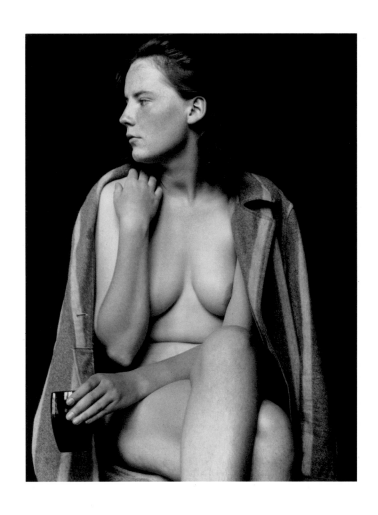

Edward Weston, *Nude,* 1934

child rearing. As young children, Charis and her older brother, Leon, were largely left to their own devices. Charis grew into a bright, precociously confident young woman with a casual attitude toward sex. Weston invited her to see his prints soon. When she did visit, he was away, but Sonya showed her the prints. Charis was amazed by what she saw and felt transformed by the experience. It was Sonya who asked her to pose nude for Edward, which she did soon after. Their first session was in early March of 1934. Of the session Charis said, "I knew I really didn't look that good, and that Edward had glorified me, but it was a very pleasant thing to be glorified and I couldn't wait to go back for more."[4] During that session Weston was easy and relaxed. Charis pretended to be relaxed and eventually she was. He kept a complimentary banter going. The 4x5 on tripod was like a dancing partner, "like a giant insect moving around feeding you great lines about how great you look."[5]

Charis has remarked that "before I met Edward, he and Sonya had already agreed that henceforth their relationship should be non-binding." If that had been so, Edward made his feelings more explicit to Sonya just prior to the second nude session with Charis. On April 17, the fifth anniversary of the beginning of his affair with Sonya, he called off their relationship, saying that he had no interest in living with any other woman and that she (Sonya) was an ideal companion, but that others in his life "were as inevitable as the tides." He told her that he rebelled against being "tied" and that (in order to place the responsibility on her) if her jealousy stood in his way, "we would have to part."[6]

Five days later, the tide came in. He had his next nude photographic session with Charis. In his Daybook entry for April 22, 1934, he wrote "A new love came into my life; a most beautiful one, one which will, I believe, stand the test of time."

Between the first and second sessions, Weston's view of Charis changed. The first session featured fragmented nude body parts. The second session produced a different view. "The photographer steps back to enjoy the whole of the woman now, and one senses a languorous ease as she lies on the sofa with one leg curled up underneath her, or as she relaxes in her old robe, her face now visible and her identity revealed."[7] Charis says of Weston: "Edward made a model feel totally aware of herself. . . . He was also the best listener I've ever met. So that when he turned that vitality and receptiveness on a woman, he made her feel more completely there than she probably had ever felt in her life."[8] This mature attentiveness was a revelation for Charis. While she was not new to sexual encounters, she felt completely liberated by the open intensity of their passion.

Throughout his career Weston made insightful portraits of many friends, colleagues, and clients. In the mid-1920s, and well into the 1930s, Weston's approach became more dramatic. Strong postures and intense expressions mark these images. The famous photographs of *Tina Reciting* of 1924, the 1925 series of Johan Hagemeyer, Rosa Covarrubias from 1926, José Clemente Orozco from 1930, and *La Teresina* from 1933 are all good examples of the sort and illustrate his dramatic flair with the personalities he respected.

Weston also, from the late teens through the late thirties, made hundreds of nudes. Occasionally seen in the environment, these pictures were most often of fragments seen close-up. While they speak of intimacy, and every follicle is defined, the inspection is often of the dissecting-table variety. He elaborated his passion for female flesh, for the touch, texture, and weight of breasts, the curves of buttocks, the torsions of an athletic body twisting on its axis. But identities were hidden. Heads, and particularly faces, on these nudes were rare indeed. Few of his nude models seem to interest him beyond their flesh. The primary exceptions are women who related to him in greater depth, like Tina Modotti and Sonya Noskowiak. In his first sitting with Charis, in early 1934, he used her body parts for numerous compositional arrangements. These are elegant, graceful, and decisive. Weston was functioning, then, in top form at his favorite game. Charis was simply his latest model. He stated in his second Daybook that "the first nudes of Charis were easily among the finest I had done, perhaps the finest. I was definitely interested now, and knew that she knew I was. I felt a response. But I am slow, even when I feel sure, especially if I am deeply moved. I did not wait long before making the second series . . . a day always to remember. I knew now what was coming; eyes don't lie and she wore no mask. Even so, I opened a bottle of wine to help build my ego. You see, I really wanted Charis; hence my hesitation. And I worked with hesitation; photography had a bad second place. I made some 18 negatives, delaying always delaying, until at last she lay there below me waiting, holding my eyes with hers. And I was lost and have been ever since. A new and important chapter in my life opened on Sunday afternoon."[9]

As Amy Conger states in her encyclopedic *Edward Weston: Photographs,* "the second session photographs were less successful because they became sexually involved and their minds were not on modelling and the beauty of the nude form."[10]

Importantly, Charis was Weston's only major relationship with a woman who was not a photographer and who never wanted to be one.

Weston would have taught her, but she wasn't interested. "I would have been the kind of photographer Edward would have hated. I don't see something instantaneously. I have to re-work it. I can't stand the nasty parts of photography. Photography is a burdensome profession."[11] Charis did have an important influence on Edward's art, however. "If I had an influence, I think it was being around, making him more mobile — he got to places he never would have gotten to." She drove thousands of miles as they surveyed California and the West, working on his Guggenheim project (1937–38), and later (in 1941), a twenty-four-state, eight-month tour to create the photographic accompaniment to a new edition of Walt Whitman's *Leaves of Grass.* In fact, Charis wrote Weston's Guggenheim application, which resulted in the first ever awarded in photography. While she drove, he often slept in the backseat. Charis has been quoted as saying, "I'd wake him up if I saw something that looked like a Weston."[12] She also wrote many of the articles he published in photography magazines and provided much of his eloquence in text and discussion. Writing was a frustrating chore for him and a pleasure for her. She describes their relationship. "In a very short time we achieved a degree of intimacy I had never before experienced: Edward was the person from whom I need have no secrets. . . . He was the person from whom I could expect understanding, sympathy, acceptance and love. As for making love, with Edward I discovered right away that, while I had an extensive acquaintance with the mechanics, the deep exchange of feelings that can transform the mechanics into a profound fusion of two individuals was entirely new to me. With patience and tact, and without ever commenting on my lack of erotic presence, Edward gradually broke down my resistance to real participation. In loving Edward, my heart had found a home."[13]

She soon penetrated his working methods, his rhythms, his psyche, enough to become an indispensable partner — not in picture making, though she was a useful assistant. Rather, she helped propel his life, organizing his trips and his household, editing his own writing and creating her own about him; paying his bills, and becoming a sounding board for his thoughts for eleven years.

By August of 1935 Charis was living with Edward and there were more portraits, including some unclothed. She was the perfect model, lively, beautiful, uninhibited, playfully experimental, and always at hand. He was inspired and fully receptive. While their tiny house made all of their domestic chores visible, they are never the subject of the images. The photographic sessions were formal events, consciously separate from meal preparation, laundry, or entertaining visitors. The photographs identify what he saw in Charis and how he felt about her, not what their life together looked like. In the late 1930s he often photographed her outdoors, in the stunning sand-dune nudes (1936), with an adobe oven on Willard Nash's patio (1937), or the haunting 1939 nude floating in a pool. Humor and satire enter into the Charis pictures in the early 1940s (1943, *My Little Grey Home in the West;* 1942, *Charis in Bonnet, in Front of Shed;* and also *Civilian Defense,* 1942). The passion for photographing her body was replaced by a desire to see her in the context of their daily environment. In fact, he had little vocabulary for such pictures. He never had an aptitude for the spontaneous, or a love of the passing episode. She did, however, expand his vocabulary for the portrait by her willingness to be photographed anywhere, by her nonchalance about nudity, and her love of being photographed.

In Charis he found his last and best model. While he was often interested in gestural portraits, he began to find the casual gestures of Charis to be the raison d'être of his nude photographs. Charis's spontaneity and physical freedom without clothes, whether in the studio or outside, made these endeavors easier and more casual for him. "Tina and I both knew when it was time to take our clothes off."[14] It was Charis's sense of play that led to the finest nudes he ever made. While he photographed sand dunes at Oceana, California, on a warm and sunny day, she pulled off her clothes and playfully tumbled down the steep sand. He quickly turned his camera on her and produced the exquisite series of nudes. Suspended in space, they were floating, relaxed, sculptural. He felt no need to use the frame to deliver a section of the figure, or in fact, to interfere at all. He simply photographed her with no horizon and intense sunlight. (He did, however, retouch the negatives, removing not only Charis's appendectomy scar but also the fresh imprints of her underwear around her waistline.)

In a sense, the dunes afforded Weston a larger studio for the figure than he had been accustomed to. They allowed him to back off and use the frame generously, much as he had years earlier with Tina on the Azotea in Mexico. In the years following the dune pictures, he repeatedly used similar framing — including Charis's full body and some surrounding context. His use of fragmented body parts was over. Backing away from a subject was not typical of Weston's intense personality, and it occurred largely late in his working life. Moreover, Charis often showed eye contact. Such images are personal, immediate, and specifically about her. In the 1940s, Charis and Edward entered a different phase of their relationship. Comparisons of his 1937 Lake Ediza photograph and a similar 1942 New Mexico hiking picture show the change of attitude that we know from interviews occurred in the relationship. Both images feature a vertical view of Charis bundled in hiking clothing, head

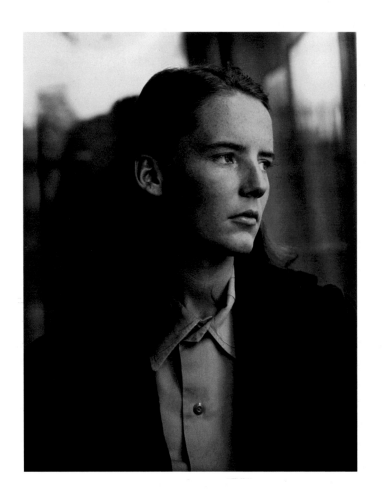

Edward Weston, *Charis, New Mexico*, 1941

covering, and boots. The 1937 image is direct, eye-level, and overtly sexual. None of these adjectives fit the 1942 image, which shows a withdrawn, unresponsive yet not uncooperative Charis. The 1937 nude with adobe oven in Willard Nash's patio in New Mexico shows Charis stretched out in the sun on a large black cape. Her eyes are covered by her arm. The gaping, organic shape of the oven offers a sexual metaphor. The session included a few variants that show how open and willing Charis was.

Weston was hyperaware of Alfred Stieglitz and his photographs of Georgia O'Keeffe. He first visited Stieglitz in 1922, when Stieglitz was making his O'Keeffe images and had recently (February 1921) had his major exhibition of the photographs at the Anderson Gallery in New York. Weston was shown ten of the O'Keeffe images. Twelve years later, when Charis entered his life, the template for such portrayals was well in place. When Charis and Edward visited Stieglitz in New York in 1941, Charis said she was "prepared for a neutral stand-off scene. . . . Edward never got the real reinforcement from Stieglitz that he would have wanted." [15] It is likely that Weston showed Stieglitz some of his finest work during this visit. Stieglitz was generally uninterested and unsupportive.

Charis identified the period of 1941, just prior to the onset of World War II, as the time when their marriage began to deteriorate. Edward became emotionally distant and withdrawn. The warmth and passion that marked their early years had dissipated and neither seemed able to reconstitute it. The nudes of Charis after 1941 separate the artist from his model by distance, by windows, by shadows, or by humor or grostesquerie. Among them is the 1945 photograph of Charis posed nude in the garage with the rear of her car. It has its humor and, of course, is not among their finest efforts together. It does, however, identify the theme of departure, just as we saw O'Keeffe protectively posed in the window of her car as she heads away from Stieglitz to her beloved New Mexico. As Charis and Edward divorced in November of 1945, this image of Charis and her car was one of the last images that explored the emotionally difficult terrain toward the end of their relationship.

By contrast there are two remarkable previously unpublished images from the Center for Creative Photography's Weston archive in Tucson (which exist only as 8-x-10-inch negatives) of Charis at Point Lobos in 1945, which were made late in the year. In these pictures Charis was fully clothed and clearly upset. When interviewed about them, Charis identified herself as "one very unhappy young woman, at the time." In one, Charis is lying on a large flat rock with a rocky cove behind her. It is a cold and windy day despite bright sun. The wind whips her pant cuff and pulls

spray off the incoming waves. The pose so belies his earlier nudes (especially the aforementioned image on Willard Nash's patio with the adobe oven) that she seems, in contrast, even more than clothed. She seems protectively clothed, emotionally clothed, yet still willing to pose in a prone, if not relaxed, posture. Weston has pulled his camera back to include rocks and water in the cove beyond Charis, but more than the camera distance, the emotional distance is most salient.

A striking comparison may be made between a late image from Weston's marriage and one of the last O'Keeffe images by Stieglitz. In Weston's, Charis sits on rocks in full sun, her left arm resting limply on a camera case. Her right leg is drawn up and her right arm is resting on it, with her fingertips gently touching her forehead. Her hair is covered by a scarf. She is looking away from the camera toward the sky, off the left side of the frame. Her eyes are puffy, her expression preoccupied. The image is a correlative of a 1933 Stieglitz portrait of O'Keeffe also looking to our left, right wrist limp, left hand to her mouth, hair pulled back, with a very pensive expression and a serious mood (page 72). O'Keeffe was soon to leave Stieglitz for the Southwest. The mood is heavy enough in each of these images to make the viewer wonder why the two couples agreed, in such a moment, to make photographs — painfully honest images that add poignancy and respect to our reception of these enterprises.

In late 1944, Edward had developed symptoms of Parkinson's disease, including bouts of depression. Weston was a controlling person and a lifelong devotee of exercise and diet. He worshipped a healthy body. His deterioration was a catastrophic turn of events.

No other person but Charis is seen so often in Weston's work, nor is any other characterized with such sensitivity, intensity, appreciation, and desire. With his sexual passion intact he could make of a shell, a pepper, a smokestack, or a writhing sea cove a sensuous metaphor of pulsating life forces. Minus those passions, his subjects could claim to be little beyond their mundane identities. As his life ended, he was still surrounded by acolytes, other artists, old friends, and his sons, but without Charis, his passion for women — loving them, photographing them, pursuing them — came to an end. There is something about Weston's romantic relationships with women that suggests that he pursued them to affirm that he existed and that the world thereby was a more vital place, as a child might make up songs against the dark night. When the pursuit was finally ended for him, something seemed to collapse and resign within him, and the night began to descend.

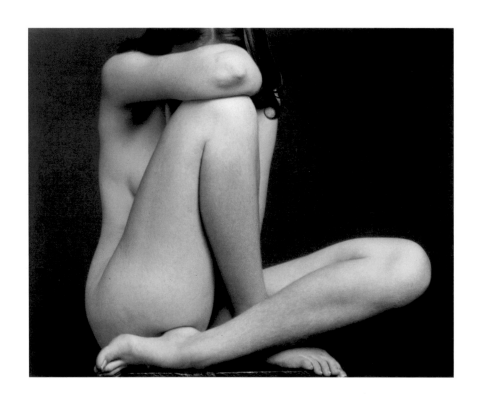

Edward Weston, *Nude*, 1934

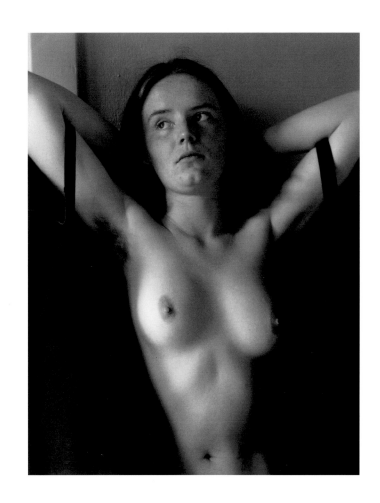

Edward Weston, *Nude,* 1935

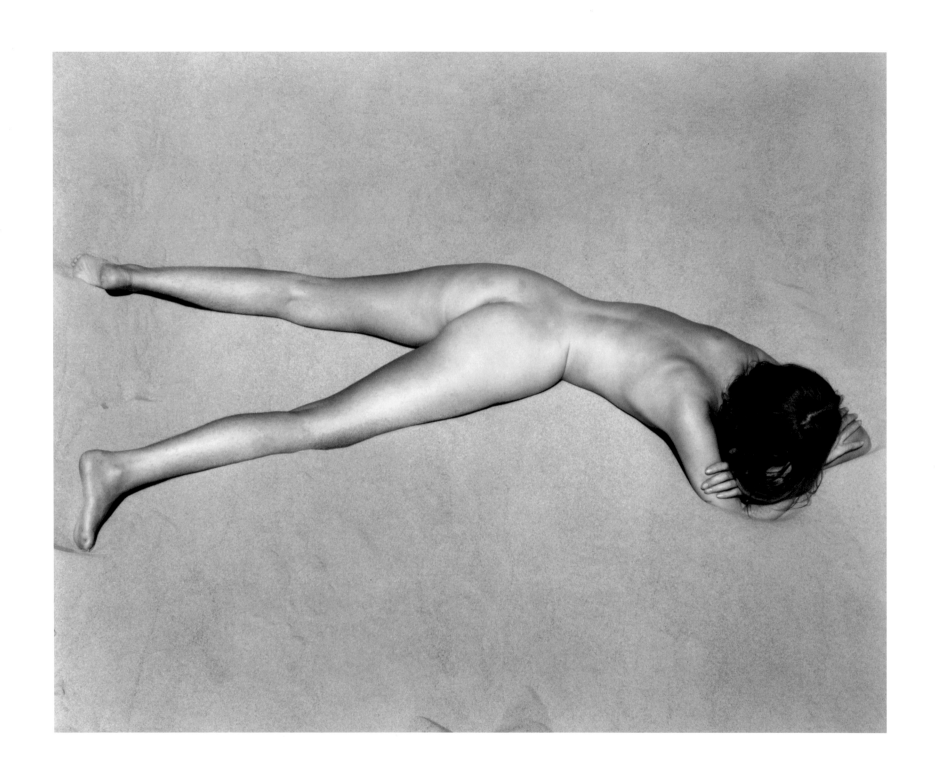

Edward Weston, *Nude*, 1936

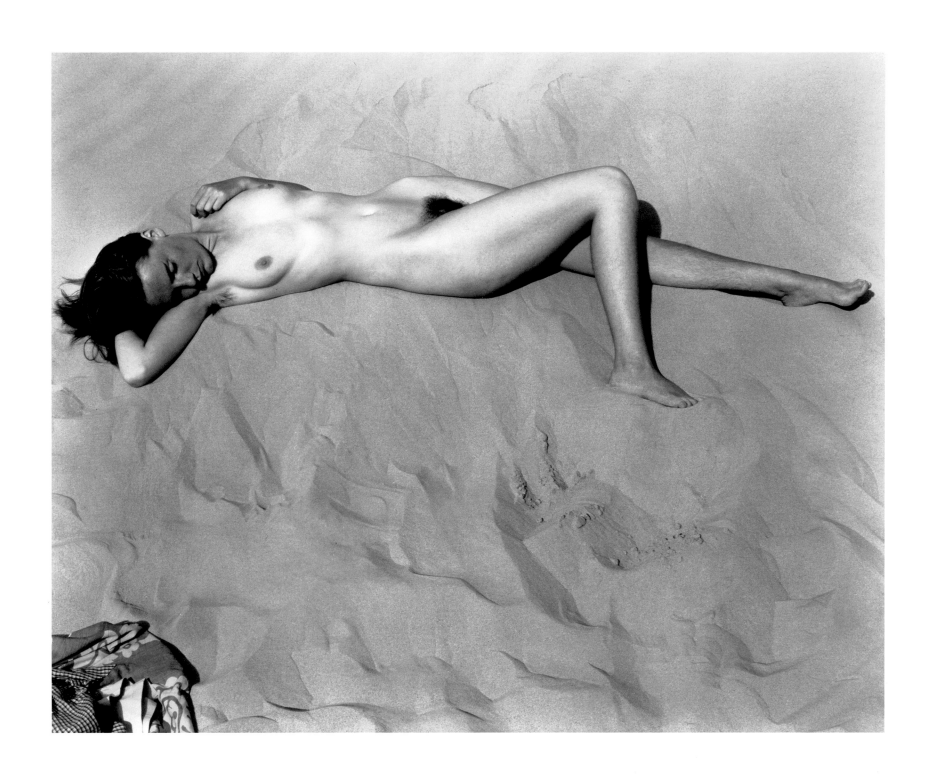

Edward Weston, *Nude,* 1936

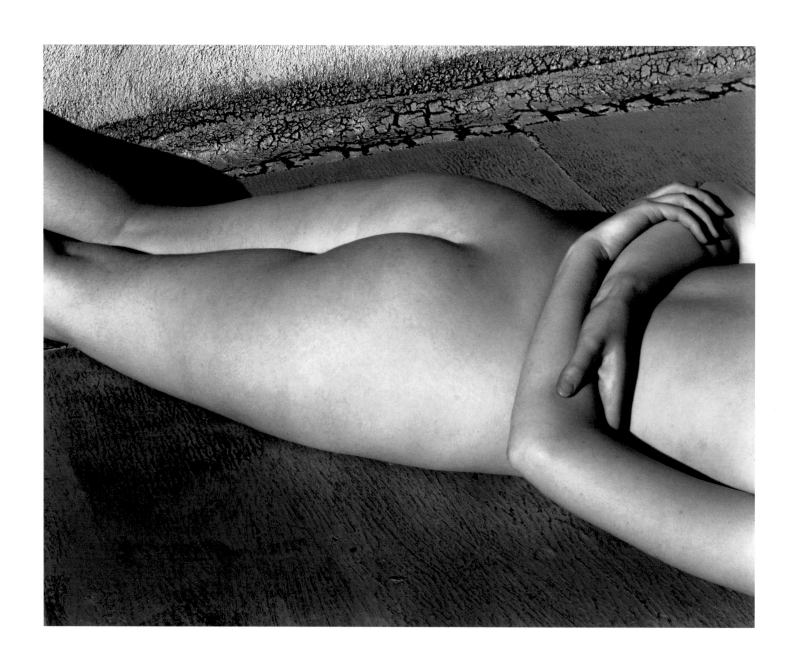

Edward Weston, *Nude*, 1935

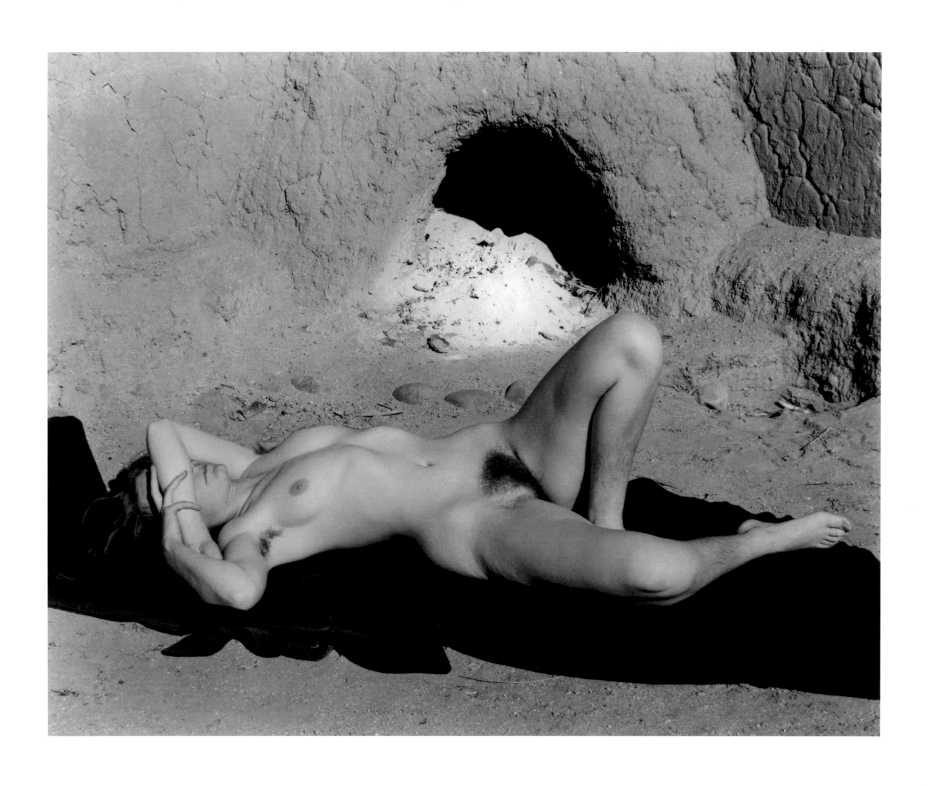

Edward Weston, *Nude, New Mexico*, 1937

Edward Weston, *Charis, Lake Ediza*, 1937

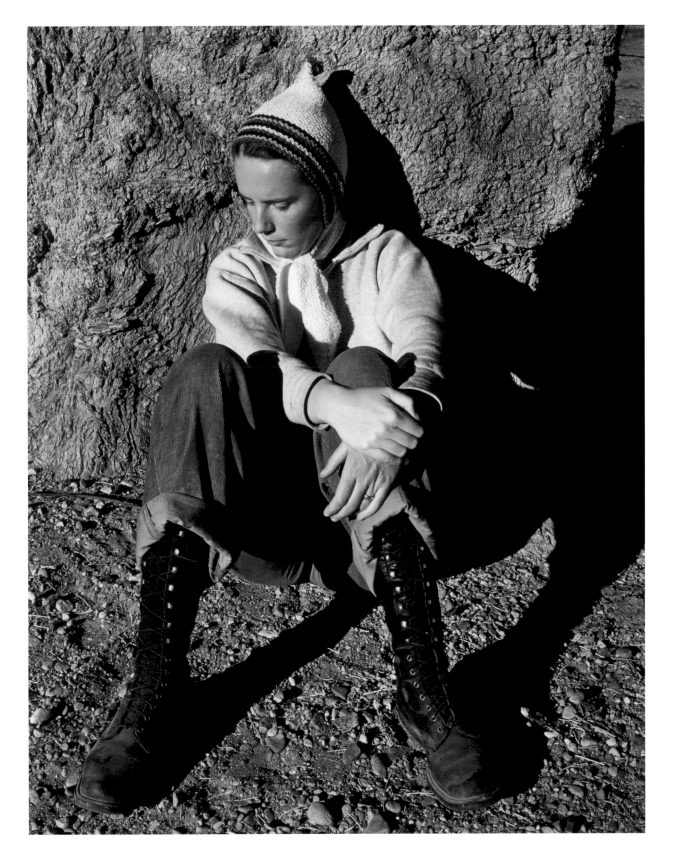

Edward Weston, *Charis, New Mexico*, 1942

Edward Weston, *Nude Floating*, 1939

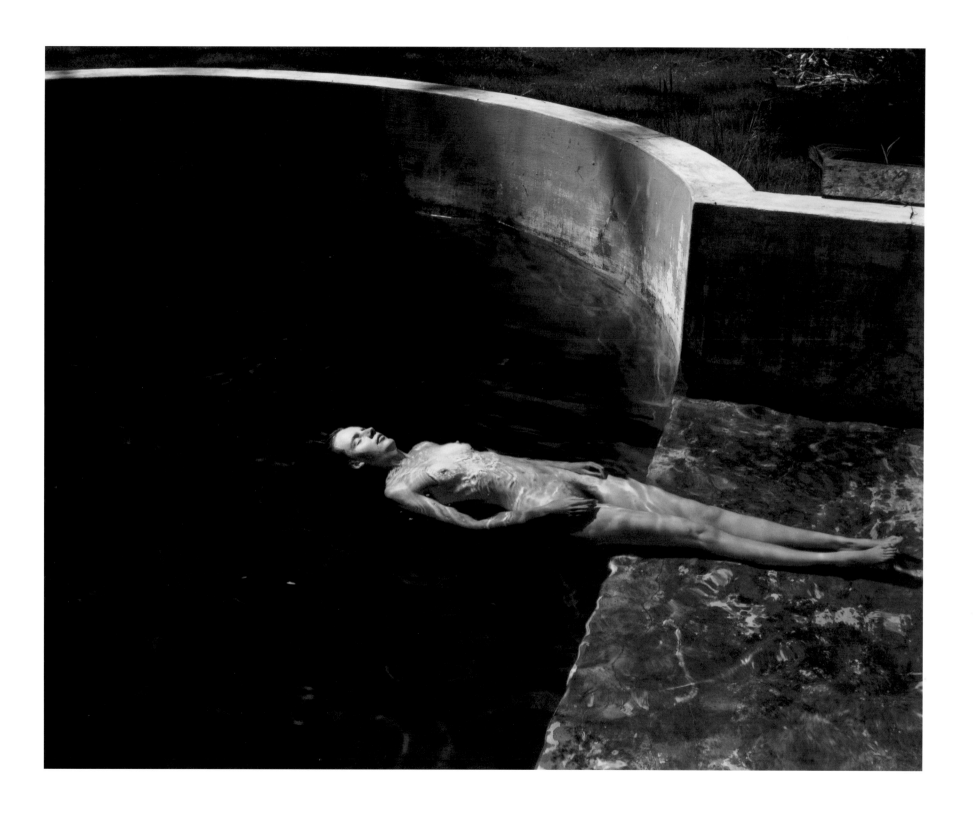

Edward Weston, *7 A.M. Pacific War Time, Carmel,* 1945

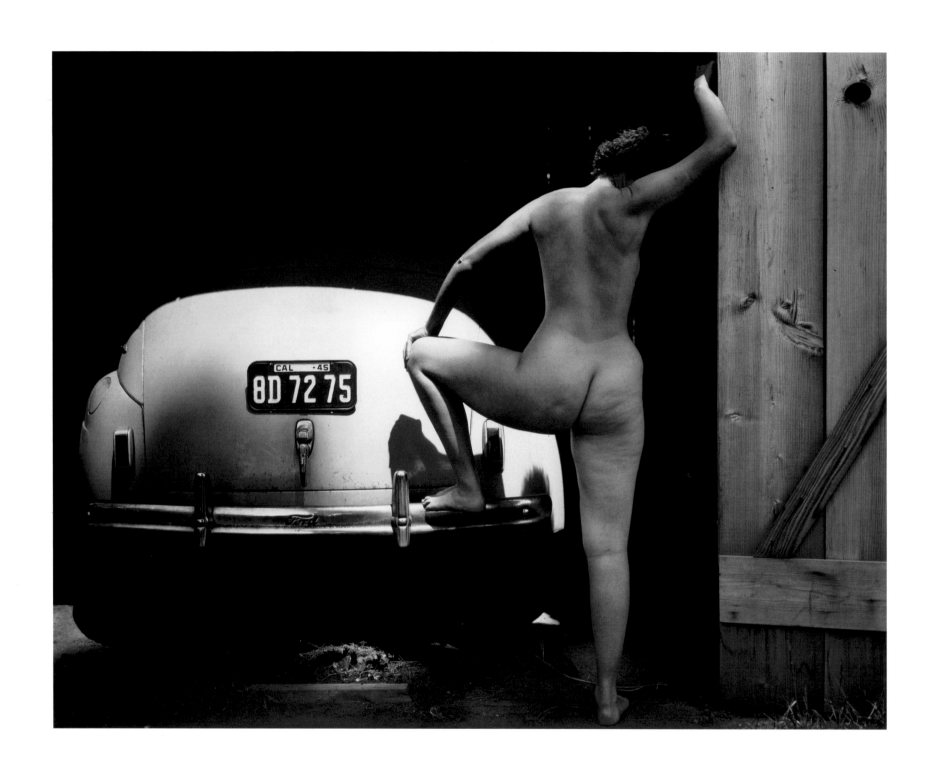

Edward Weston, *Heimy*, 1945

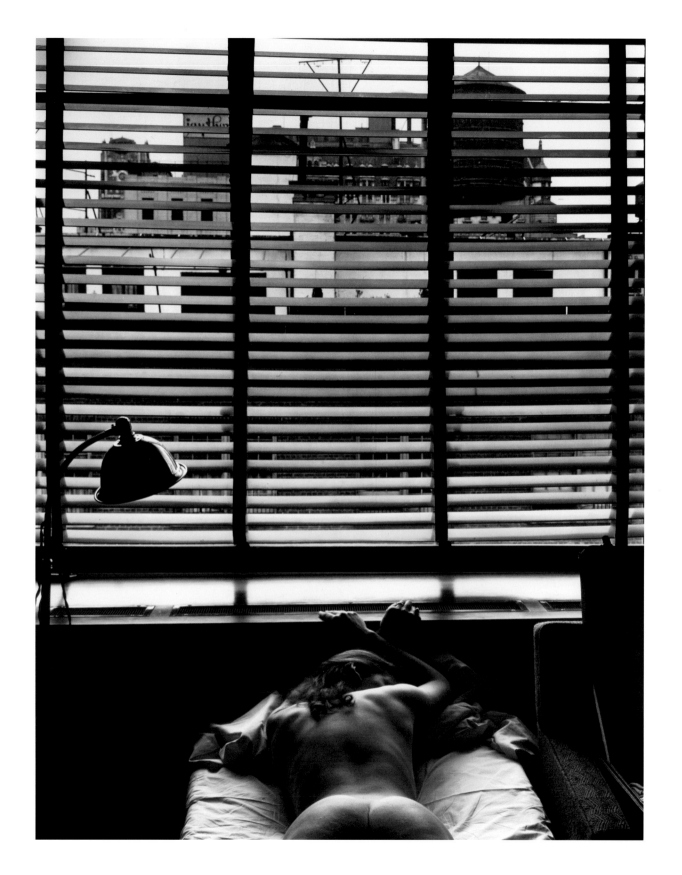

Edward Weston, *Nude, New York,* 1941

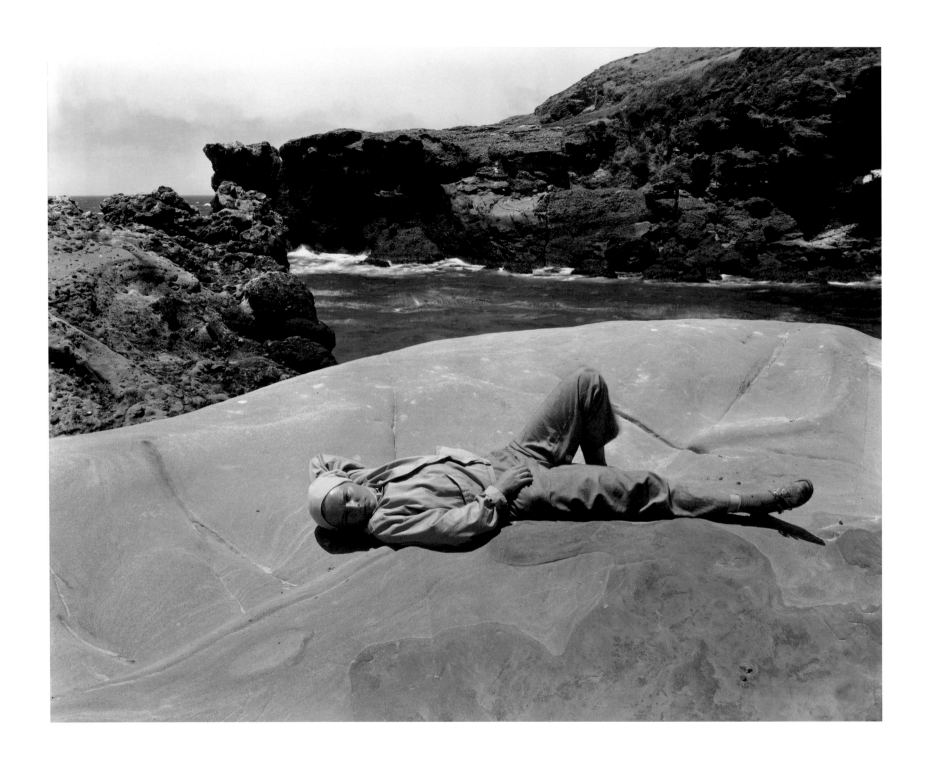

Edward Weston, *Charis*, 1945

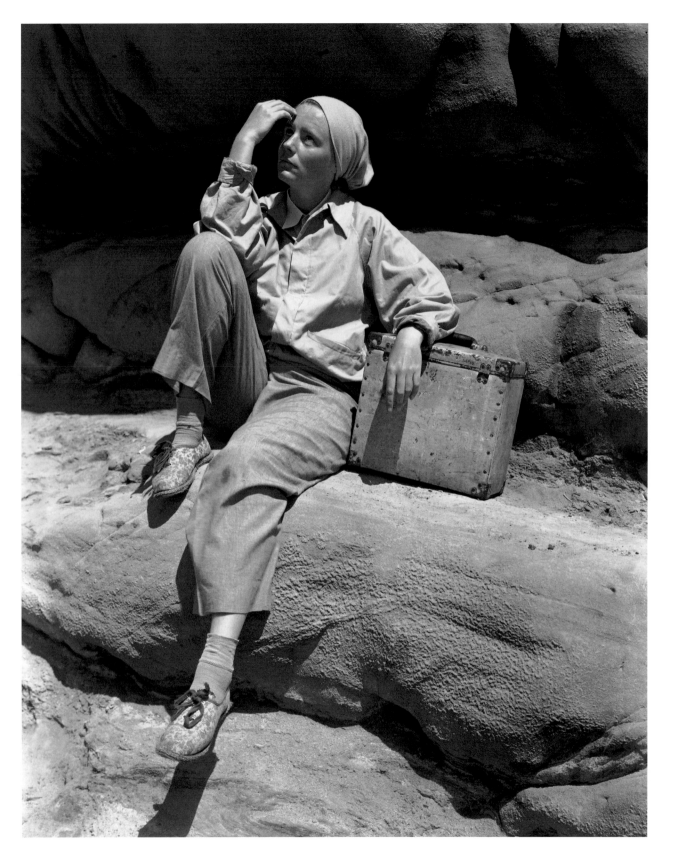

Edward Weston, *Charis*, 1945

HARRY CALLAHAN

HARRY CALLAHAN WAS A COMPLEX MAN who seemed to be a simple man. His apparent simplicity was engendered by reticence and frail verbal skills. He explains himself plainly. "In my life, being married was one powerful experience, photography by itself was a powerful experience, coming to Chicago to teach was a great experience, having a daughter was another experience, as well as living in Europe. I think these have all been very strong influences in my growing as a photographer." [1]

No doubt these were the forces that shaped Harry Callahan's life and art, yet a close study of his work reveals that he also absorbed artistic insights from the important figures he encountered along the way, and, as much as any photographer ever did, Callahan learned from his own experimentation. Modernist experimentation with materials and equipment are central to his art. Callahan's art, to quote curator and historian Keith Davis, embodies the "attitude that values experience over theory, facts over preconceptions, and whose goal (to a large degree) is the very process of inquiry — photography itself." [2] That Callahan applied this formal inquiry to an exploration of his private and vulnerable inner life made him nearly unique.

Harry met Eleanor on a blind date in 1933. Three years later they were married. In 1938 he began photographing and joined a camera club for camaraderie and to broaden his understanding of the medium. In 1942 the Callahans visited New York, saw the museums, and met Alfred Stieglitz before returning to Detroit. During World War II, Harry worked in the photography department of General Motors. In 1945, after the war, they spent four months in New York and developed many contacts — Nancy Newhall, Paul Strand, Berenice Abbot, among others. He began to

worry about how he might support himself and his passion for making photographs. "I thought I'd have to get a job and just try to keep going. My wife could always get a job and I could never get one. She was a secretary and could work all the time — she even set up a secretary service of her own. So I always knew we could always pay the rent and eat." [3] In 1946 Callahan was hired by László Moholy-Nagy to teach in Chicago at the Institute of Design, founded in 1939 and known as the New Bauhaus. There he became acquainted with Aaron Siskind, Walter Gropius, Herbert Bayer, Mies van der Rohe, Hugo Weber, and soon after, Edward Steichen. The flavor of their collective philosophies is present in his work, but Callahan didn't incorporate those ideas through self-conscious strategies, or intellectual ruminations. He was far more able to adjust his practice through experimentation. His home, his neighborhood, and particularly his wife were close at hand and available for depiction. "It takes me a long time to change. I don't think you can just go out and figure out a bunch of visual ideas and photograph. The change happens in living and not through thinking." [4]

Callahan's work was a deeply personal response to his own life and the various torsions of his time and place. He was a genuinely shy man with little of the social ease we often associate with someone who has spent a lifetime talking to students in classes. The shyness, in contrast to the loquacity of an Alfred Stieglitz or the easy conversation of an Aaron Siskind, made him the sort of photographer who could record people anonymously in the street but could not photograph people intimately unless they were nuclear family members. He was well known to encourage his students to turn their cameras on their lives, and he led by exam-

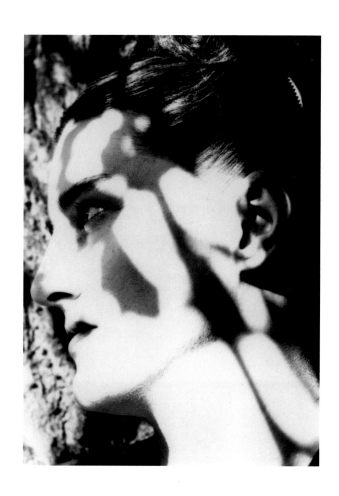

Harry Callahan, *Detroit,* ca. 1941

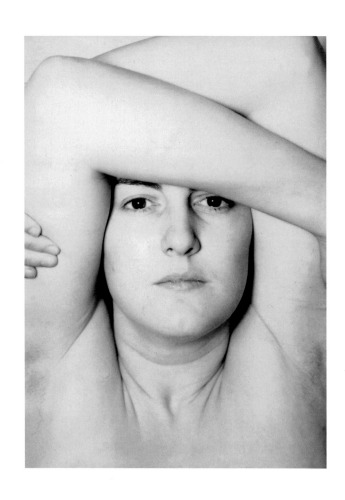

Harry Callahan, *Eleanor*, 1947

ple. Even as he did this he was not sentimental, romantic, or emotional. Harry illustrated the centrality of Eleanor in his life by his tender treatment of her, his physical proximity, even intimacy, and his obsessive return to her over fifteen years as his prime subject — she is subject more than model — but the images are not about who she is, what she does, what she thinks as an individual. The same can be said of him. What his life was like, his teachings, his politics, his sexuality, his attitudes are not the subject of his pictures. Harry Callahan's art is a long meditation on the possibilities of photography as it might be expressed playfully, openly, but never naively, in the hands of a powerfully motivated, single-minded artist who is convinced that he needed to focus on that which he was closest to. As John Pultz explains in *Art Journal,* Callahan's focus on a personal vision of those elements of his life closest at hand opened the door for "several generations of photographers and teachers to the possibility of such diaristic work, giving permission for photography that claims, above all else, 'This is what I saw.'"[5] As with many pioneers, some who followed him are empowered to go farther than their progenitor. Emmet Gowin, who is probably Callahan's best-known student, is far more "revealing" of his life (and his wife) than is his teacher. Callahan was a less overt individual, for whom performance was not part of his emotional lexicon.

Eleanor was essential to his art from 1947 to 1960. Harry photographed her everywhere — at home, in the city streets, in the landscape; alone, with their daughter, in black and white and in color, nude and clothed, distant and close. He tried every technical experiment — double and triple exposure, blurs, large camera and small. An attitude of respect and warmth permeates the endeavor. The architectural photographer Ezra Stoller told Callahan that he photographed buildings because "I get a thrill out of it." Harry echoed these feelings: "I think that's part of the feeling I have in photographing Eleanor. There's some beauty that you don't want gone. You want a part of it."[6]

Many of the Eleanor Callahan images are groundbreaking expositions on an intense and complex devotion. Her presence in much of the work is literally full frame. In the late forties and early fifties he photographed her intimately, eye to eye, corner to corner. A tiny portion of her anatomy often fills his images, the curve of her hip, the division of her buttocks, her thighs and pubic hair, her face dissolving in shadows, her face framed by her upraised arms. Dozens of experiments in form resulted in wonderfully mutated images that are well known in the photographic canon. In these years Callahan's "eruption of formal invention" redefined the depiction of a figure. His intimate studies are marked by both elegant formality and the tender appreciative caress of a lover. While they are not lustful, they speak of a passion based in the eyes and the intellect.

In 1950 their daughter Barbara was born, and even prior to her birth she showed up in pregnancy photographs. As a toddler she accompanied Eleanor on outings, climbed on her recumbent mother in bed, cavorted in silhouette, in front of venetian blinds, slept and stood beside her mother in vast landscapes and city views.

In 1952 and 1953 Callahan began to superimpose Eleanor's backlit studio figure on elements of the Chicago landscape, winter trees, water, brick building facades. The pictures seem to declare that wherever he goes on his daily rounds, he sees Eleanor. From 1948 to 1953 Eleanor is shown out in the city as a tiny counterpoint to large expanses of park, skyline, or water. No matter how small a part of the scene she is, she still dominates our perception. In one, the minuscule Eleanor and her three-year-old daughter, Barbara, counterbalance the entire downtown Loop area of Chicago. In another, they draw all our attention, in the midst of a calm and oceanic Lake Michigan.

These remarkable images led to the otherworldly, sparse Cape Cod images of the 1980s — empty skies, empty ocean surfaces, subtle textures, and a trace of horizon. Vicki Goldberg has said of Callahan, "Every artist wants to reach the edge of nothingness — the point where you can't go any further."[7] He had mastered reduction before. His 1948 photograph of Eleanor's buttocks, a delicate cross of two thin lines, became an icon in Harry's portfolio. According to Vicki Goldberg, "Like the human face, the nude, especially the female, lends itself readily to simplification and abstraction — a couple of well-placed lines and dots will do for either." No one in photography did dots and lines as well. These photographs stretch visual perception and invent new methods of compositional weighting, but their meaning is familial devotion and tenderness.

The Callahans found a way to nourish and sustain a mutual balance of sharing, productivity, and personal commitment. Eleanor remembers, "It was part of our daily life for twenty-five years. . . . He took pictures of me wherever we happened to be. I might be cooking dinner, and Harry would say, 'Eleanor, the light is just beautiful right now. Come on, I'd like to take a picture of you,' and we'd go and make a photograph."[8] Callahan never presented his wife's nudity to his audience for their sexual delectation. Even the full nudes are chaste and tender.

In 1956 the Callahans traveled on a grant to Aix-en-Provence, France, for more than a year. It is often recounted that while he studied the pastoral loveliness of the terrain, he admitted that he could think of nothing but Eleanor. His superimpositions of her nude form over the landscape

illustrated not only his equation of Eleanor with the fertile and abundant earth, but also the notion that she was fully embedded in his perception and more than metaphorically, she is his grounding. To extricate her would transform his world to just another landscape.

Harry and Eleanor, and for a few years, Barbara, were remarkably prolific, producing hundreds of images and thousands of variants, working day after day. Callahan's life was experimentation and investigation. Those efforts were not "about" his life. They were his life.

For the Callahans, formal experimentation was the impetus and often the overriding subject of the work. Eleanor was not presented for psychological inquiry — it is the medium that is continually interrogated. While in purely formal terms the model might have been any other woman, in fact the proximity, partnership, and the momentum of their lives together freed Harry to invent spontaneously and rhythmically with a discipline that would have been unavailable to an artist needing to arrange for a hired model. It is also true that seeing his wife in daily changes of light, mood, and life's phases inspired numerous interpretations.

By 1961, Harry no longer photographed Eleanor. Barbara was in school and Eleanor went back to work. Harry went out into the world more often to shoot. "I guess, looking back, the best I can say is that my life changed, and I wasn't motivated to do it anymore. When our daughter had her children, I know she would have loved me to photograph them, and I would love to have nice photographs of them, but it means a super-involvement and you have to be ready for that. I didn't feel I could be involved with somebody else's children like I was with Barbara."[9]

It seems that Callahan, the landscape photographer, was not interested in landscape — its politics, its philosophy, its science — as were the landscape giants like Ansel Adams or Eliot Porter. Nor was he interested in people and their accomplishments in the manner of Edward Steichen or Richard Avedon, when he photographed Eleanor's face. He is not, strictly speaking, an urbanist, as was Cartier-Bresson or Robert Frank. His prime interest when photographing anything, even his wife, is photography. His passion was to push its ideas around, test it, interrogate it, map its potential boundaries, and play with it.

An artist like Callahan must always begin with the assumption that his or her notion of things has value. To some extent he must believe that the world needs his input, that to some small degree, the world revolves around him or that which inspires him. Callahan's formal experiments were conducted with the people who were the trusted center of his universe. The photographs were marinated in meaning. When his family appears as a tiny counterpoint to a huge landscape or city view, one senses that the one small percent of the image that is Eleanor and Barbara was simply the axis of his life.

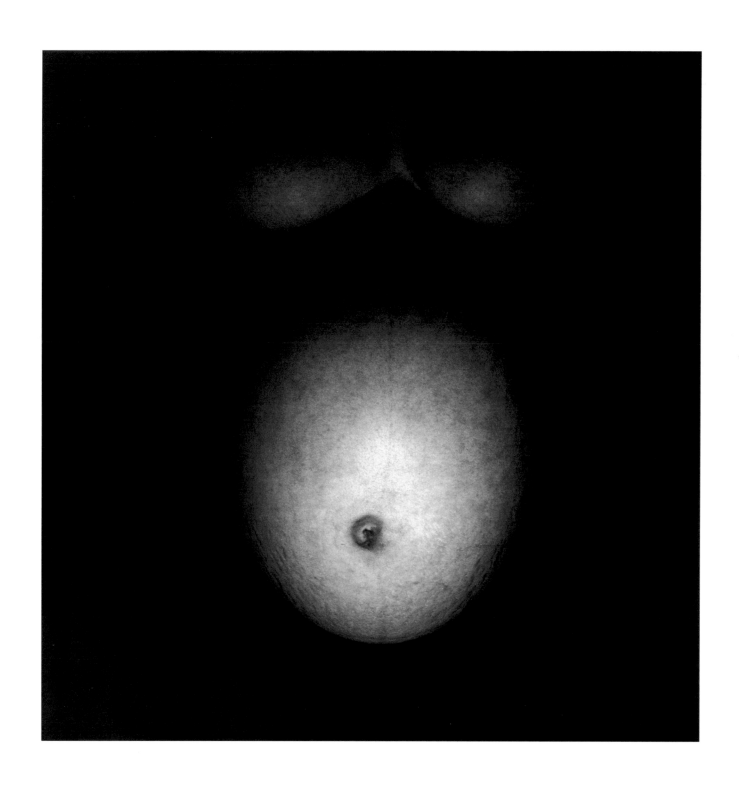

Harry Callahan, *Eleanor*, 1949

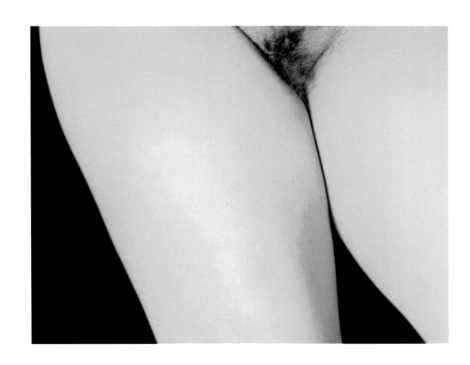

Harry Callahan, *Chicago,* ca. 1949

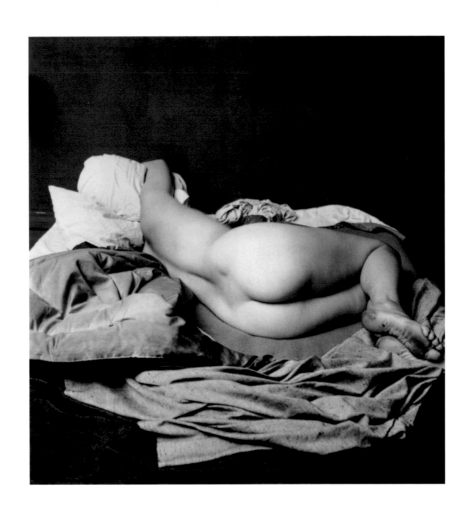

Harry Callahan, *Chicago,* ca. 1949

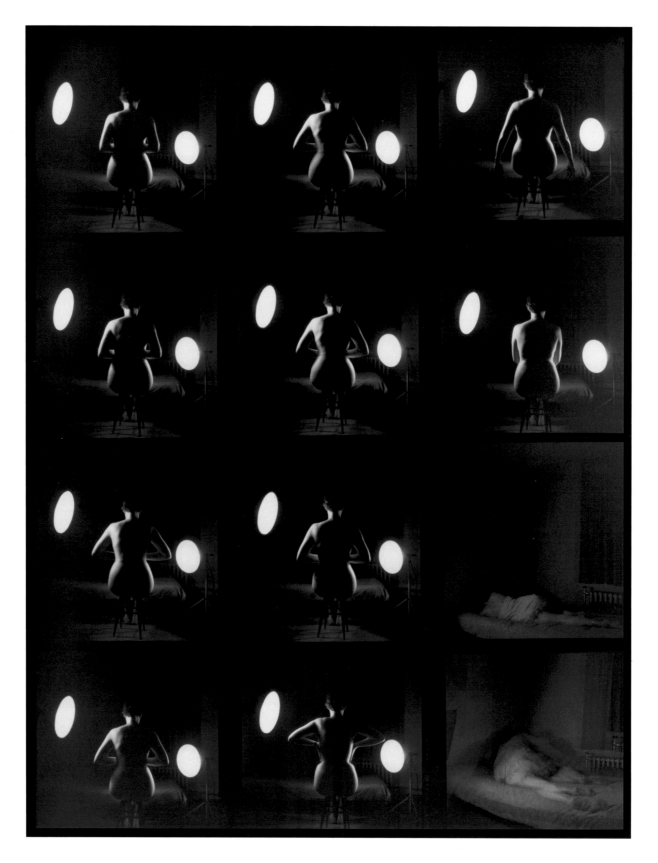

Harry Callahan, *Contact Sheet 12, 10/w, 2/w*, ca. 1953

Harry Callahan, *Chicago,* 1953

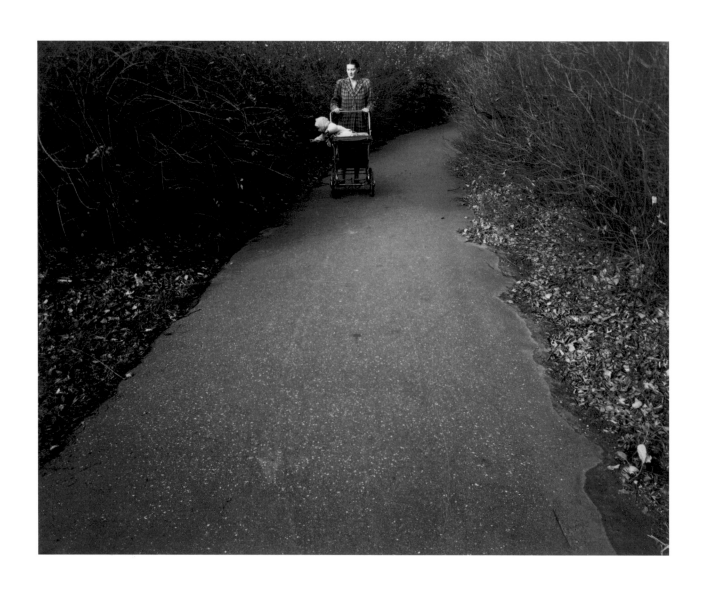

Harry Callahan, *Chicago,* ca. 1953

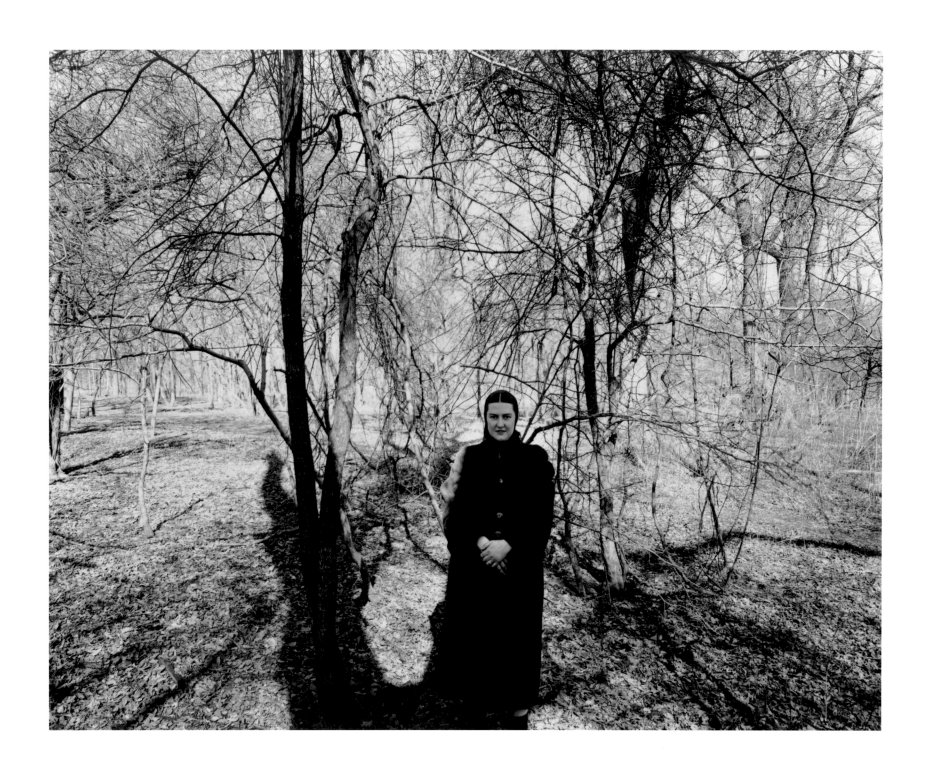

Harry Callahan, *Chicago,* ca. 1952

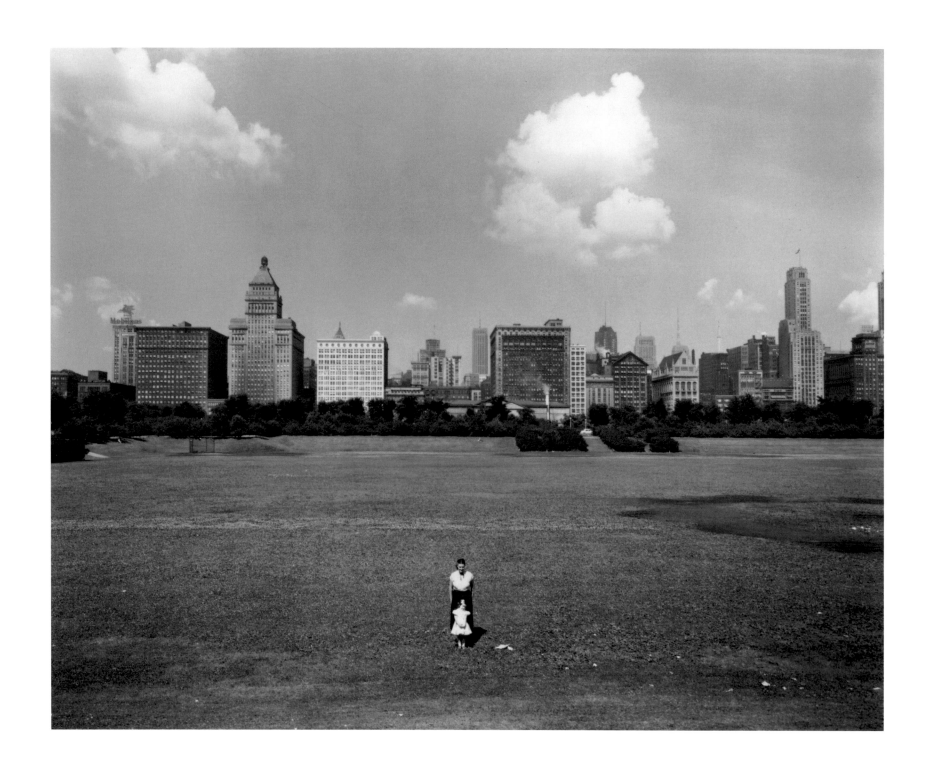

Harry Callahan, *Chicago,* ca. 1953

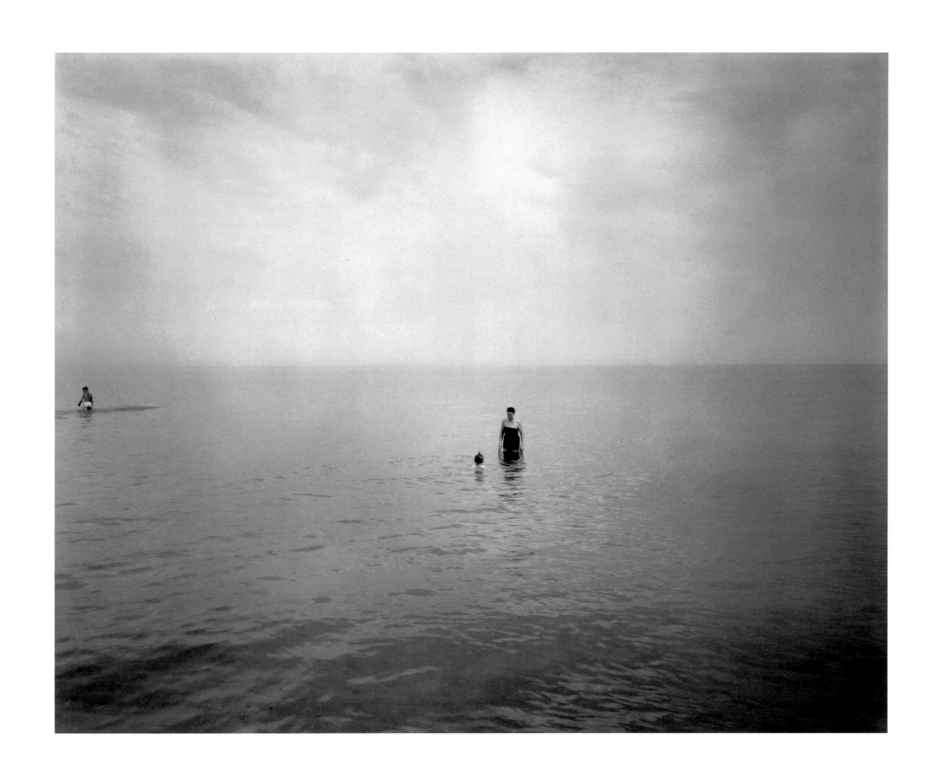

Harry Callahan, *Lake Michigan*, 1953

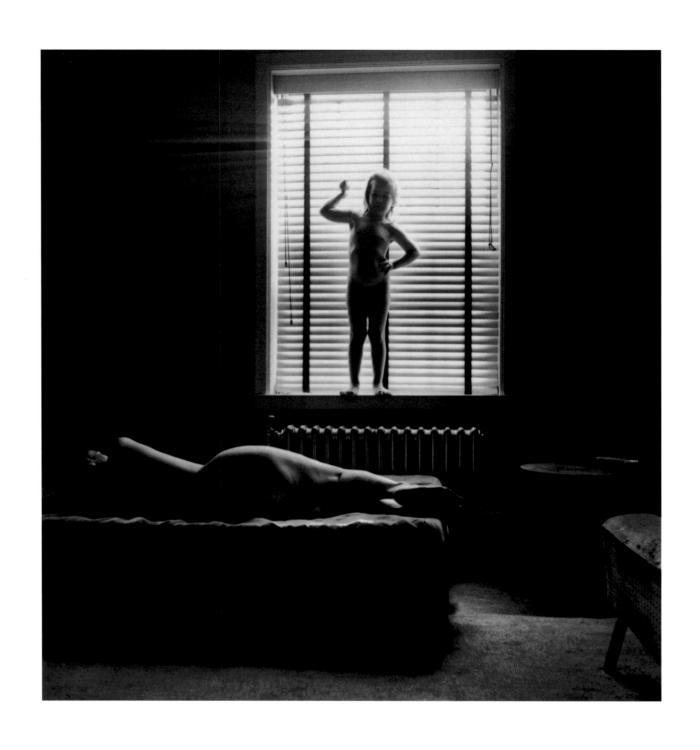

Harry Callahan, *Untitled*, 1954

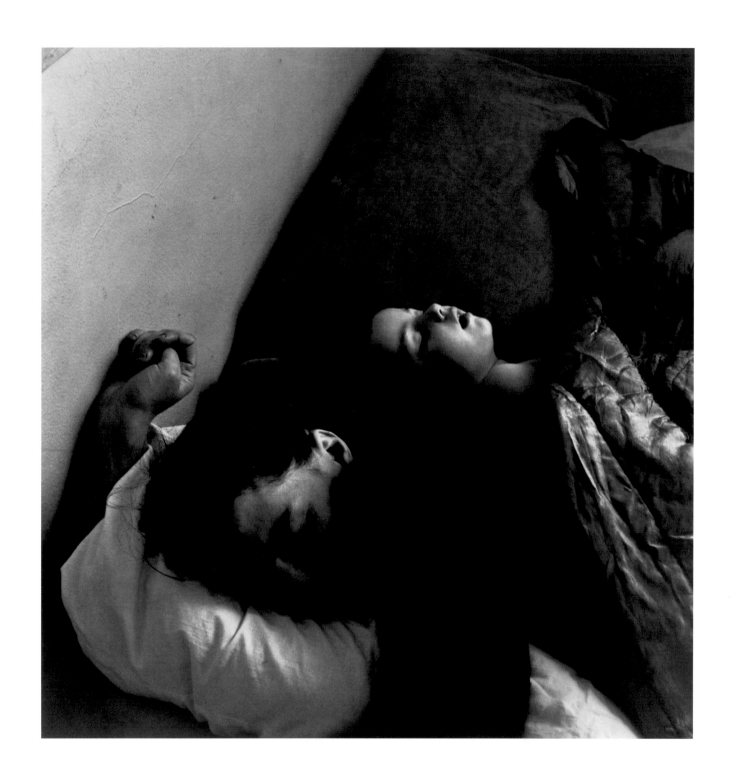

Harry Callahan, *Chicago,* ca. 1955

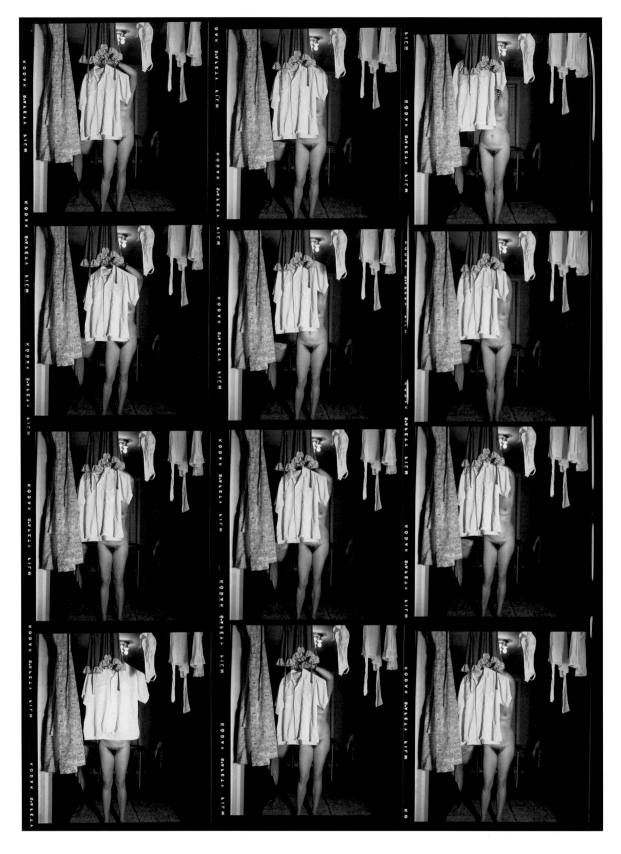

Harry Callahan, *Chicago,* 1952

Harry Callahan, *Eleanor and Barbara*, n.d.

Harry Callahan, *Eleanor, Chicago,* 1949

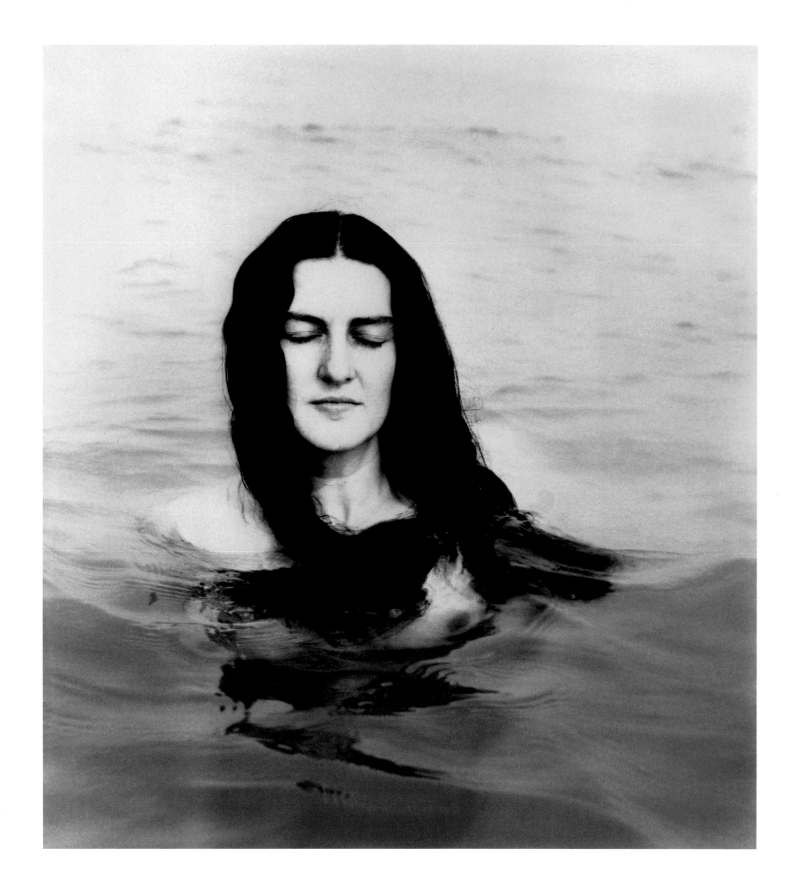

Harry Callahan, *Chicago,* ca. 1960

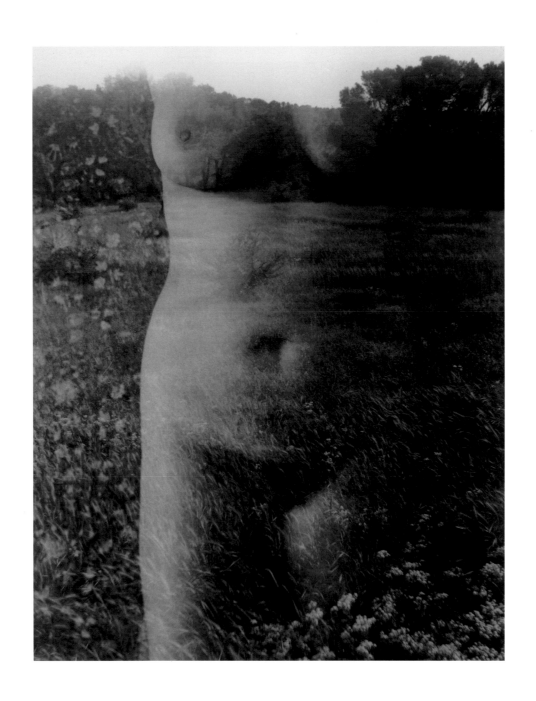

Harry Callahan, *Aix-en-Provence*, 1958

EMMET GOWIN

EMMET GOWIN IS A CONTEMPLATIVE MAN. Contemplation is a solitary activity. It requires stillness, time, and focus. He believes that the connections between things are not always apparent. He speaks slowly, deliberately, poetically. His descriptions of episodes in his life, even those that he has often reported in print and lectures, are retold carefully and in new terms, hopefully to uncover a meaning, a flavor, previously overlooked. Gowin continually shows an interest in nuance, in subtle distinctions, in identifying states of the soul. The world, he posits, is what it seems to be but it is also so much more.

His work is not based on formal experimentation, though he has done some of that. Nor is it centered in the visual transformation of objects. His photographs generally employ veracity and close rendition in order to present a deeper reading of the subject. It is this resonance and this amplification of his subject that propel his art. All of his work balances substance and poetic insight. He respects the medium, its materials, and traditions. The craft is, for Gowin, a serious pursuit.

Emmet Gowin's work is romantic, and his romanticism is inflected by contemporary *fin de siècle* awareness of time; its conflation, its melt, the way it sticks to us. Old objects, old buildings, old people, old crafts, present their splendid decay to him; Italian gardens, rugged hill towns, ancient ruins, moldering farmyards, fallow fields; a fecund nature, past its time, fairly oozing in overripeness. All attract him with a deep evocation of the past.

Richly textured, often horizonless, split-toned images of Italian hill towns, Mount Saint Helens, and Petra evoke the power of time to soften, warm, erode, and even decimate what both man and nature have constructed. The two-thousand-year-old Jordanian ruins of Petra at dusk

provided, in his words, "an equilibrium not unlike forgiveness." He trusts the stones of Italy and the sod roofs of Ireland. In his written and spoken descriptions of these sites, there is much that sounds like love. The aerial photographs over Mount Saint Helens in Washington, which he began making in 1982, resemble moon shots made from an orbiting module. The textured, patterned, and cracked landscape reads both as abstraction and as a heavenly view of God's own playing field. The scale is unknowable. Landscape is generally overlaid with expectations of archeological time. Mount Saint Helens, however, transformed itself in seconds. Gowin's awe is unmistakable, and perhaps that gives us a clue to his other imagery. Awe is a constant feature of Emmet Gowin's work. His newer aerial landscapes still offer visual delight in indecipherable patterning but add to the sense of awe elements of anger, anguish, and righteous wrath over our willful assault on the land. His art, he says, "is in dialogue with New Testament burdens and insoluble propositions."[1]

Gowin understands, probably at a chromosomal level, that the place, its land and light, its history and how its populace has been inserted into it, are what define us. Like many of our great Southern artists in every medium (and in photography we have numerous examples: Walker Evans, Clarence John Laughlin, William Eggleston, William Christenberry, Sally Mann, Debbie Flemming Caffrey, Birney Imes, Keith Carter), a fierce attachment to the land and its idiosyncratic keepers is central to his affections. Emmet Gowin was the first of these to place his family at the center of his exploration of place.

Gowin saw an Ansel Adams photograph of burnt grasses and a charred tree stump at the age of sixteen. He intuited, from the first, the metaphoric possibilities of both the image and its subject. Grass was the

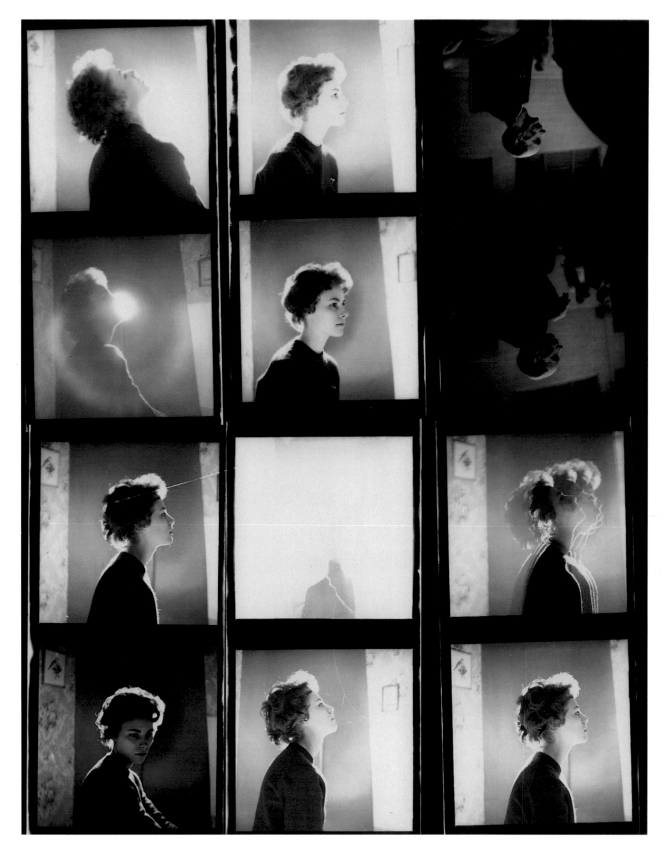

Emmet Gowin, *Contact Print*, 1961

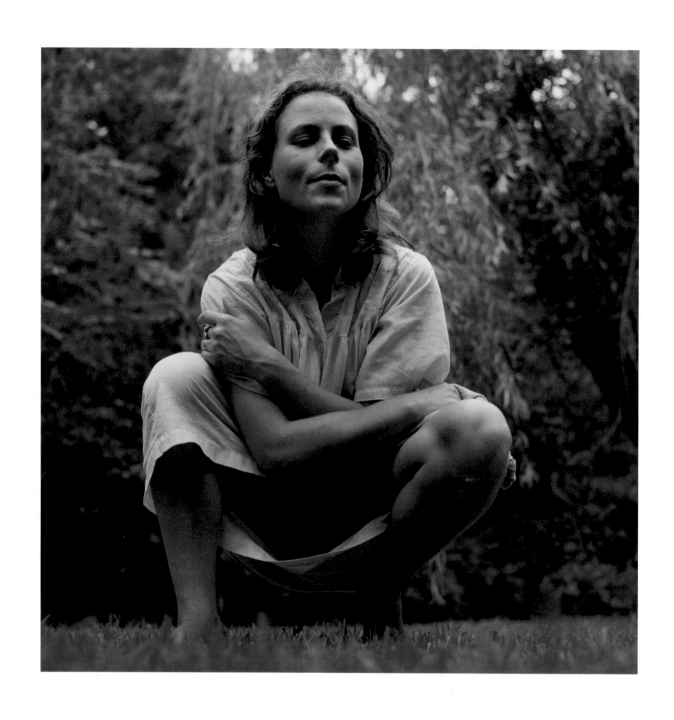

Emmet Gowin, *Edith, Danville, Virginia*, 1978

resurrection of the tree. An animal is the resurrection of the grass. He began to make related landscape photographs. Being raised on New Testament theology and, in the mid-1960s, largely falling out of step with its particulars, Gowin sought and found a new and different theology; his sages became Alfred Stieglitz, Harry Callahan, and, a few years later, Frederick Sommer.

Emmet Gowin was not raised for an art career. Neither of his parents had much worldly sophistication. Art was not part of their understanding of life. They understood photography as a commercially viable occupation. When Emmet received his MFA in photography at Rhode Island School of Design, he recalls his parents were thrilled and proud — they had been afraid he would become an artist! His father was a minister, of stern demeanor, who seemed, to Emmet, to often confuse the central meanings of the Gospel with specific laws. "It was terrifying to me because the law could destroy the spirit. I was seven years old and I could see that, so I have no doubt that my fundamental character was fixed by that time. My father frightened me with his theology, whereas my mother practiced patience and forgiveness. She was the influence in my life." [2]

His senior thesis at Richmond Professional Institute (now Virginia Commonwealth University) was titled "Concerning America and Alfred Stieglitz and Myself." It was based on fourteen of Gowin's photographs and seven pages from a 1934 festschrift on Stieglitz. In this paper he expresses his homage and relationship to Stieglitz. Thus the portraits of his wife encompass deep artistic aspirations and expectations based on the Stieglitz-O'Keeffe images.

In 1960 he met Edith Morris at a YMCA dance. "Our attraction to one another was an alchemy beyond my analysis," says Gowin. [3] They were married in 1964. He came of age photographically making images of his wife's family. "I realized that my own family — Edith's family — was as miraculous as the most distant people in the world and they were at the same time, the most available to me, and perhaps available only to me.... I had not realized that art could be made by simply telling the story of your own life, of your own experience." [4] Edith is seen at the center of an orbiting constellation of cousins, uncles and aunts, nieces, nephews, and neighbors in rural Virginia. The work is infused with innocence and affection for place, for his relatives, and a tentative insertion of the artist's voice in dialogue with his heroes in the history of his medium. And one senses in his portrayal of Edith much of Stieglitz photographing O'Keeffe at Lake George. Edith Gowin seems aware, even so early in their efforts together, that she could stare soberly at the camera, as O'Keeffe did, with

similar tight mouth and strong cheekbones and equal seriousness toward the photographic enterprise.

A copy of the catalogue for the Museum of Modern Art exhibition *The Family of Man* introduced Gowin to the work of Robert Frank. In 1963 he visited Frank in New York and was encouraged by him to go to graduate school only if he cared to be a photography teacher, and if he did, to study with Harry Callahan at the Rhode Island School of Design. He enrolled at RISD because of what he now describes as Harry Callahan's "poetry of feeling and intimacy — and the revelation of a secret and unrecognized dimension in the commonplace." Callahan posited that one need look no further for the transcendent than one's own environment. What subject, after all, does one know more intimately? It was a lesson that became central to Emmet Gowin's vision. In the frontispiece of his first book, Gowin quotes James Agee, " . . . and all of the consciousness is shifted from the imagined, the revisive, to the effort to perceive simply the cruel radiance of what is."

Emmet Gowin was the sort of student every great teacher wants. He took Callahan's inspiration and elevated the dialogue to another plane, all his own. There are many examples to select from. Edith, leaning on the bed, between windows in a spare room, is small enough in the image to recall the Eleanor Callahan photographs, in which Harry balanced her tiny form against the whole Chicago skyline or the vastness of Lake Michigan. In another, Edith Gowin is dwarfed and surrounded by the sort of Christmas morning mess that speaks of young children and a doting family. In Gowin's 1986 images, Edith Gowin is shown nude and seated, surrounded by rich foliage. Superimposed on her body is a profusion of bulbous root vegetables. These images recall Harry Callahan's exquisite photographs of Eleanor nude, transposed over the pastoral landscape loveliness of Aix-en-Provence in 1956. Nourishment, fertility, and the life force itself interleave in Gowin's homage to Callahan. Gowin's specific life force here is subterranean and earthy, while Callahan used light, air, and open space.

Virtually none of Harry Callahan's students can recall their taciturn teacher providing words of wisdom. He considered himself ineloquent and clumsy in verbal expression. He did, however, encourage by example. Emmet Gowin has always credited his influences, and he is eloquent and highly expressive of his debt to Callahan. In December of 1994 he said his photographs of his spouse were "made possible by Harry's [Callahan's] work with Eleanor" and that his work does look a lot like Harry's. He assures us, however, that there is no need to worry about too much influence, as "each moment given to us is unique and the product of the

convergence of many forces and is thus only available to the particular artist at a particular moment, and never again to him or anyone else. It can't be repeated."[5]

Emmet's photographs of Edith identify her as sometimes serious but also playful, teasing, and spontaneous. In an early piece, Emmet places Edith's grandmother in the lower right corner of the frame, in her rocking chair. She is a blur of rocking motion, looking off to our right. Edith occupies the near center of the image, and is posed frontally, staring into the lens. She holds her shirt aggressively open to us, exposing her breasts. The image seems to express a tacit understanding between the artist, the model, and the audience, that we (artist, model, and audience) are young, sexually liberated, and free-spirited, and the older generation doesn't understand and is marginalized. The kinder and kindred interpretation of the work, of course, relates to two phases of womanhood. Are Emmet and Edith Gowin acknowledging the short span of days until Edith is the old woman in the rocker? In this light, it is a sensitive recognition of a Samuel Becket quote, "We give birth astride the grave. The light gleams an instant and then is no more." Mortality and the sanctity of our gleaming instant is a continuing preoccupation of the Gowins.

There is open sexuality in the Edith pictures, which exude trust and tenderness. These are not pictures that could have been made by another who might have happened to be there. They result from the particular intimacy of the Gowins, in that place, at that time, in that light, and in response to their own attraction. She is treated with warmth but never candidly. No pictures are made in the passing instant; these are not sketches or quick notations. They are moments of still reflection. Edith may enhance a moment with a gesture, her posture, or an animated expression, but, for that, they are no less contemplative.

Gowin's work became less about the textures of family life as he and his wife evolved into a more discrete unit. Edith became the principal object of his passion. The famous photograph of her in a diaphanous blouse, standing in the doorway of a barn, legs spread, as she urinates on the wooden floor, may be shockingly explicit or a transcendent poeticising of a lover's human functions. The image was made in 1971 — a period of nearly delirious sexual openness in America. In the art world of 1971, this photograph simply supported and underlined prevailing notions of the body. The image itself is sensitively treated. Its drama is more a product of Edith's strident and proud posture than the stream she produces. When asked if such images threatened her modesty, Edith states that the pictures that do invade her privacy have never been shown. Emmet related that "[our] picture making world was first a private world. Over time, however, what had been private was moved into the public domain. Edith was strong enough emotionally to stand outside the pictures. We realized that there was no way through the pictures, to her. Her own dignity, or even her privacy, was never available to the public."[6] Only the Gowins themselves had the key to a personal understanding of these photographs.

By the mid-1970s Gowin often depicted Edith alone, simply looking back at her husband. Then came pregnancy pictures. These had a humorous, ungainly curiosity. The children appear in their first years as tender, vulnerable beings, generally appended to Edith. Emmet's scrutiny is on Edith as mother, rather than on the babies. Throughout the Edith photographs of the 1970s and 1980s one senses increasing depth in Edith's portrayal. Emmet seemed to demand greater insight and sensibility in each new addition to the portfolio. As Edith aged she seemed no less natural in front of the camera, no less willing to be seen, no less loved by her husband. In recent years, Emmet has made fewer photographs of his wife. Though each year new ones emerge, he feels the pressure to not repeat himself. The successful Edith picture is increasingly elusive as he has continually raised the standard.

Over the years other subjects have dominated Gowin's attention. The landscape, especially agricultural sites, is the most enduring. He has spent years photographing from small airplanes. The early ideas, present in his work from the late 1960s, continue to inform his art. He identifies the earth, just as he does his wife, as a home to his spirit. Intimacy for the land, love for a place, and the caress of light upon it are what drive these works. This desire to find resonance and emotional attraction in the land replicates those same qualities in his photographs of Edith. Emmet Gowin's awe is directed at that which is most present yet largely unseen: the connections between us, our attachment to the places we find ourselves in, and the container of time in which we are all encased.

The famous view from above and behind Edith Gowin, showing her head, shoulders, nape, and cheek, is a subtle love letter. It is a haiku in middle tones, a caress of silver ethers, as simple a photograph as has ever been made. Longing and fulfillment are twined in the lover's knot of her hair. Edith is absorbed in her thoughts, gazing into watery distance; Emmet holds her as surely as he is held by his own skin. It is the eternal instant for which photography was invented.

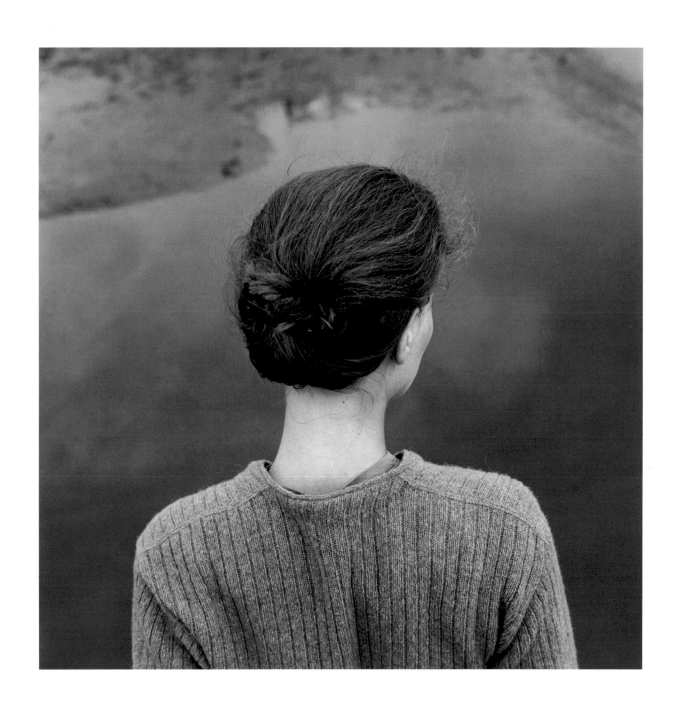

Emmet Gowin, *Edith, Chincoteague, Virginia*, 1967

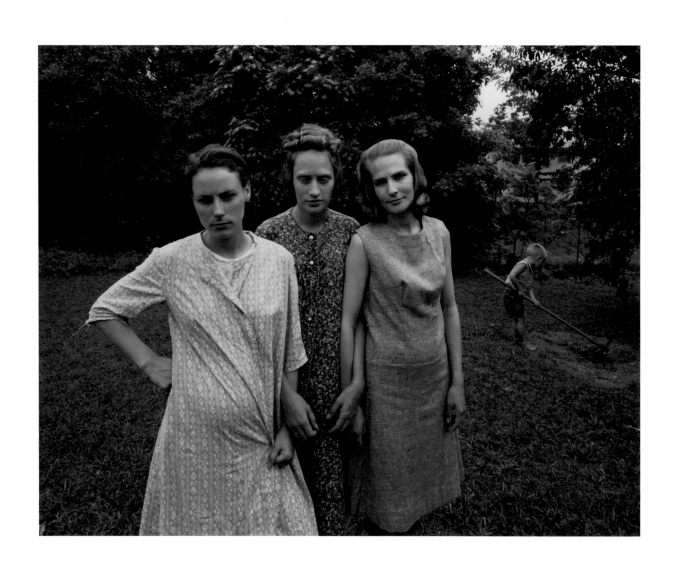

Emmet Gowin, *Edith, Ruth and Mae, Danville, Virginia*, 1967

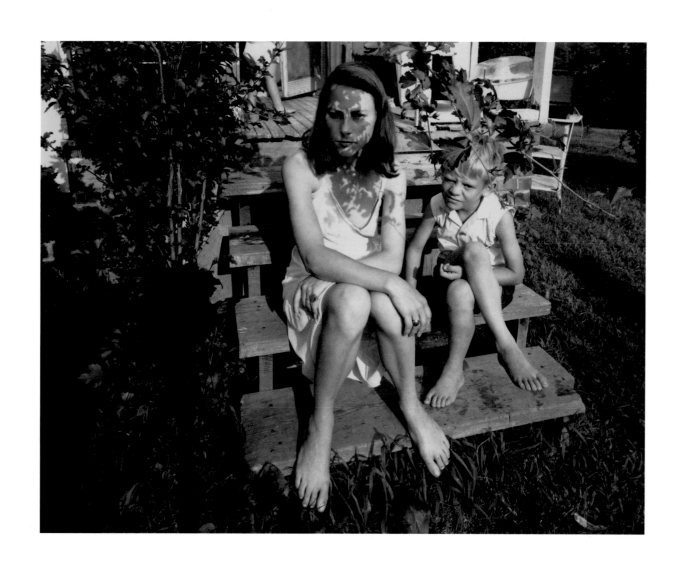

Emmet Gowin, *Edith and Dwayne, Danville, Virginia*, 1969

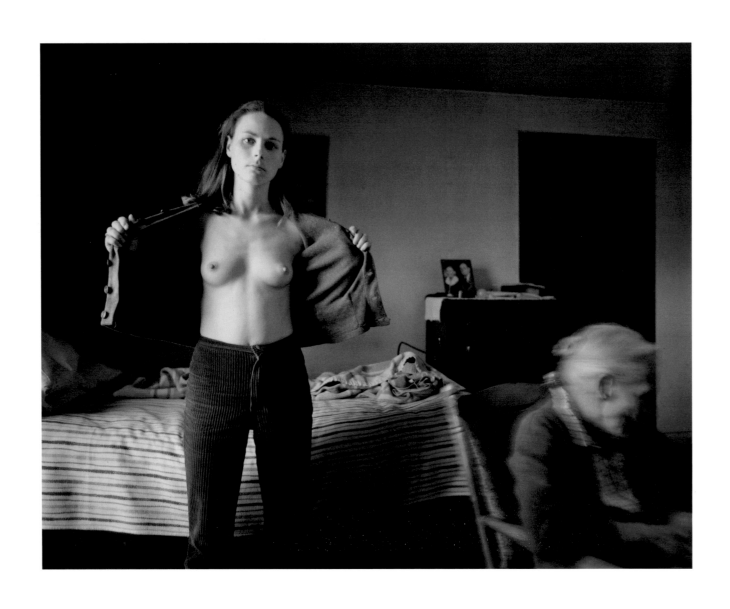

Emmet Gowin, *Edith and Rennie Booher, Danville, Virginia*, 1970

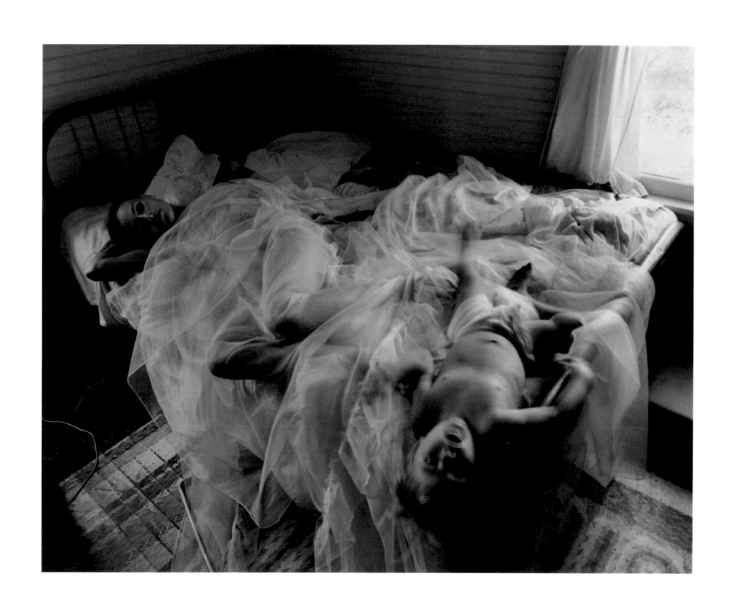

Emmet Gowin, *Edith and Elijah, Danville, Virginia*, 1969

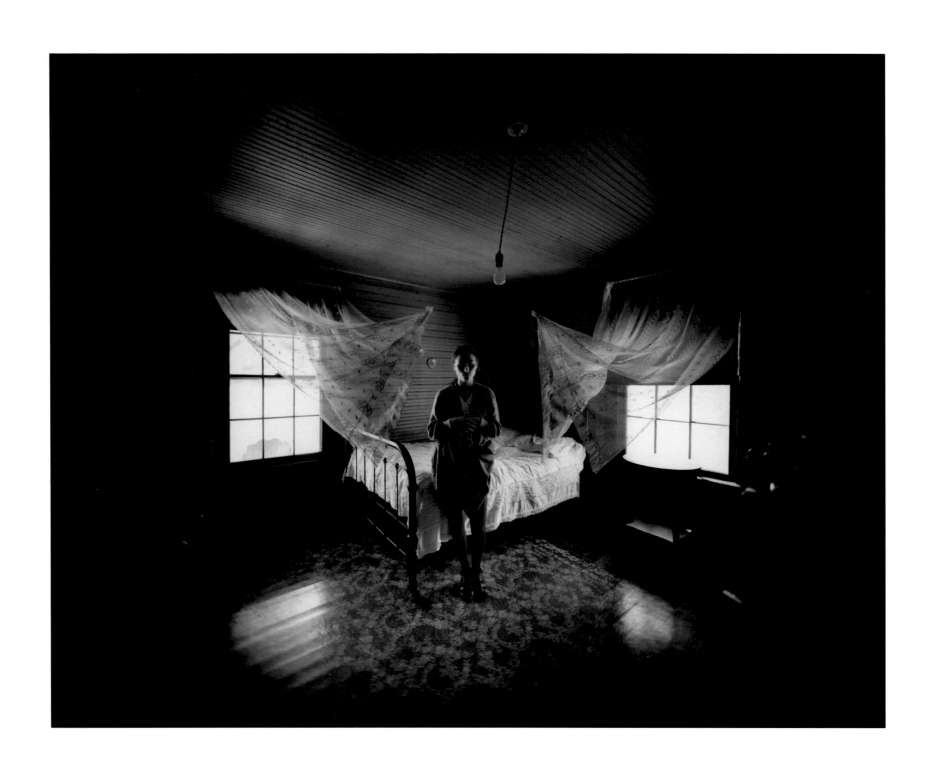

Emmet Gowin, *Edith, Danville, Virginia,* 1970

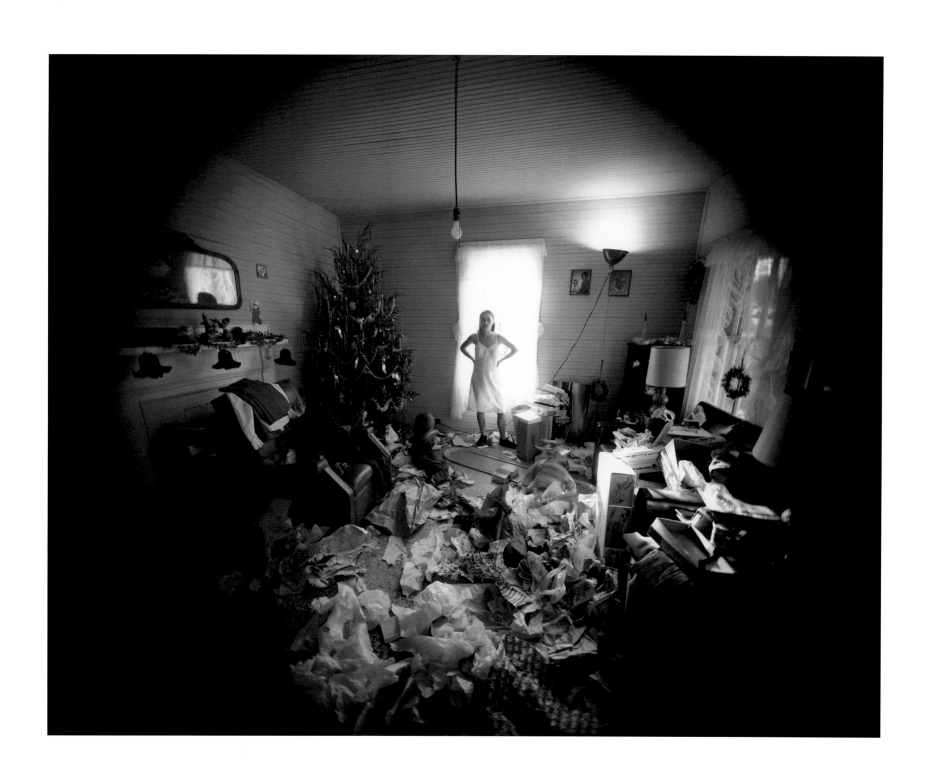

Emmet Gowin, *Edith, Christmas, Danville, Virginia*, 1971

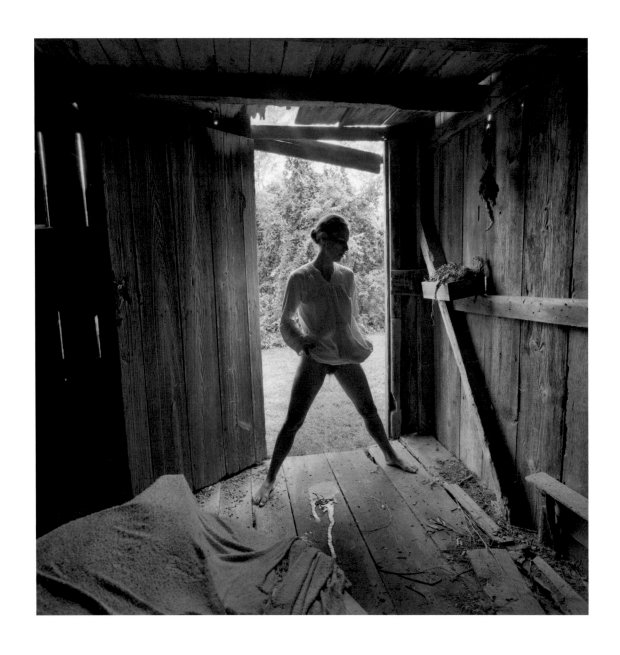

Emmet Gowin, *Edith, Danville, Virginia*, 1971

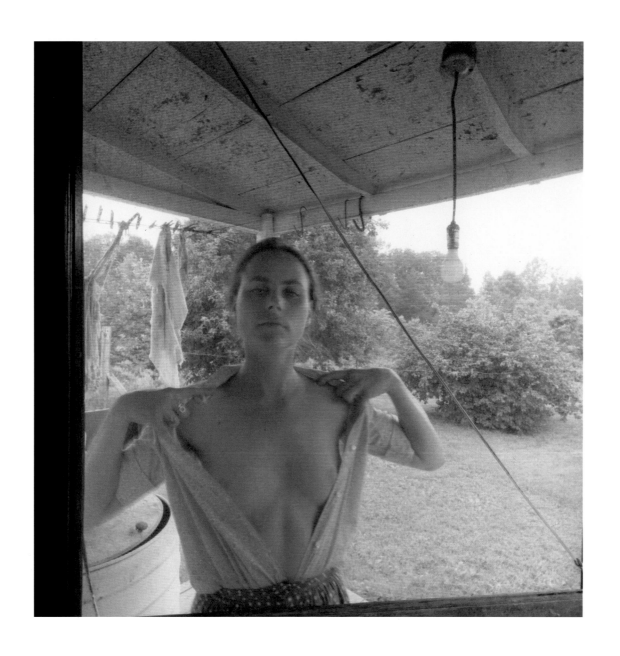

Emmet Gowin, *Edith, Danville, Virginia*, 1971

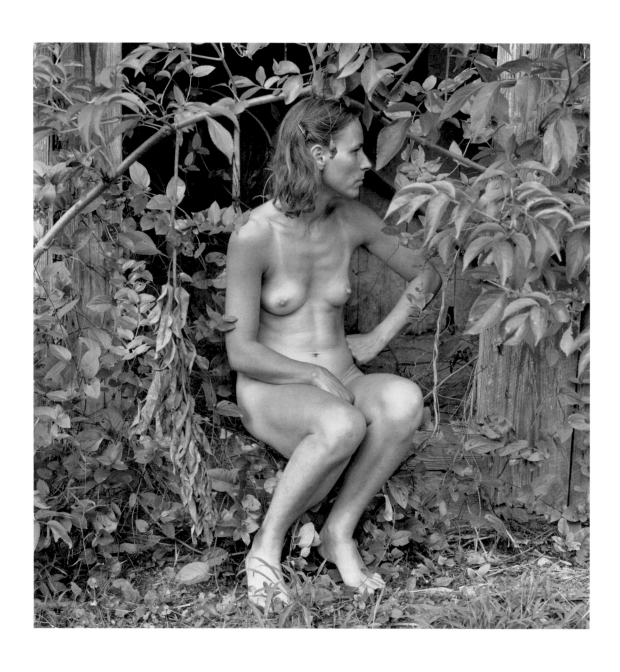

Emmet Gowin, *Edith, Danville, Virginia,* 1980

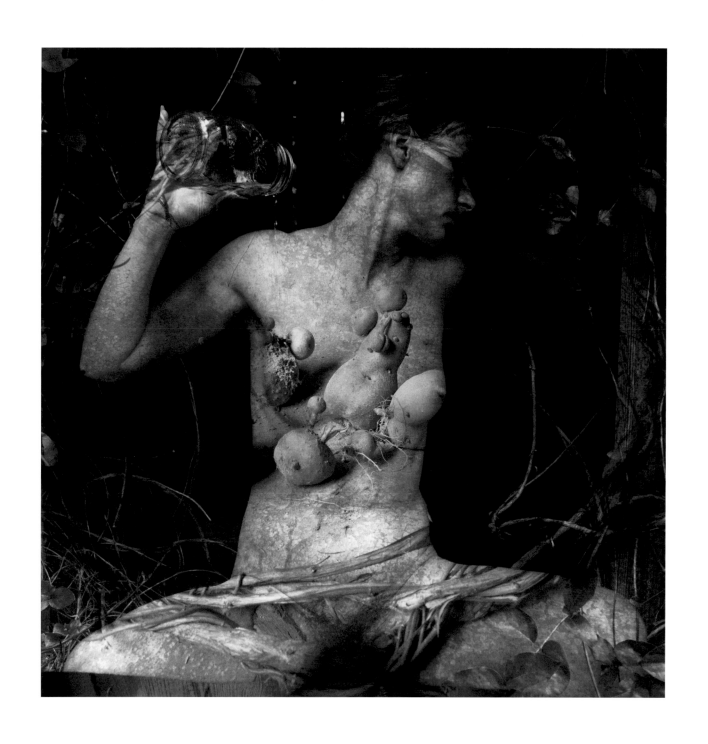

Emmet Gowin, *Edith*, 1986

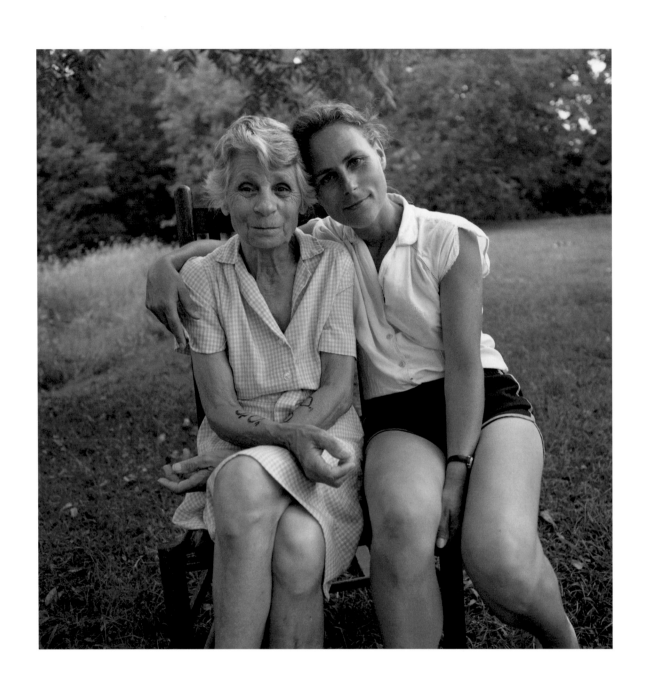

Emmet Gowin, *Reva and Edith*, 1986

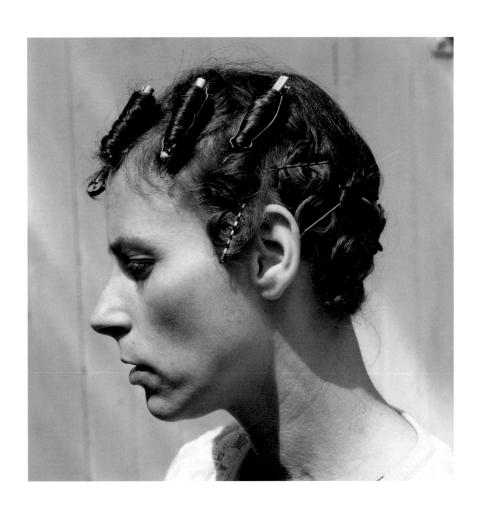

Emmet Gowin, *Edith, Newtown, Pennsylvania,* 1980

Emmet Gowin, *Edith,* 1996

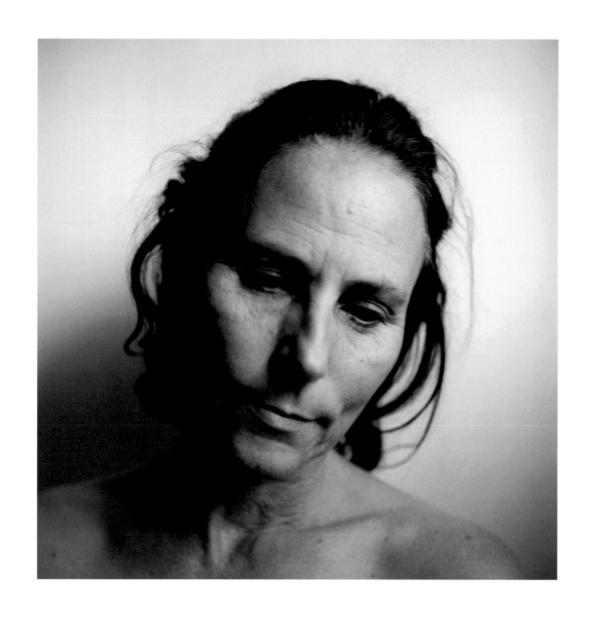

LEE FRIEDLANDER

LISETTE MODEL SAID, "There is nothing so mysterious as a fact clearly presented." Lee Friedlander's photographs are both clear and mysterious. Their mystery lies not in identifying the subjects or in deciphering the techniques whereby they were made, but rather in recognizing the person who chose to make them. Friedlander is an elusive figure and a taciturn one. He is prolific. His art is pure, unmanipulated, straight seeing. He has never mixed media, rarely worked in color or large format, has not philosophized obscurely or even been usefully interviewed. His statements are disarmingly simple. He is not a theoretician. His friend the printer Richard Benson once told him, "Lee, you wouldn't know an idea if it bit you in the ass."

Friedlander seems to have found himself when he came upon 35mm photography. This became the only outlet for his proclamations, the only mechanism of his interests and passions. Yet his practiced stance of neutrality masks his very human search for a vision. He can be maddeningly understated about his work: "I tend to photograph the things that get in front of my camera." Friedlander's art is famous for its obsessive, uninflected neutrality; a flat, picture-making style that emphasizes his curiosity and desire to be clear. His aestheticizing is of an astringent sort. His work on monuments, industrial workers, people on the streets, cactuses, is stylistically of the same vocabulary as his self-portraits, Japanese cherry trees in blossom, and his nudes. There is no nostalgia, only present-tense description. "I always have a mistrust of subjects that look perfect," he says. He has no interest in the symbolic or the metaphoric. He is a specifist. He prefers the time in between the decisive moments, the ungainly, accidental, casual, unmemorable instant; that which is far more common and real in all our lives. It is the moment that is perfect for photography.

Lee Friedlander is not a romantic. He is incompatible with sentimentality in art. And while he is a friendly and engaging fellow, he is not a warm one. He is wary, cool, and can be diffident. Neither is he a practiced diplomat. If he doesn't care for someone else's work, he won't lie about it. His perception is linked to his camera more than one might suppose. His wife, Maria, recounts, "Years ago he photographed my friend Helen Costa in Malibu. When he showed me the picture, he held it up and said to me, 'She's rather shy, isn't she?' and I said, 'Haven't you known that about her?' And I thought it was interesting — it's almost as if Lee sees when he's looking through the lens, but not so much when he's not." [1]

It is interesting, then, to look at his photographs of his wife. Is this work as unemotional, as neutral, as his pictures of cactuses? He has photographed her for forty years. Is this work free of nostalgia and romanticism, is it all just visual curiosity? Until recently very few Maria photographs had been shown or published. In his monograph *Like a One-Eyed Cat* (1989), there is only one small spread of four Maria pictures. In 1992, the Smithsonian published a book entitled *Maria Photographs by Lee Friedlander*. The thirty images reproduced are a small sample from his hundreds of Maria photographs but they are well chosen and give us a clear sense of what he sees when Maria "gets in front of his camera."

It is true that 35mm allows Lee Friedlander to be spontaneous and search for the unprepared, casual or "off" moment. "With a camera like that," Friedlander explains, "you don't believe you're in the masterpiece business. It's enough to be able to peck at the world. If I was using a piece

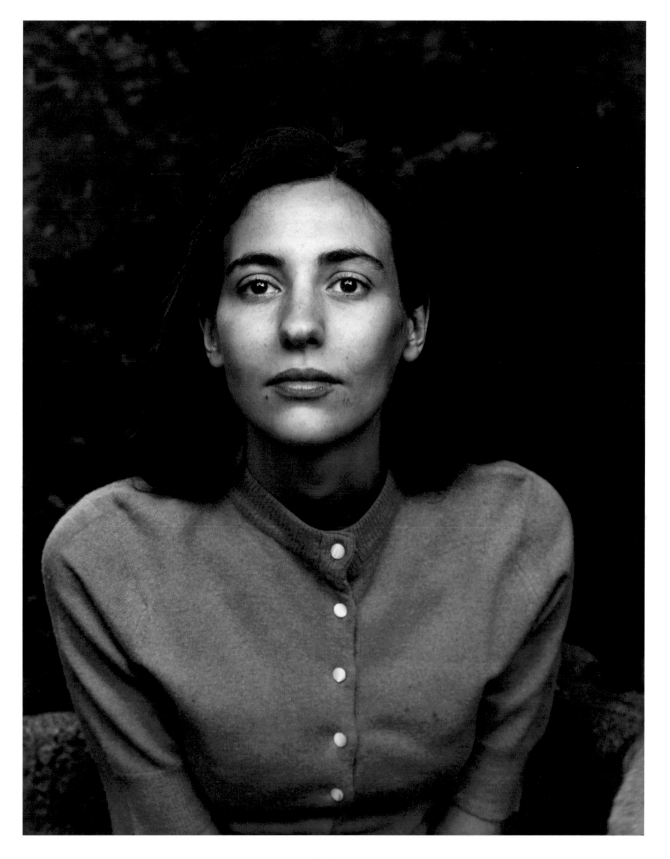

Lee Friedlander, *Maria*, 1959

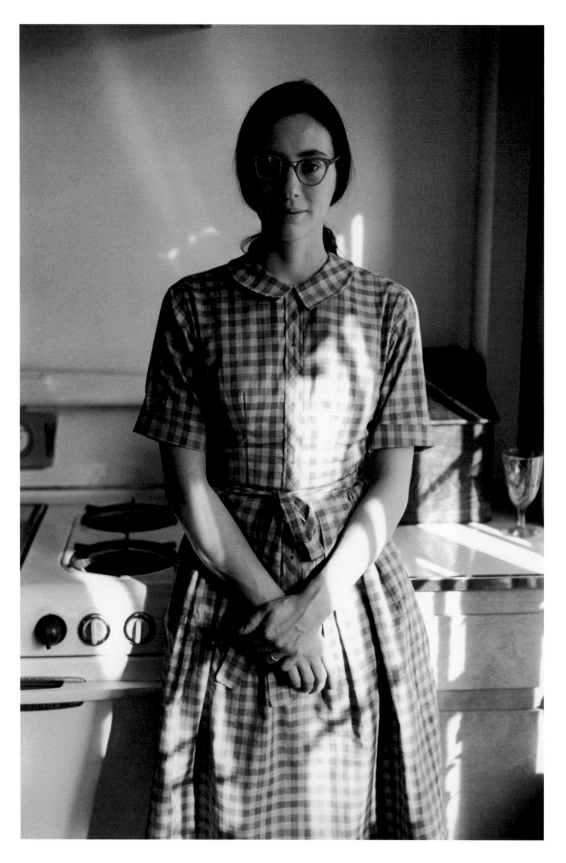

Lee Friedlander, *New City, N.Y.,* 1962

of equipment that was big, and I had to carry that thing around all day, I'd probably think twice about what I did with it. But when you're using such a small piece, it doesn't matter. The more junk you put in, doesn't cost you any more. It's a wonderful little medium."[2]

Friedlander was born in 1934 in Aberdeen, Washington. His mother died when he was seven. His father felt unable to raise him and sent him to live with a farmer about 110 miles south of Seattle, where he grew up. He met Maria de Paoli in 1957. He was twenty-three, she twenty-four. She was a child of New York's Little Italy, surrounded by the tumult of family and community. Working at *Sports Illustrated* as an editorial assistant, she ran into the young Lee Friedlander, who was trying to get assignments at the magazine. Maria's family resisted the marriage. The small civil wedding ceremony, with only half a dozen people present, was photographed by Garry Winogrand — he finally delivered the pictures seventeen years later! They both understood the editorial photography world and the wandering energy it demanded, but Maria understood the needs of children and household far better. Lee had insisted on his independence since childhood, while Maria had been immersed, all her life, in extended layers of family and community. Maria provided a stable home, so Lee could go where he needed to work.

The photographs of Maria are notably free of some of Friedlander's most typical attitudes. The images usually feature Maria as the dominant figure of a relatively simple scene. The frames tend not to be cluttered with distractions. They are generally shot within a dozen feet or less with wide-angle lenses. They are intimate, participatory views where his presence was undoubtedly known to her. They lack the jaundiced humor and tough critique that he has been known to illustrate. While many of his portraits of workers, musicians, artists, and friends show respect and even occasionally affection, none are repeatedly so gentle in spirit and even complimentary. Lee Friedlander's unemotional warmth is showing at the center of his life.

Maria is seen calmly, dignified, alert, and gently admired. She often shows eye contact — she was given an instant to compose herself — in essence, to create her own self-portrait. She is seen as a daughter, a cousin, a wife, a mother, a reader, a homemaker, a regular and companionable traveling partner. While rarely presented sexually, it is clear she is loved. The images are often sensual, and tactile references abound. Her daughter brushes her hair, Maria sleeps in the sun, shadows gently line her cheek in a café. A few nudes exist, but both agree they are private photos not for public view. Little effort is made to present symbolic ele-

ments or dramatic moments. The ordinary is his principal emphasis. How far Friedlander's images are from de Meyer's idealizations, and yet these too idealize. No fights, no ugliness, no bickering, nothing undignified. If this is documentary vision it is highly selective. It identifies a solid, trusting family structure. Friedlander's selection of daily observations reaches high poetry.

The two Friedlander children show up on film nearly as soon as they are born. They engage in all the occupations of childhood, often alongside Maria. Friedlander is in the family hierarchy as an affectionate, if not effusive, partner — a sort of observing buddy. He was not a very "hands on" father, but the photographs of his children show pride, affection, and interest. And there are a lot of these pictures, indicating that he spent much of his time at home, where he prints all his work. He appears more often in his pictures than any of the other photographers in this group appear in theirs. His appearances on film, however, have a certain ambiguity to them. He seems to stare back into the lens as if to later prove to himself that this indeed is his life, this really is his family, that he really was there.

Friedlander's pictures of Maria show that even in his uninflected way of picture making, with its trope of neutrality and curiosity, that love and dependence are absolutely unlike other emotions. Love looks different from simple curiosity. Tenderness and respect, no matter how alloyed with other complex emotions, are inconsistent with neutrality. The photographs of Maria Friedlander illustrate affection that is apparent and considerable.

Maria has stated, "I have some detachment from having seen Lee work, and seeing how he evolved. So the fact that there are a lot of pictures of me is no surprise. I do find the book *[Maria Photographs]* collectively touching, but also an invasion of privacy, disturbing, and it puts me in center stage, where I'd rather not be. But I wasn't going to say to Lee, 'No, you can't do it.' " The Maria book continues to draw attention to her. "Had Lee said to me, I'd like to do a session with you, either nude or clothed, even dressed, I think that would have been wrong for me. In some ways I'm shy. I think it would have destroyed whatever it was Lee saw of me in these pictures."[3]

In 1977, Friedlander began photographing nudes while spending six months in Houston, teaching at Rice University. The Texan photographer George Krauss was using a lot of nude models and he interested Lee in trying to do the same. For the next twelve years Friedlander periodically hired nude models for two-hour sessions, during which much film was exposed and considerable experimentation resulted. His normal method

of shooting what got in front of his camera was replaced by a strong interest in unpolished images of nudes and atypical, ungainly poses. These largely faceless young women writhe on the floor, in chairs or on sofas, dodging table legs, offering contorted, stretched, and twisted postures, or they sit quietly, nude, while reading in their kitchens. Friedlander was regularly very close, occasionally under his models, and fascinated with the imperfect body. This is either a visual feast or gluttony, depending on one's appetite. Some found the work offensive, others thought it ugly. Ingrid Sischy, in the introduction to his book of nudes (1991), praises Friedlander for the purity of his curiosity.

It is most important to weigh the nudes alongside the photographs of Maria. Far from being neutral, the Maria images are the very antithesis of the nudes. Maria is seen with affection and dignity. She is shown engaged in an activity, a place, or a social situation. She lives, raises kids, reads, or jokes with her family. She has dimension, an identity, a face. Friedlander is dependent on Maria for much of his support as she is on him. He has every reason to see her with a generous spirit. While his work with the nudes taught him to be very close and direct, the Maria pictures are more vulnerable and personally revealing. With hired nude models, Friedlander felt free to shoot directly, frontally, explicitly, and with minimal context. (He now recognizes that his subsequent cactus pictures were very likely the result of this frontal, unsubtle approach.) The nudes are not easy to categorize. They stem from traditions of commercial pornography and private sexual photography between consenting partners. But they do not readily occupy these niches. They have antecedents in the art history of painting and photography. Yet, some viewers find them uncomfortably graceless, antagonistic, and possibly misogynistic. There are others who feel they identify a bold and smart new departure from the elegant and worshipful traditions of the female nude as icons of icy perfection.

The years during which Lee worked on the nudes were not easy for Maria. Many women would find it disagreeable to support a husband's interest in photographing many nude women. That the photographs were quite direct, made in intimate premises, and all of women younger than Maria, didn't make it easier. She was, however, convinced that the sessions were professional, well within the sphere of Lee's art making, and involved no impropriety. Maria does not find the nudes beautiful, but she recognizes that they fit within Lee's way of working. As in the case of the Maria book, she would never attempt to veto her husband's work.

In his latest photographs of Maria, Friedlander conflates several of his noteworthy motifs. The first group of images that established his reputation was self-portraits, published in 1970. Many variants on several ideas placed his own shadow and his reflection in a wide variety of environments. There were also a number of straight portraits of Friedlander as a slightly disheveled and deadpanned everyman, in unattractive but not dishonorable settings. In the late 1990s he is placing himself in the frame along with Maria. While he has, on occasion, appeared there before, he now seems to be inserting himself in a more aggressive, ungainly fashion. His poses recall the ungraceful positions taken by his nude models, and, in fact, he appears in some of these photographs at least partially nude. While Maria remains as dignified and attractive as ever, Friedlander seems intent on identifying himself as a homely, uncomfortable, and somewhat repellent presence.

Not every relationship is balanced the same way, and each has its unique accommodations. The responsibilities of a couple extend to and from each other. Friedlander's need to photograph nudes, cactuses, monuments, portraits, and even his wife, is central to his work. He has made photographs of Maria that are fully honest to their relationship. Maria's image has not been romanticized or embellished. It has been treated with respect, charm, affection, and playfulness. She has been shown to be an attractive, intense, intelligent, occupied, and loved partner. No other person appears as often in his work and no other personality is as fully described. Stieglitz proposed that a life could be depicted by enumerating multiple aspects of it in a succession of images over time. Friedlander's extensive diaristic observations of his wife, for more than forty years, prove Stieglitz was right.

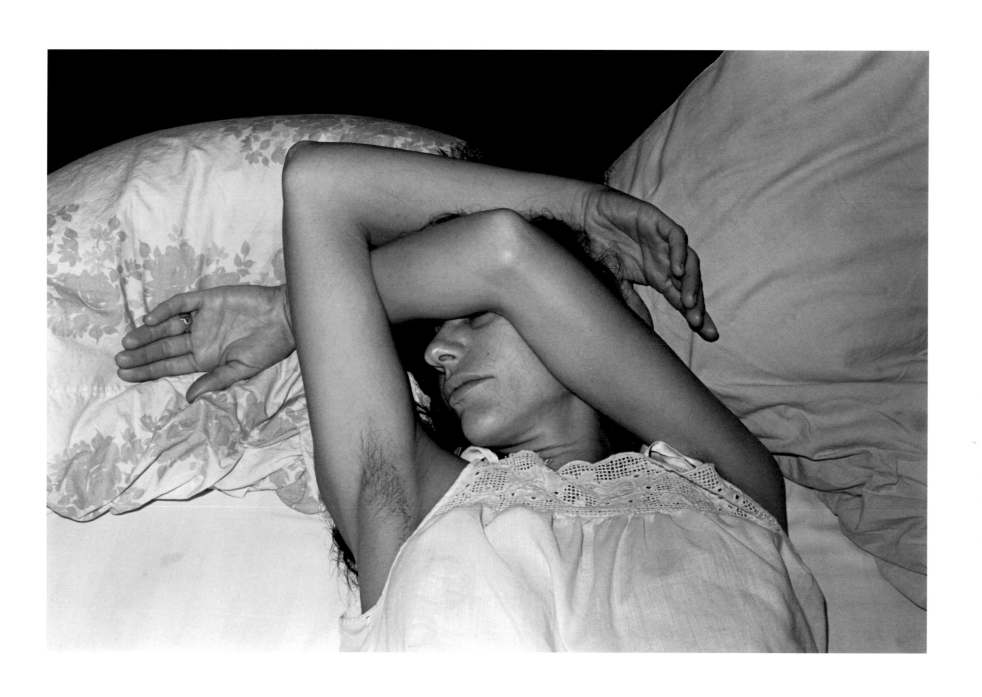

Lee Friedlander, *New City, N.Y.*, 1971

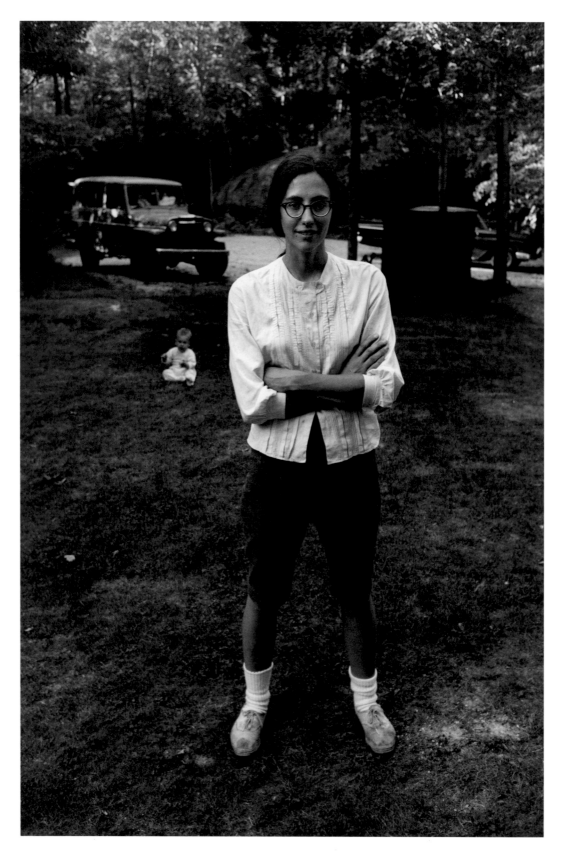

Lee Friedlander, *Maria*, 1961

Lee Friedlander, *New City, N.Y.*, 1963

Lee Friedlander, *Ft. Lee, N.J,* 1972

Lee Friedlander, *New City, N.Y.,* 1972

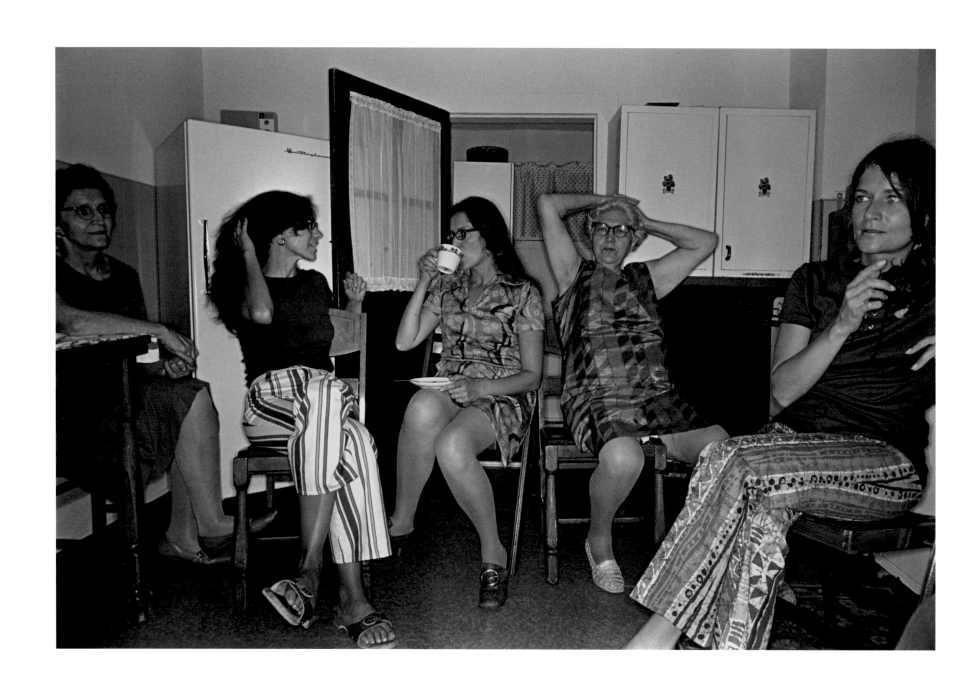

Lee Friedlander, *Ft. Lee, N.J.*, 1971

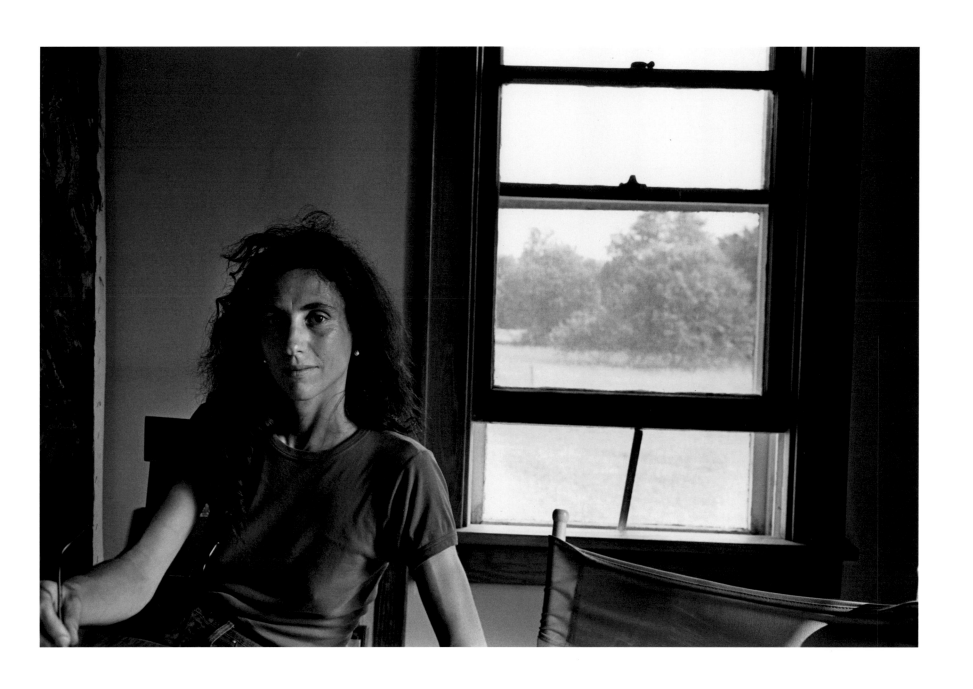

Lee Friedlander, *Stone Ridge*, 1971

Lee Friedlander, *Arches, N.P., Utah*, 1972

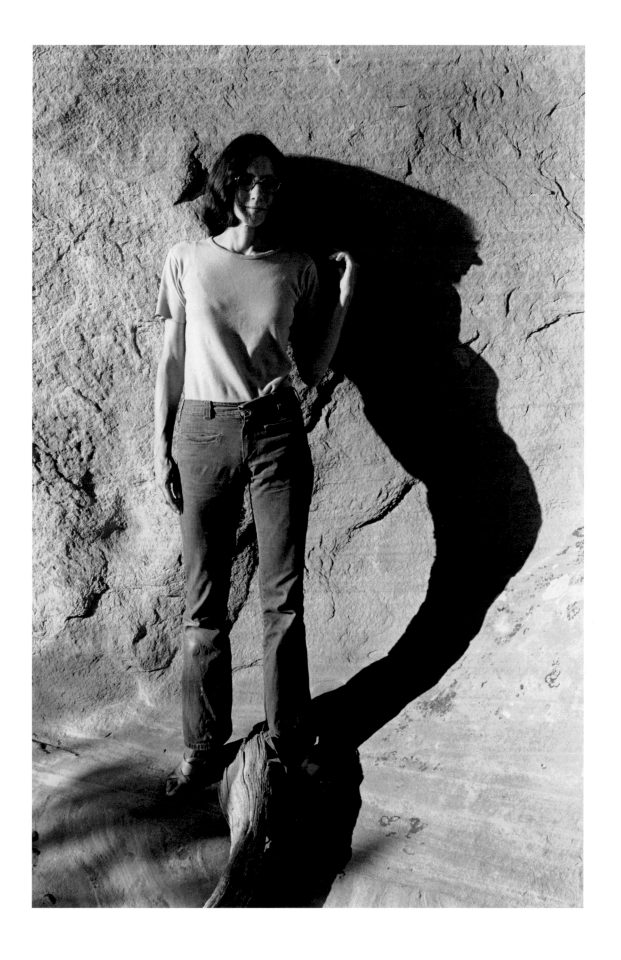

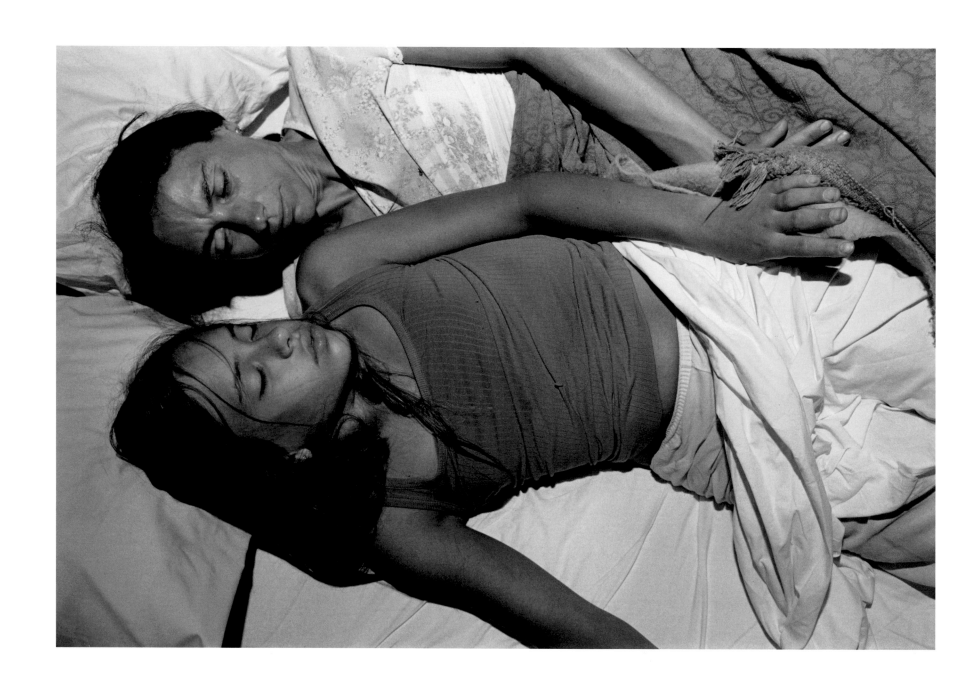

Lee Friedlander, *Chicago*, 1974

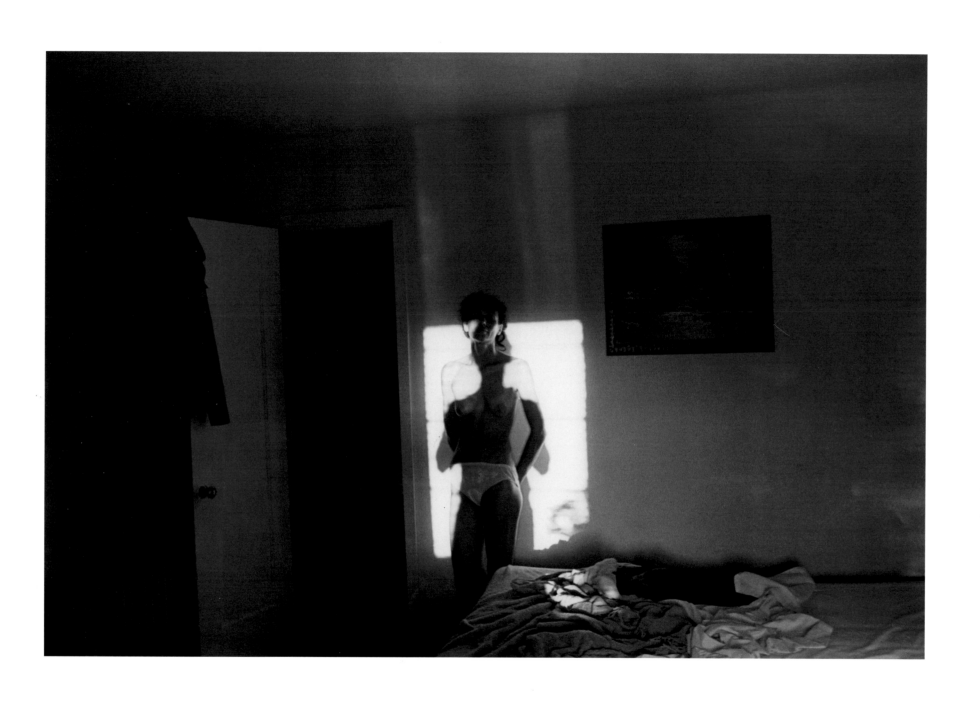

Lee Friedlander, *Las Vegas,* 1978

Lee Friedlander, *Copake, N.Y.,* 1987

Lee Friedlander, *Arizona*, 1989

Lee Friedlander, *Wales,* 1992

MASAHISA FUKASE

WHEN TWO CURRENTS IN THE OCEAN INTERSECT, rough water results. Navigation is made more hazardous. This turbulence also stirs up nutrients and may nurture a hearty food chain. Japan is arguably the world's greatest fishing nation. It recognizes the meaning of strong currents colliding, the dangers and the opportunities.

The artists who came of age in Japan in the 1950s and early 1960s were forced to live with realities that their parents could never have conceived. The best of them fed aggressively on the upheaval of ancient traditions being replaced by American-style life. The catastrophe of the war and the destruction of Japan's central mythologies, based on the divinity of the emperor, led to an embrace of raw realism and a stark reappraisal of all subject matter. The pace of Japanese society lurched into high speed, further altering perceptions and meanings across a broad cultural spectrum. Many of Japan's young artists of this time felt orphaned in their homeland, both outcast and liberated. Dissonance became a principal ingredient in the oeuvres of many artists. Yayoi Kusama, Yoko Ono, Kazuo Ohno, Tatsumi Hijikata, Shomei Tomatsu, Hiroshi Hamaya, Daidoh Moriyama, Nobuyoshi Araki, Eikoh Hosoe, and Masahisa Fukase all embraced new synthetic opportunities of atonality, expressionism, and abstraction. Others, like Yukio Mishima, struggled to integrate new modes with old values, updated and purified. These artists and many others were immediately attracted to and adopted by the art world avant garde for their purity, passion, drive, and discipline, and their exoticism.

Among the richest nutrients surfacing in the late 1950s was a new focus on the individual, his aspirations, and his voice, in place of the collective concerns of community and the general society. Artists of every medium began to craft a new and personally expressionist vocabulary in Tokyo. Together, they produced imagery that symbolically identified the explosive cultural forces at work on the individual and the society that made Japan the world power that it is today. As a young artist arriving at the photography department of Nihon University in Tokyo in 1952, Masahisa Fukase was shaped by these currents.

His early imagery documents the working-class neighborhoods of his native Hokkaido town and similar sections of Tokyo. They are intimate, reflective photographs of children playing in crowded streets while old people go about their business. They resemble 35mm work by early Magnum photographers in Europe at the same time. Balanced, poetic, and affectionate, they are also animated by their spontaneous complexity.

In 1956, Fukase began his career in the relatively new field of commercial photography at Dai-Ichi Advertising Company. He rapidly began to build a reputation with several one-man shows in the early 1960s. In 1963 he met Yoko Wanibe and immediately began photographing her. He continued photographing her for thirteen years, until their divorce in 1976. This body of work was his signature production, resulting in numerous exhibitions and publications, though his later work would be seen internationally by a wider audience.

It is a commonplace story line in many movies from the late 1950s to the present: A couple begins to fall in love, and a dozen short scenes in rapid succession illustrate their playful adventures together — talking on the phone, flying a kite, riding bikes, bathing at the beach, skiing, laughing at the camera. In the work of Masahisa Fukase and his wife, Yoko, you see these and other motifs that identify the playful experimentation in

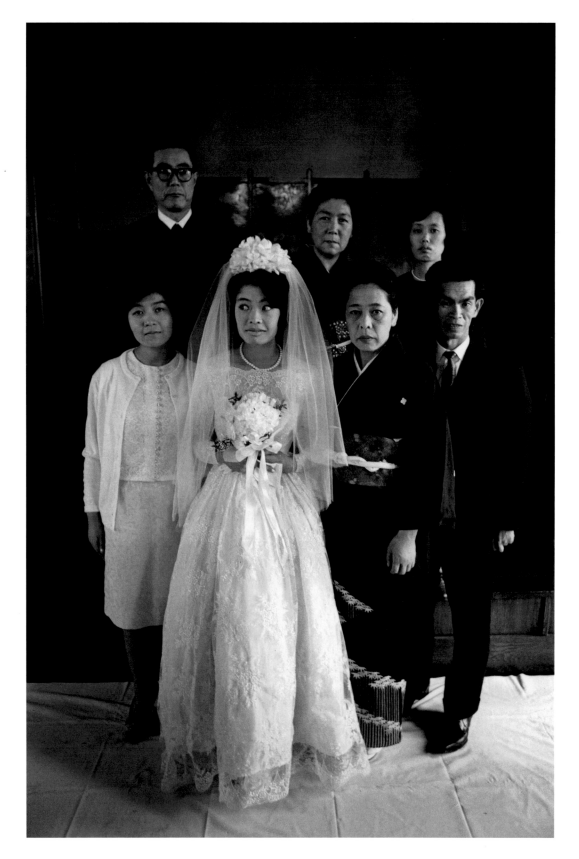

Masahisa Fukase, *Kudan Church*, 1964

their marriage and the joyous, casual expression of that relationship. He found that his cooperative wife was the ideal partner with whom to explore new artistic ground. Yoko became his improvisational collaborator, his experimental catalyst, his prod and his accomplice. Yoko was trained as a classical Noh dancer and is remarkably expressive in her gesture. In the photographs she can be comical, placid, aloof, and sculptural. The couple's experimentation was not limited to making photographs. Like many others of their milieu, they also approached alcohol and wild orgiastic parties experimentally. Their life in those years was both turbulent and productive. Long periods of drunkenness, separation, humorless stupor, and angry confrontation were interspersed with playful, inventive interludes. Such periods of turmoil don't last forever and always present a steep toll.

In the early pages of *Yohko* (she prefers the more common English spelling, Yoko), the 1978 book Masahisa Fukase published of his pictures of his wife between 1964 and 1976, there are several images of Yoko on her wedding day. In one, a traditional family poses formally, with Yoko at front center. The older women are in kimono; the younger women and the men in contemporary Western garb. The bride wears a white Western-style wedding gown. Were it not for Yoko's expression, the picture would identify a story told over and over throughout Japan. Western culture was replacing elements of traditional Japanese culture even in sacred ceremonies. Yoko, however raises the scale of change radically. Her wide eyes are cast to our left and her expression is comically startled, while everyone else stares stiffly into the lens. This is no outtake from the commercial wedding shoot. The bride and groom were doing this ceremony in italics. They could not get themselves to take it seriously. They were bound by a joke that no one else present understood. But they shared it with us and, in fact, they were right, the scene is funny. They appear to be announcing values that their milieu is unprepared for. There was a tacit understanding that the husband/photographer and wife/model were embarking on something that would separate them from their roots; a brave new territory would, in the end, claim them as well. Their energy and desire to craft a new way to organize their world would provide a very rough ride indeed.

Throughout the book we see a great flirtation with the horrific. In one photograph Yoko's face is caked with a facial mask, cracked and peeling, with searing light and deep shadows, as she holds a bouquet of hydrangeas. Her serious demeanor recalls images of Hiroshima's *hibaksha* (bomb-damaged people). Interspersed with images from the slaughterhouse, funerary crows, and their own sweet play as a couple in love, the darkest images infuse the entire project with an ominous quality. The book was published after Yoko left Fukase and he was diving headlong into the hellish half of his life.

The emotionalism of Fukase is not subtle but its means are often economical. On the cover of *Yohko*, he juxtaposes two images taken from the same negative. One is a traditional portrait of his wife in kimono, a waist-high portrait on a gray backdrop with studio lighting. It is a classic, uninflected, identification photograph. Next to it is a full-frame close up of just the face, from the same image, covered with glass that has been shattered. The metaphor is startling. Is he identifying their break with conservative tradition? Is he enacting his anger toward her? The epicenter of the shatter lines in the glass is between her eyes at the brow line, the position of the second, or *ajna*, chakra, the Hindu organ of psychic insight and clairvoyance, the Buddhist third eye. Light and dark lines radiate from this fracture as her eyes engage our own. Is Fukase identifying Yoko as someone whose perception was highly evolved, or is it a dramatic opening announcement of the artist's interrogation of himself, his partner, and his photographic tradition?

Fukase acknowledges that his inspirations were linked with several American photographers. One of his strongest influences was Yasuhiro Ishimoto, an American of Japanese descent who studied at the Institute of Design in Chicago in the 1950s. Ishimoto studied with Aaron Siskind and Harry Callahan before moving to Japan in 1953. His work profoundly affected many young photographers there. Fukase seems at times to migrate through Ishimoto, to find inspiration directly from Callahan. In the 1987 book *Japanese Photography 1945-1985* Fukase is quoted: "I don't speak a foreign language, but I could communicate with Garry Winogrand and Lee Friedlander without a translator." Fukase reinterprets Harry Callahan's famous 1949 portrait of Eleanor in the water with her eyes closed (page 115) by similarly positioning Yoko in a lake, but she is seen from behind (page 170). In an ominous twist she appears to be heading out toward an enormous expanse of open water. Even more ominously, in another related piece, she is seen floating face up, eyes closed, her face a deathly white. Very slight changes have added layers of fear and loss to the ideas initiated by Callahan. A New York street image from their 1971 visit is a dead ringer for Callahan's early sixties street scenes, which show pedestrians on shadowy streets, isolated in flashes of bright sunlight. In this image the pedestrian is Yoko. In another image made in the tradition of social-documentary street photographers, he photographs Yoko walking through mean Bowery streets surrounded by collapsed drunks.

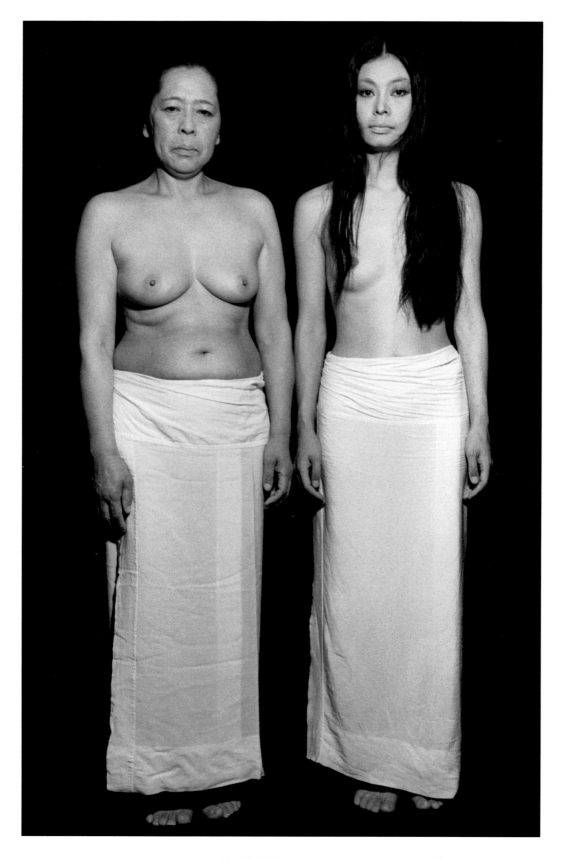

Masahisa Fukase, *Tokyo,* 1970

His attitude of serious play occasionally bends toward humor. He posed his nude wife, holding her clothing, and his father in underpants and slippers outside the family portrait studio in northern Japan. At the elegant opening of the Museum of Modern Art's exhibition "New Japanese Photography" in 1974, in which a number of Fukase's Yoko images were displayed, Yoko is seen in formal kimono, kneeling on the floor in front of several images of herself, while well-dressed patrons pass her by, ignoring her utterly. In another, Yoko holds her hands before her face, mimicking the focusing gestures of a 35mm photographer — her face hidden behind the "camera" and pointing out the invisibility of the photographer in the typical photographic enterprise. When Yoko is serious, however, there is a·sense of impending tragedy or even of the hopelessness of existential human isolation. One gets the impression of two people walking a razor's edge of manic and depressive episodes in their life together. In their embrace of attempted liberation through alcohol or wild behaviors, there is a perception of desperation and excess woven together with exceptional sensitivity and delicacy.

Yoko has described this period as one of suffocating dullness, interspersed by violent and near suicidal flashes of excitement. It is clear that Yoko felt her own needs were not being met and she needed more control of her own destiny. While she feared for Fukase's safety without her, she needed to get away from him. Indeed, when Yoko left him in 1976, Fukase fell into a drunken and near suicidal depression. Anguished and lonely, he made a trip to his hometown in a remote area of Hokkaido. He found himself one night in a field, amidst a flock of ravens. He was excited by his ability to photograph them in low light. The series of night ravens begun then became his most famous body of work. In his postscript to Fukase's *Yohko* book, Shoji Yamagishi states that his work "testifies that both happiness and misfortune are intertwined, like the strands of a rope, in the lives of us all." While Fukase immediately remarried, he never stopped mourning the loss of Yoko. In 1992 he divorced his second wife.

Fukase's two large bodies of work may seem to have been made by entirely different temperaments. In fact, they were. The man whose eyes we inhabit viewing the Yoko photographs could not have been the dark specter who prowled among the night birds. The beautiful young Yoko, buoyant, playful, and flirting, certainly is not interacting with such a tragic mask behind the camera. There simply had to be a playful Fukase or at times a chemically enhanced one to synergize these moments. The connection that links the work is his intensity. His vision is not centered on observation but rather on participation.

In the afterword for *The Solitude of Ravens,* Akira Hasegawa states, "I think he never could find in either his woman or his other friends an external world with which he could merge unconditionally. Masahisa Fukase's work can be deemed to have reached its supreme height; it can also be said to have fallen to its greatest depth. The solitude revealed in this collection of images is sometimes so painful that we want to avert our eyes from it." Indeed, the photographs enumerate a litany of persistent and troubled moods: sadness, loneliness, anger, pain, discouragement, indignation, loss, and more. Fukase was able to mine his negative impulses to find wisdom there. In the end, of course, what we see is creative invention, insight, and a kind of expressionist blues — beauty alchemically squeezed from misery.

In 1992 he published a group of vigorously grotesque and ominous self-portraits submerged in his bathtub, made with an underwater camera. It is said that he was trying to photograph the moment of his becoming unconscious. In June of that year, he fell down the stairs in a bar that he frequented and suffered severe brain damage. He has been institutionalized since then and has little useful grasp of his daily reality or his contributions to photographic history. Twice a month, Yoko (now happily married to a retired salaryman) visits Fukase and tends to his needs. Of her ex-husband she says, "With a camera in front of his eye, he could see, not without. He remains part of my identity. That's why I still visit him."

Masahisa Fukase's ultimate fate seems to have been preordained. In Kabuki drama, the mask is assigned to an actor and he has no choice but to play the role as the mask indicates. Fukase has been cast as the tragic figure, and no amount of struggle, creativity, or play can change his fate. His has been, in the end, a tortured life. From both Eastern and Western theater we know the tragic figure may also be a heroic one. In Japan one often sees representations of the gods and the mythic figures in fierce snarling faces. The god of the wind rules not only tornadoes but spring zephyrs as well, yet he is usually portrayed with an expression of fearsome anger. The delight of love in blossom is no less present in Fukase's work for all his torturous identification of loss.

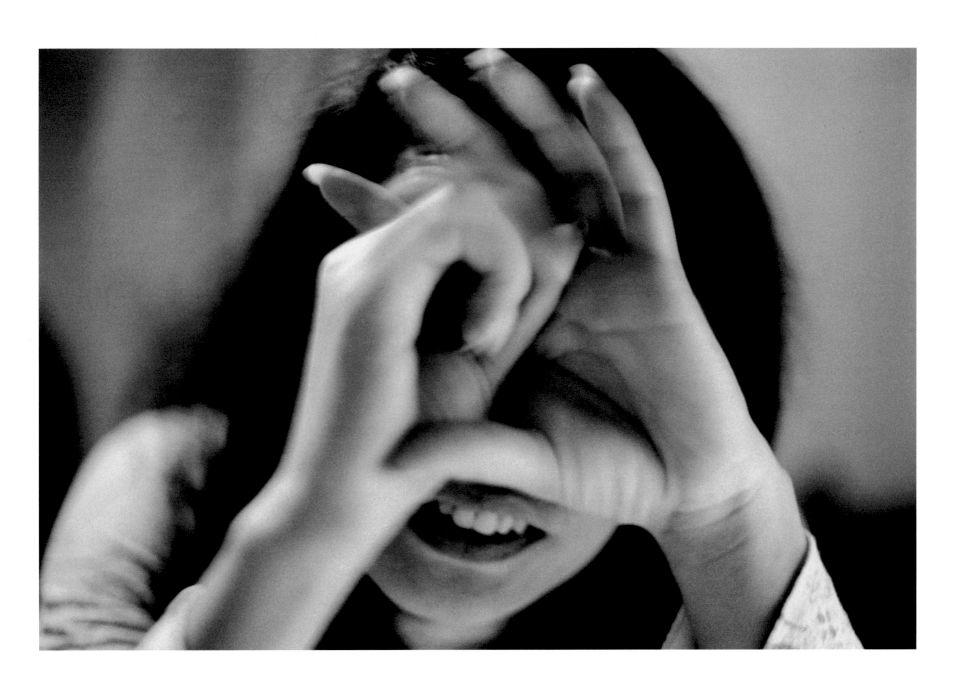

Masahisa Fukase, *Matsubara Apartment*, 1968

Masahisa Fukase, *Bifuka, Hokkaido,* 1975

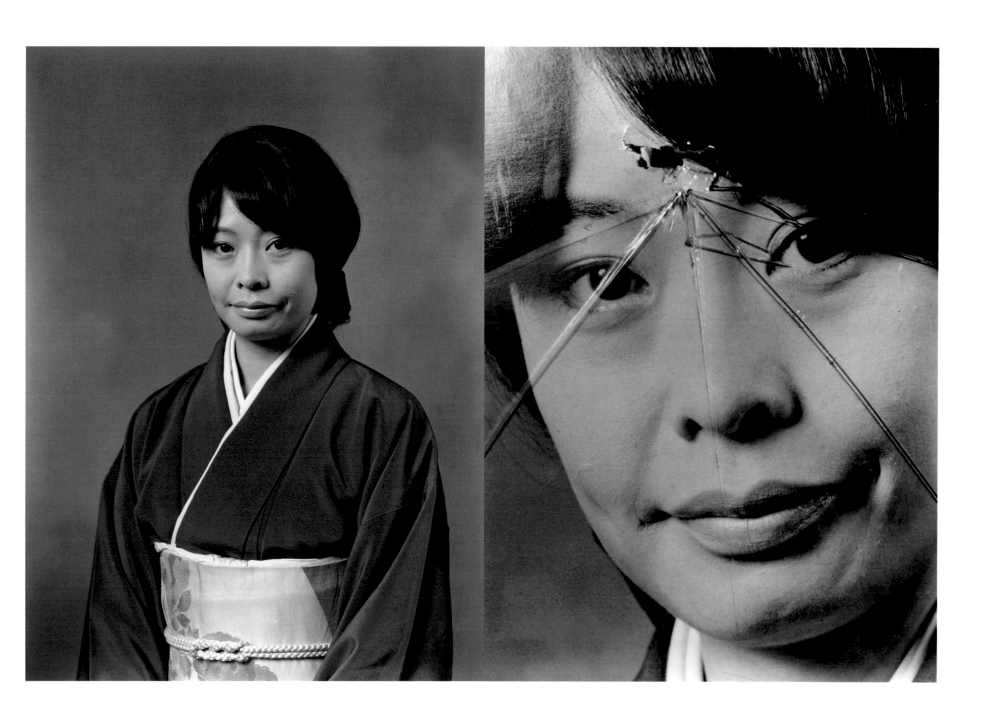

Masahisa Fukase, *On a Plane to Hokkaido*, 1971

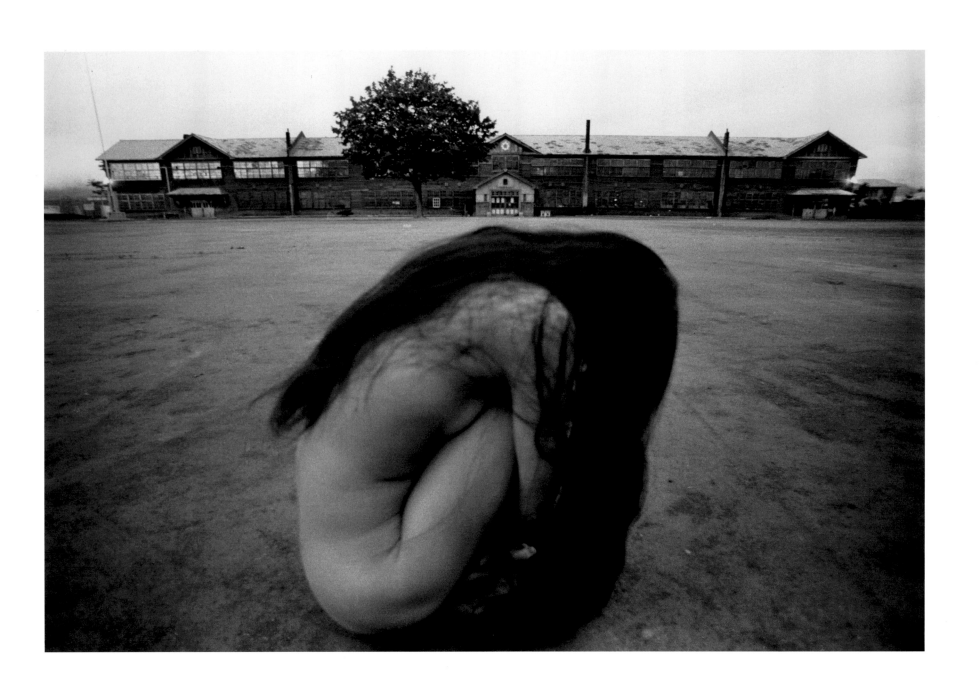

Masahisa Fukase, *Bifuka, Hokkaido,* 1971

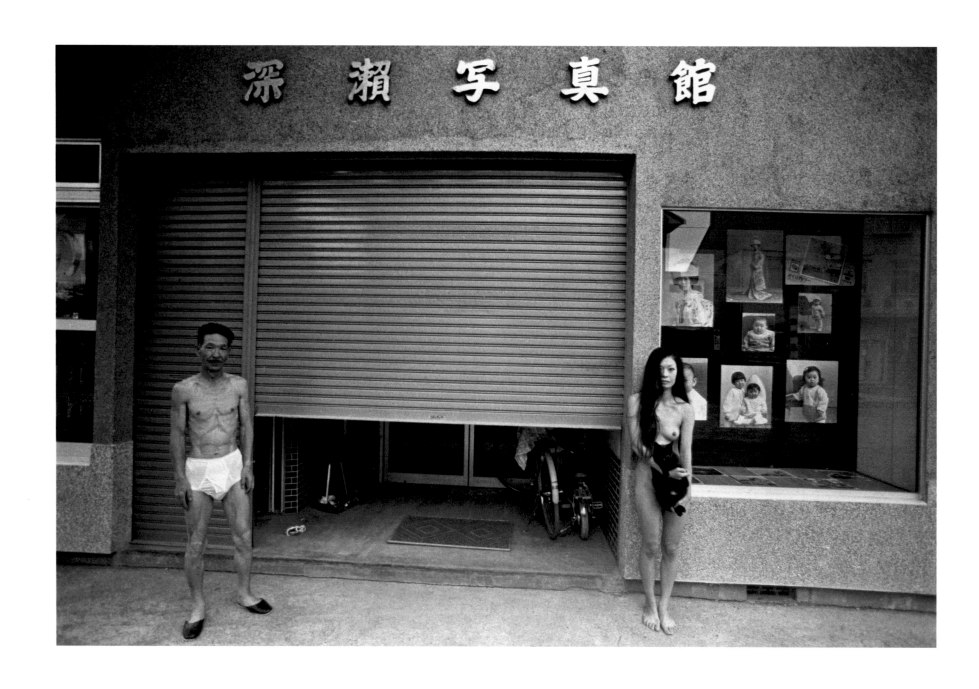

Masahisa Fukase, *Bifuka, Hokkaido,* 1971

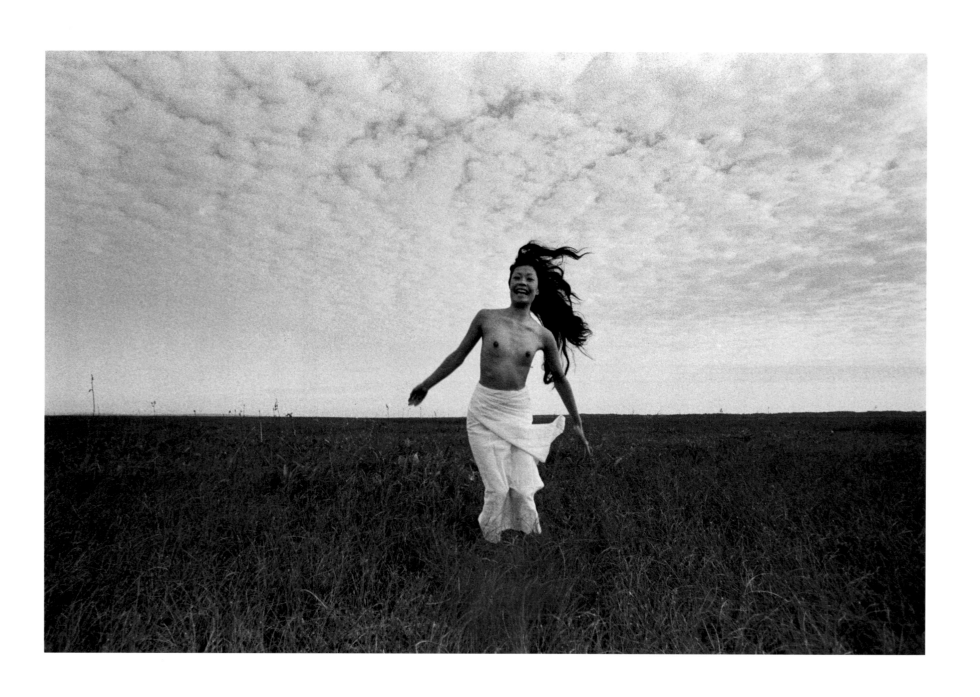

Masahisa Fukase, *Sarobetsu, Hokkaido*, 1971

Masahisa Fukase, *Izu*, 1973

Masahisa Fukase, *Izu,* 1973

Masahisa Fukase, *New York*, 1974

Masahisa Fukase, *New York*, 1974

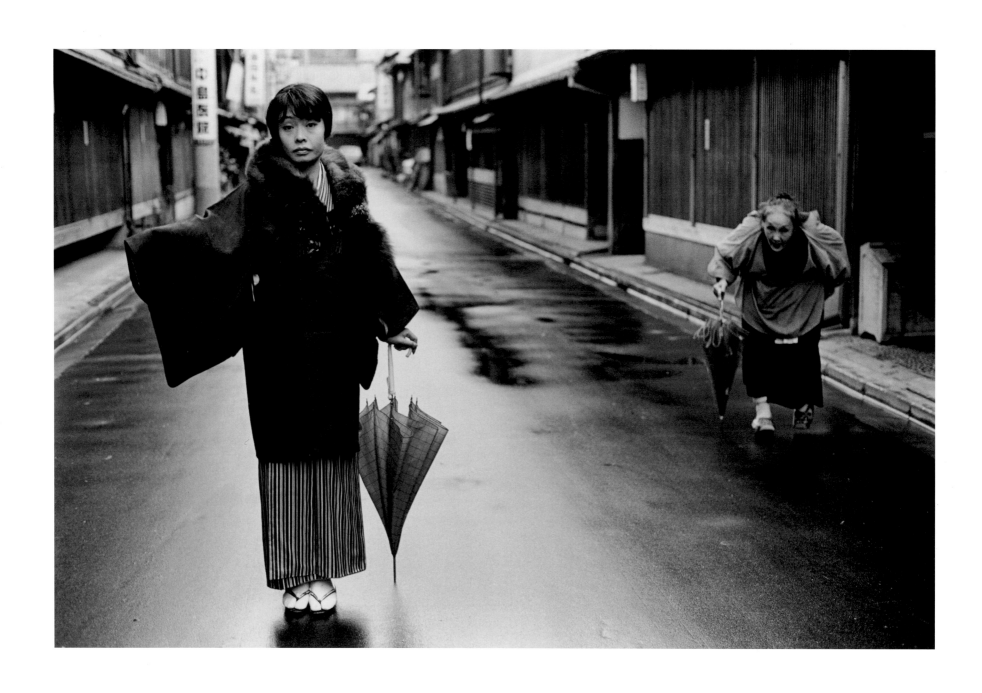

Masahisa Fukase, *Kanazawa,* 1977

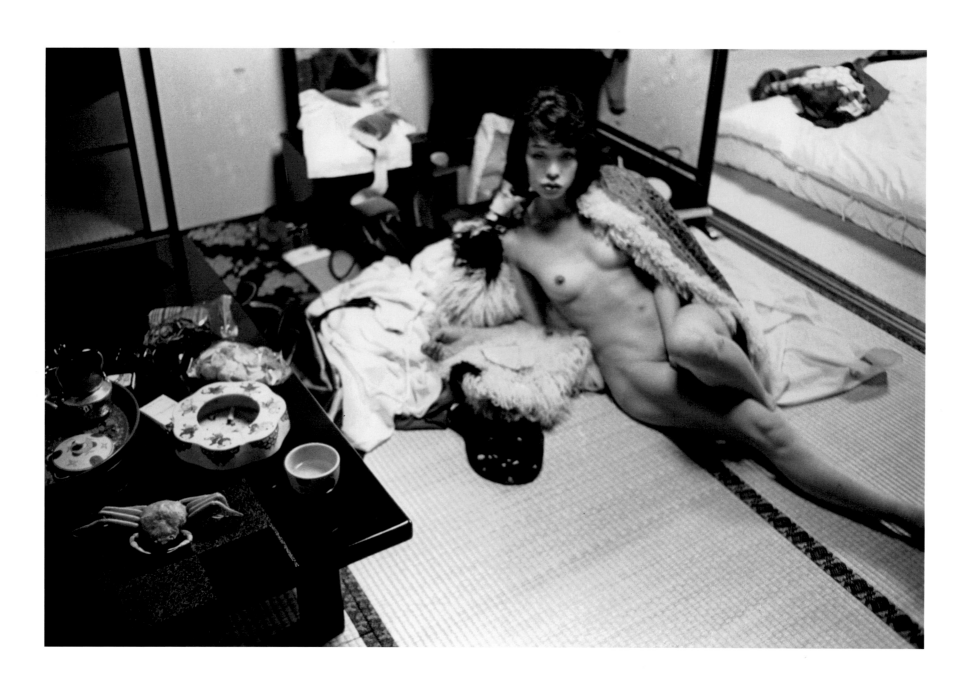

Masahisa Fukase, *Kanazawa,* 1977

Masahisa Fukase, *Kyoto,* 1977

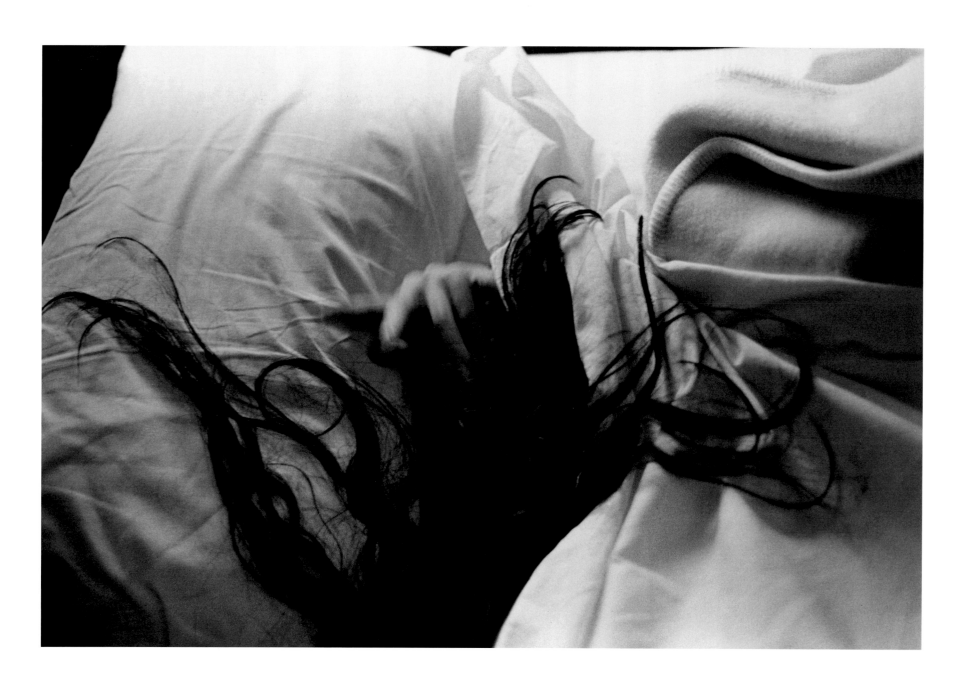

SEIICHI FURUYA

SEIICHI FURUYA IS A MAN IN EXILE. He wears alienation like an obligation, a shroud that he finds comforting in its necessity. He was born in Izu, Japan, in 1950. His memories of childhood are few and generally painful. His younger brother has severe mental and physical disabilities and was permanently institutionalized. He recalls episodes wherein he felt deeply for his brother's vulnerability and sharp pain at his own inability to protect him. As a youngster, Furuya narrowly escaped death in an automobile accident caused by his father's drunk driving. He was trapped in the wreckage for a prolonged period.

Perhaps in an effort to create permanent structures for his own emotional shelter, he studied architecture. In 1970 he began two years of study at Tokyo College of Photography, which he abandoned in 1973 to travel across Siberia to Moscow and then to Vienna, where he stayed for two more years.[1] As a Japanese in Vienna, he enjoyed his identity as an exile, intrigued by the disjunction between his disparate cultural perceptions. When one is young, unattached, and wandering abroad, displacement can be invigorating.

Friends invited him to Graz and arranged for him to work in a camera shop. The vivacious young woman who came into the shop one day in 1978 was introduced as Christine Gössler. She hoped for an acting career and had an air of both confidence and vulnerability. She also had a long scar on her neck and another on each wrist when she met Furuya. Less than a year earlier she had attempted suicide when her lover broke off their engagement. These two intensely serious, wounded young people buoyed each other up. They soon married. Gössler seems glowingly happy in an early image, on an outing to Furuya's hometown in Japan. Her open expression, erect posture, and jaunty air communicate a willingness to step into a new adventure. The sunny disposition of the image is the early identifier of a recurrent mood of play, mugging, and pleasure that we see throughout much of their initial time together. Furuya brought his camera with them everywhere. Photographing was never discussed, it was simply done, at any time or place. The photograph was used like a diary, or a note to underline a moment's insight. Furuya produced hundreds of rolls of film that included many notes from each day's activities; where he was, who he saw, what he encountered, what attracted his eye, was quickly recorded. Beginning in 1978, Christine was his central subject.

The early photographs are close-up, intimate, loving notations to a day's outing, an evening's bath, their visit to his family in Japan. The artist and his wife were connected by strings of romance, love, and hope. Soon, however, a weft appears, intersecting these warp strings. A look of seriousness and confusion clouds Christine's face, as her jaw tightens in an image from *Graz 1979*. It is convenient and perhaps facile to reverse the chronologies of pictures, seeking early evidence of known outcomes. It is perhaps inevitable that we attempt to identify premonitions of the emotional disintegration that would follow.

The veil of Furuya's displacement grew lighter as he began to establish connections to his adopted continent. But he never found profitable or even meaningful employment. His conversations about the period revolve around uncertain finances and the clash between his wife's need for stability and predictable circumstances and his willingness to let the future present what it would. "She often wanted me to tell her everything would be okay, but I would never tell her that. I couldn't predict the future," he states.[2]

In 1980 their son, Komyo (in Japanese, *Ko* means light, *myo* means bright), was born. Gössler worked for Austrian Radio (ORF), first as a secretary, then as reporter and producer, and developed an interest in study-

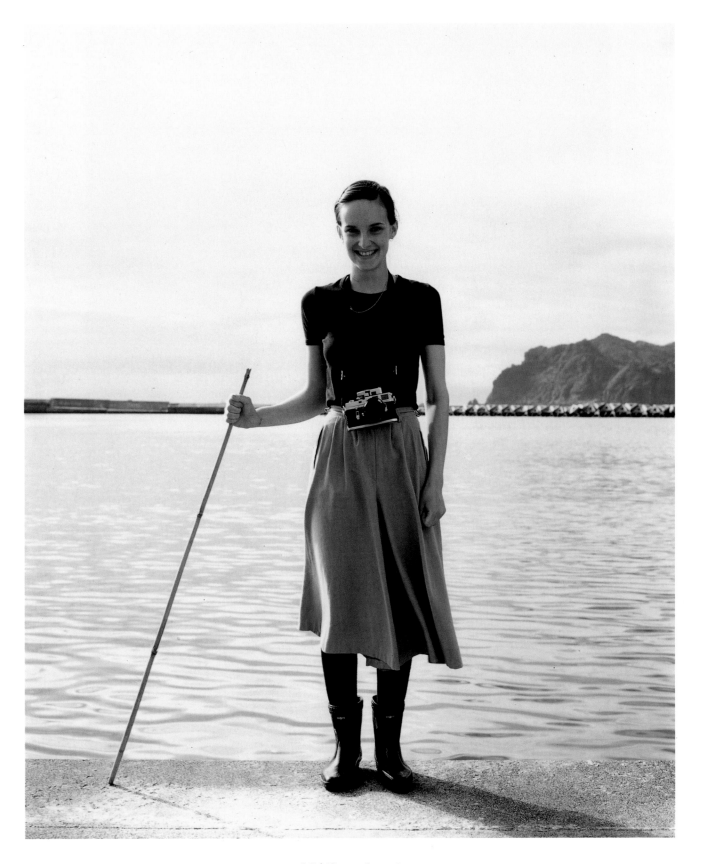

Seiichi Furuya, *Izu*, 1978

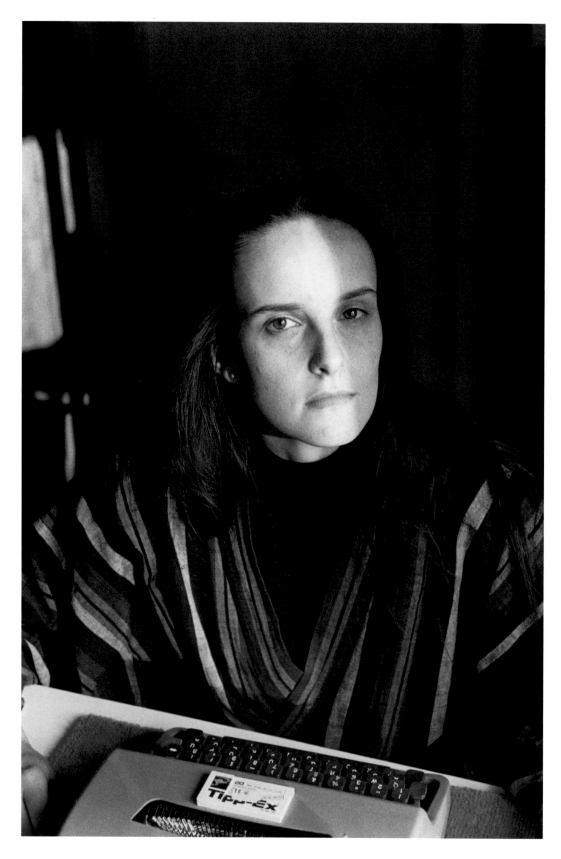

Seiichi Furuya, *82/8*, 1982

ing drama. In 1982 they moved to Vienna, where she enrolled in an acting program. Seiichi states that she worked so hard on her studies that she would inhabit dramatic roles for days on end, unable to free herself from the character. She would have difficulty finding herself, after a time. Often depressive, Christine found in her acting a format for manifesting, exaggerating, and externalizing some of her own dramatic sensations. In 1983 Christine was institutionalized in Graz and again later that year in Vienna.

In 1984 Seiichi was hired to do translations for a construction company in Dresden. After the move, Christine's depression deepened and her behaviors became more erratic and dangerous. She would occasionally disappear from the apartment for hours in the middle of the night with the baby, unprotected from the cold winter chill. She was repeatedly institutionalized and medicated. A series of rallies and relapses was repeated through 1984 and 1985. In March of 1985 the family moved to East Berlin, where, in October, Christine committed suicide by jumping to her death from the ninth floor of their apartment building.

Furuya, who has now spent more than half his life in Austria, is in permanent exile there. He has spent many years working on the Christine photographs — as many years after her death as he spent with her. He has stated in interviews that it is a way of keeping her alive in his daily activity. "Except only one of us ages" he says with a wistful and shy smile.[3] She was an actress and wanted to be seen and identified for her intensity. He has stated that he feels he owes her visibility.

The camera was their constant companion. Never was there a formal photographic session, though some images seem formal enough to have been staged. The story of their life in pictures is a family album of the poses and conscious staring of a performer, and what a playful performer she was. As their love and life together progressed, Furuya was a devoted audience for her effervescence, as well as her intense delusions.

Furuya, faced with nurturing a very sick wife and raising an infant son, leaned on his camera, perhaps as a crutch, a shield, a diary, a compass. Perhaps the constancy and depth of his wife's disturbance made its picturing inevitable. Perhaps it was a tool to deal with her volatility. Perhaps the camera allowed him some momentary distance or provided a bit of control over that which he couldn't readily control. Perhaps Christine Gössler, herself, allowed the camera to provide a sense of safety, a stage on which her actions might be understood to be simply dramatic. The naked revelation of Furuya's work is unique, agonizing, and brutal. Since her death, not a day passes without his involvement in these images. He has produced three books based on his wife, including one

from 1997 (*Christine Furuya-Gössler Memories, 1978-1985*) with two hundred sixty-five images.

He says: "Every day I work on this, every day I am with her. I know I can never really work this out, but I like that now. She is still with me. She is still thirty-two years old. For a long time it was impossible for me to see the pictures — I ask her in my mind . . . 'I will try to show you everywhere. I will do my best . . . to do it perfect in my way.' I try to get her permission. She said OK. Then maybe I can go on to do other things. This is the way to prolong her life."[4] He referred to it as a "sad trial" for him.

Furuya created several hundred photographs of Christine Gössler, with friends, with family, on outings, laughing, vamping, bathing, acting. The photographs are casual but very cleanly organized. The randomness of the scene is reduced to a detail or two. She occupies the center of most of the pictures. Slowly and intermittently, over time, her intensity, seriousness, and depression emerge. The pictures, even the most pained, are shot intimately and at close range. Furuya's distance to his subject is the physical distance of trusted family. This, then, becomes our viewing distance as well, and often it seems too close. Chronically unstable people easily acquire all the extra space they might care to occupy. Few others desire their company. More often than not they are abandoned. Furuya's depiction seems both intensely involved and yet objective. We inhabit Christine's space, though we may be uncomfortable. And just like Furuya, we can do nothing to slow her decline.

As Christine's illness reached its zenith, in 1985, she appeared exhausted, nearly spent, and yet in a semispiritual state. The golden iconic image of her seated on the floor against a wall with her hair shorn is the image of a saint ready for her apotheosis. She looks up enveloped in golden light. Her entropic free fall is no longer in evidence. Her face is bone thin. A shadow seems to shackle her legs. A saint's halo has fallen around her neck. It was one of the last photographs of Christine Gössler.

Furuya's cumulative portrayal of his wife's life has generated much interest, but audiences are most fixed on her suicide. The early pictures of their life together are casual and tender. The images of her sad unraveling are hard to digest. They are unnerving in their honesty, in their intimacy. They make us acknowledge our voyeuristic impulses. But they still cling to the boundaries of propriety for us.

It is the final enlarged contact sheet from 1985 containing the images of her death that is unbearable. Furuya had made a portrait of Christine and Komyo, then four years old, on an outing the day before. Then he shot the first half of the frames from the television screen — a military parade commemorating the thirty-sixth anniversary of the establishment of East

Germany. Then there is a window open and shoes neatly placed under it. Then an image taken from the window of Christine's body, dead, nine floors below. The next frames are from the ground. A blue blanket covers the corpse as a policeman stands guard over it. Then there is a frame of the Millet painting "Angelus," which provided a pious backdrop to a lovely portrait of Christine and Komyo taken earlier that year. There are frames showing an empty bed, and some other images of random household details, a kind of stuttering emptiness. There is a sense in these frames of dazed automatic activity of photographing anything near his eye. Raking, but not seeing details. How can he show these pictures? How could he have taken them?

"It was our life. Making pictures was one part of life," he says. They never looked at the pictures of her, he never enlarged them during her life. She never saw any of the prints. "It was the way we connected, a part of our relationship, a way we enjoyed each other. She never said 'Don't take pictures' and I never said 'Let's take pictures.' "[5] They exposed film and put it away in a box for another time, another life.

He had been aware she might try to kill herself. She had once asked him if he thought a nine-floor fall would kill someone. They lived on the fourth floor of a nine-story building. While watching television and playing with his son, who was four years old at the time, on a quiet Sunday afternoon, he sensed things were too quiet. He had a sudden premonition and went to the top-floor hallway to investigate. On the ninth floor he saw the open window and heard a dull thud. When he saw her body below, his first, brief sensation was one of relief for her — "It's over for her now, it's the end, all her difficulties are gone away."[6] He made a photograph. He returned to Komyo and said, "Your Mommy is dead. He asked me if I killed her. I made a big mistake. I said yes. I felt maybe if she had not met me it wouldn't have happened. I still feel that way now. I'm not one hundred percent guilty, but I still have guilt. I took pictures, just normal, then I went downstairs and took more pictures. I try to speak to Komyo now about his mother. He was very confused then, he was four, now he is seventeen. By blaming myself I can find absolution."[7] When the police investigated Gössler's death, Furuya again said he might have killed her. The police recognized his statement as grief and concluded she was a suicide.

She never actually threatened suicide. "It was too dangerous to talk about it because it's reality. It's no joke or story. During her illness, he [Komyo] was just a baby and a young child. He saw everything, there was no way to protect him from what she was going through. She stayed alive partly for Komyo. I try to rethink what I did. Maybe I could have done something different to get a different outcome. But that is only a way to destroy myself."[8]

It is far too facile to attempt to judge the participants by the scant evidence of highly edited photographs, yet the gravity of these photographs connects the images to old arguments in the field about the camera's capacity to invade another's world and also to anesthetize its operator to any horrors in the ground glass. Christine's anguish begs us to help. We share the anger, frustration, terrifying impotence of the artist. Anyone who has ever been close to a suicide understands the lifelong second-guessing, slow-motion replays, and the extreme plague of "if-only" recriminations. Furuya is explicit about this.

This intense and determined woman fought bravely for stability and normalcy. The exact role played by her husband in her survival/disintegration is unknowable and is finally not in the public precinct — the contribution of these pictures to photography is. In Europe, in the United States, and in Japan, where these photographs have been seen, they are cause for intense discussion. The images cannot be disconnected from their story. The meaning that they alchemize from the life and death of a woman, and her husband's perceptions about it, are certainly unique in the "art history" of photography.

Furuya doesn't consider himself a photographer but rather a writer with a camera. He writes articles for a Japanese magazine about Central European culture and political life. His photographs accompany the writing. Now, however, his photographs of Christine are dominating his reception. In October of 1997 there were nine simultaneous shows in Tokyo and Yokohama of his photographs in various galleries and museums. More than five hundred pictures of his wife were shown. He has become a charismatic and somewhat tragic figure. He is rarely in Japan and his mysterious persona gives him the difficult freedom of an exile. "I am idealized in Japan," he states, "because I escaped from Japan."

In 1999 he will release a three-volume book called *At Home in East Berlin*. One volume is entirely photographs shot from the television. The other two volumes identify the vision of the outsider — a stranger, an observer, an editorialist, a nonparticipant roaming the streets and making visual and intellectual connections. The Gössler pictures are so close, so intimate. They identify a different image-making vocabulary.

He feels at times that after he photographs someone, they die. He photographed East Berlin and it died too. Something of himself, something of the way in which he relates to others, and to places, has died with Christine, and cannot be reborn. Furuya has never had a serious relation-

ship with another woman since her death. He lives with Christine's mother, who helps him raise his son.

To say there is a dark side to his photographs from the past years is to miss the point. His books intersperse images of his wife with pictures from slaughterhouses, the Berlin Wall, Dachau, embers of a dying fire, a dead mouse, a cracked ceiling with dust and a crumbling image of Christ, a bloody table with a knife, gathering rain clouds, a dead bird covered with flies, a window with streaks of raindrops. His images are equal parts observation and memory.

He has made large portraits of refugees from Bosnia, straightforward mug shots against a bright sulfuric-yellow backdrop. These consistently sad and personal pieces are not full statements but fragments of a tragic poem — the phrases of an exile in a world vastly different from the one he grew up in. A land riven by its own political divisions. A culture from whose language and mind-set he is inevitably separated and excluded.

There is an unbridgeable gap between this man and all others. The depth of his pain attests to it. One senses a wound, unhealed, deep within him. He has the gentle quietude of one who has been broken. He is incapable of small talk and frivolity. He is surrounded by borders and memory. His wife, his country, his language, his son, other nations, all are separated from him to varying degrees. The camera is the recorder of time and thus assembles for us a visual diary of these gaping tears in the fabric of a life — and shows us the beauty and the pathos of the weave. The shroud of alienation, tattered though it may be, protects something precious and vulnerable. It has become a home for him.

Seiichi Furuya, *78/32, 1978*

Seiichi Furuya, *79/79*, 1979

Seiichi Furuya, *80/97*, 1980

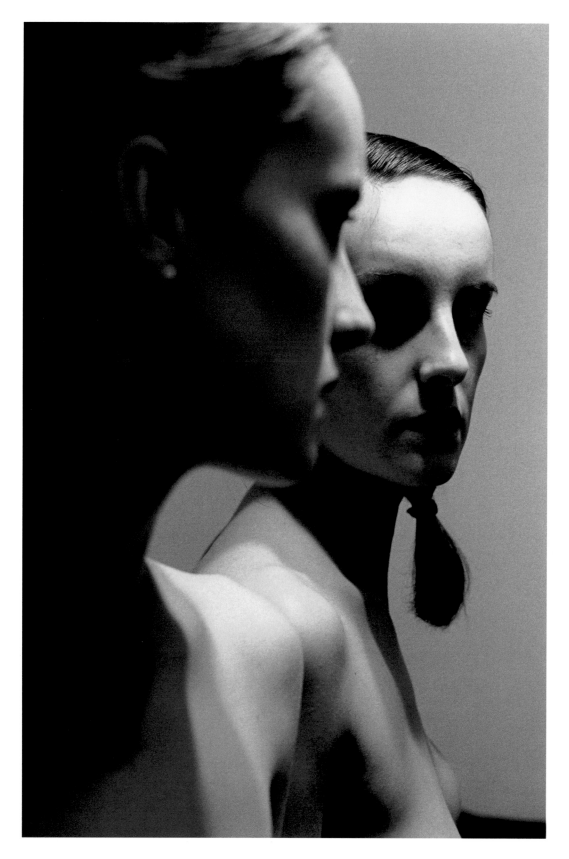

Seiichi Furuya, *80/10*, 1980

Seiichi Furuya, *81/27*, 1981

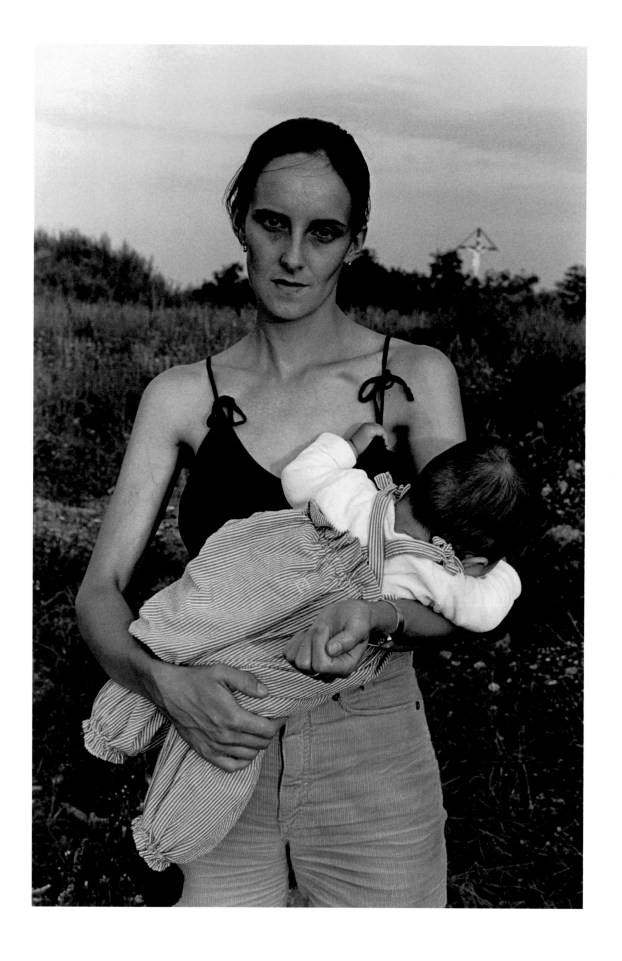

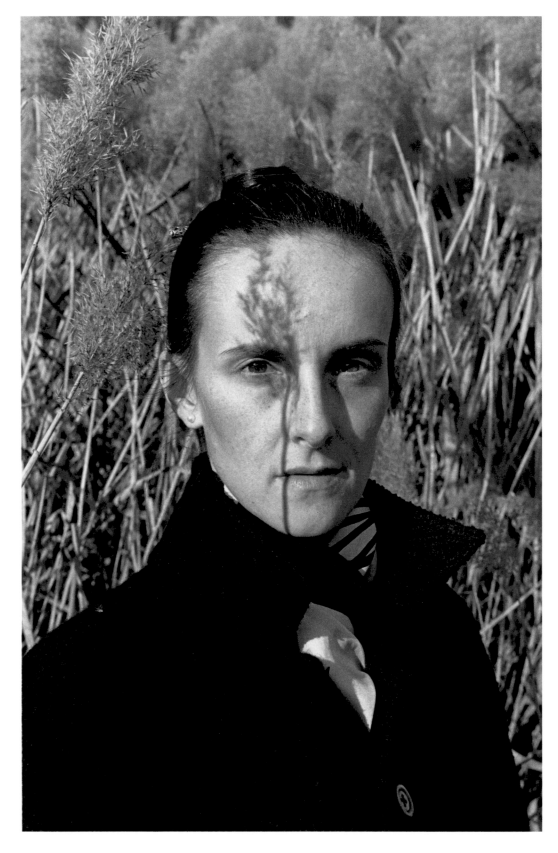

Seiichi Furuya, *81/61*, 1981

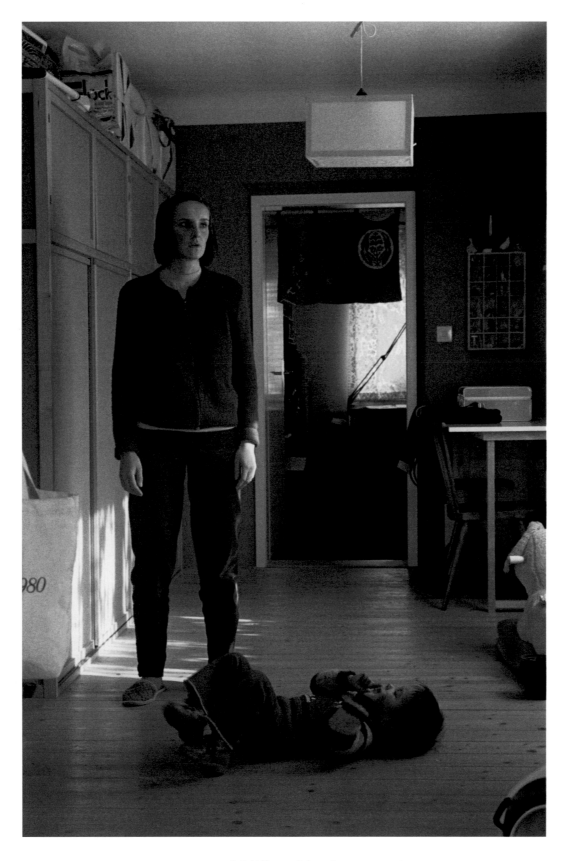

Seiichi Furuya, *83/97, 1983*

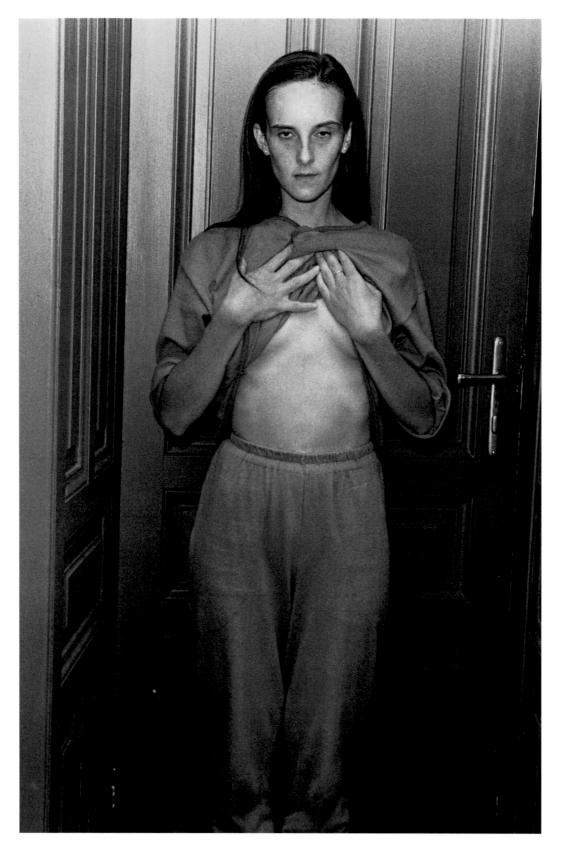

Seiichi Furuya, *82/31*, 1982

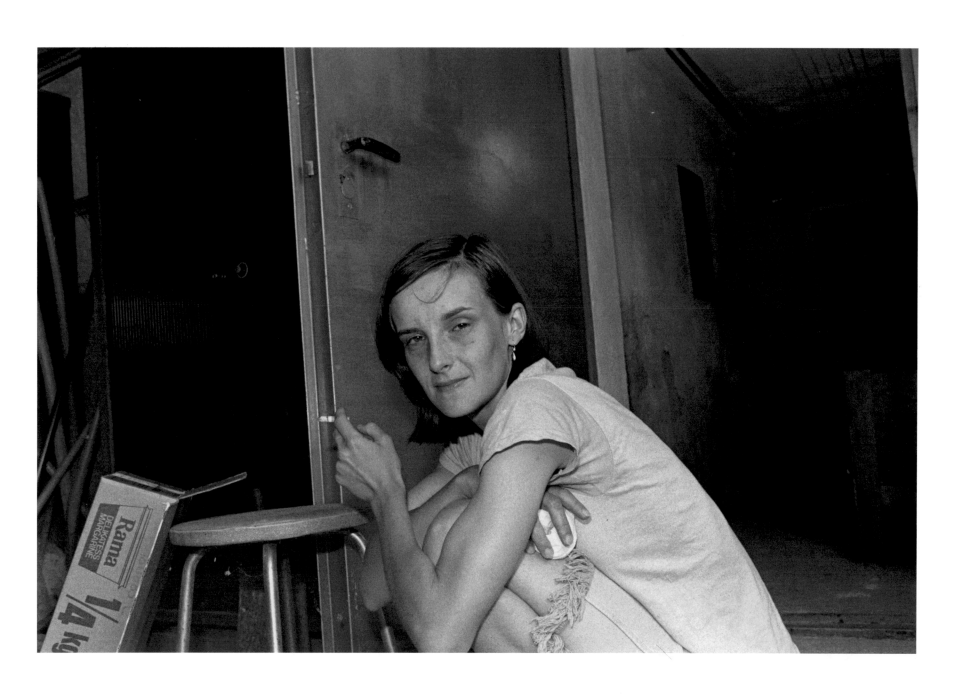

Seiichi Furuya, *83/76*, 1983

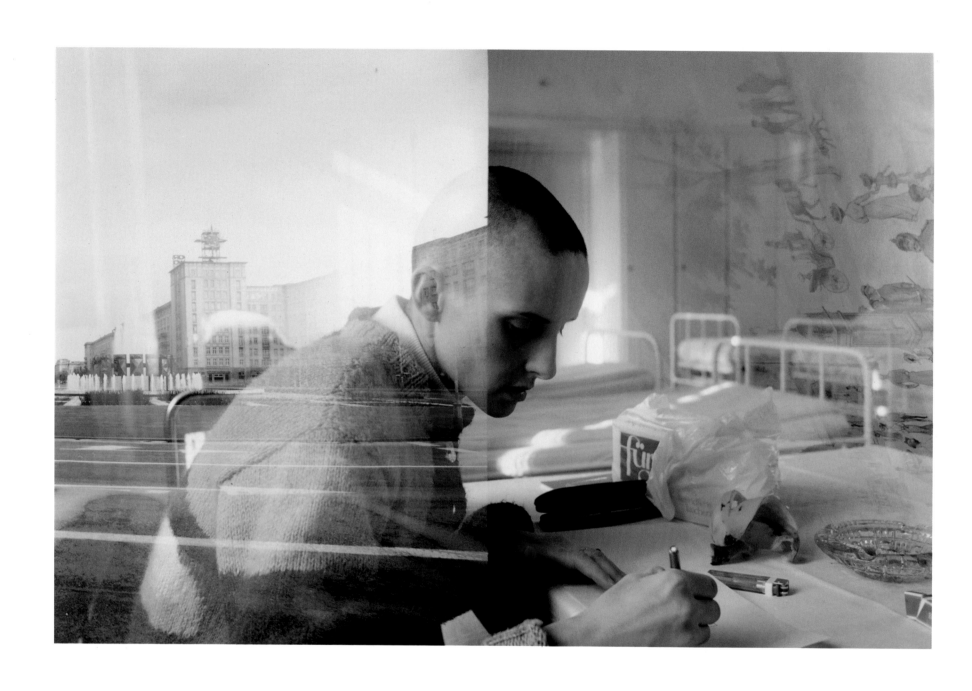

Seiichi Furuya, *Untitled*, 1985

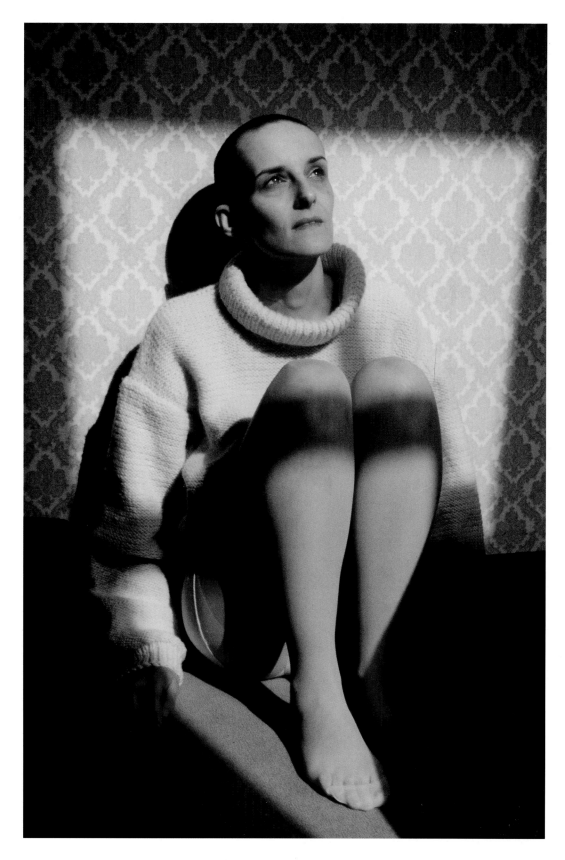

Seiichi Furuya, *Untitled*, 1985

Seiichi Furuya, *Untitled*, 1985

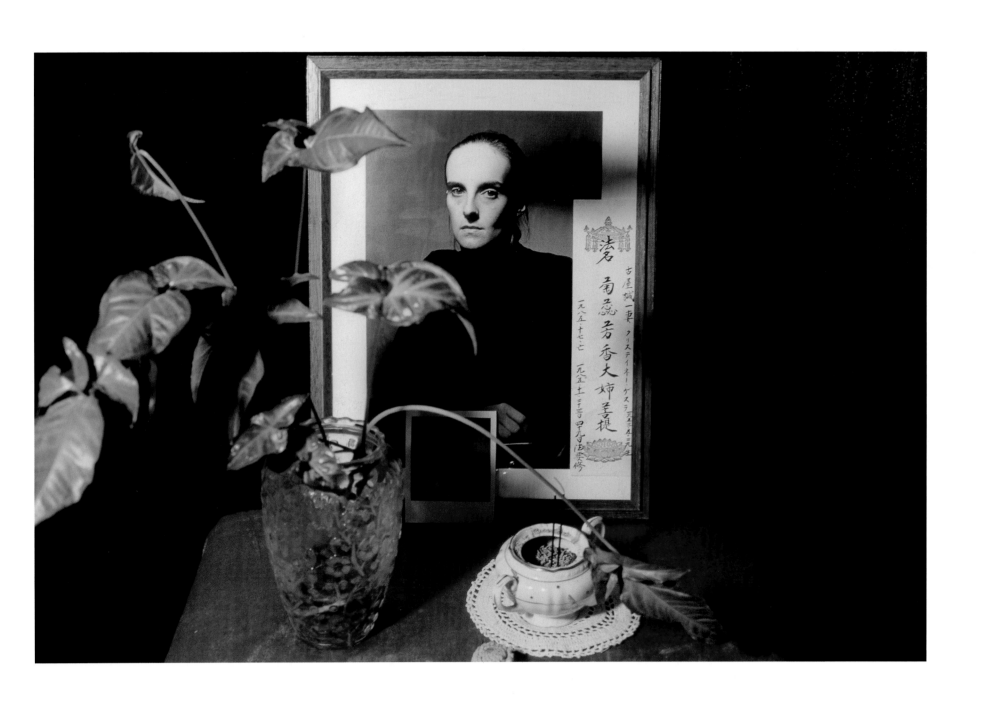

Seiichi Furuya, *Untitled*, 1985

NICHOLAS NIXON

NICHOLAS NIXON SPEAKS OF HONOR. "I'm honored to be using the same methods as Atget, as Walker Evans. I want to honor what is possible. I'd like to go deeper, get closer, know more, be more intense and more intimate. I'll fail, but I'm honored to be in the ring trying. I'd like to go deeper than Stieglitz did about his marriage. It's arrogant, but I'd like to try."[1]

Nicholas Nixon speaks of trust. "I trust photography. I trust my ability to challenge it and it to challenge me." And he speaks of obligation. "I have the good fortune to be married to someone for twenty-seven years. I have an obligation to try to tell a story about it. I want to show more about her; about us."[2]

This earnest man has cast his lot with the long tradition of photographers for whom distilled visual description is the road to understanding. For them, subject matter is not simply a personal observation, a casual idea, or an appetizer for the eyes. It is the thing itself. It embodies truth. It is the vessel of wisdom. "No ideas but in things," said William Carlos Williams — a notion sufficient to propel someone who lives through a lens.

The large view camera calls upon all its employers to exercise consideration. It is a tool of deliberation, concentration, and attention. In return for these investments it delivers veracity, tactility, and miraculously trustworthy atmospheres. Its silvery "thereness" can be palpable. It is rarely spontaneous, never candid. It is famously cruel to those with low tolerance for accurate rendition. An attractive face can, on intimate consideration, translate to topographic fissures, cratered pores, and eroded passages, more akin to NASA reconnaissance. This photographic weapon can fill an 8x10 frame with a couple of inches of skin — violating anyone's right to deteriorate privately.

Such technology, in the hands of an artist who wishes to render his loved ones with unflinching accuracy and evoke their tactile presence, is the perfect instrument. The apparent veracity of the large camera is such that it seems to make facts of one's observations and opinions.

Stieglitz's close-up portraits of O'Keeffe were often done with an 8x10 view camera. The slow emulsions of his day required exposures of several seconds and there is often a softening of the texture of the face or body caused by slight movement during exposure. Nick Nixon has worked from the 1970s to the present with the same camera technology but faster film. The facial features of his wife may thus be seen more clearly than by eyesight and be reproduced in life scale. His photographs place us intimately and at times uncomfortably close to Bebe Nixon. These intimacies make participants of viewers and deny any sense of remove. Nixon fills the frame with her face, her shoulder, or her arms. His is a devoted lover's proximity and so ours becomes that also. It is easy to imagine Nick Nixon as a young boy with a new magnifying glass, fascinated by his omnividence. "The world is infinitely more interesting than any of my opinions about it," he wrote in 1975.[3]

Robert Adams writes in his introduction to *Nicholas Nixon: Photographs from One Year:* "It is the large scale of Nick Nixon's purpose, not his 8 x 10 camera, that distinguishes him. He has taken on the hardest job of all — to convince us of the worth of our lives."[4]

Beginning the portrayal of Bebe Brown Nixon in 1970, a year before they married, the Nixons are still actively working on it. The images are more reserved than those of Gowin or Fukase. Though they involve intimate, face-to-face scrutiny, they are not sexual. They are discreet, dignified, respectful. In fact they hold a great deal in reserve. They haven't the casualness of Friedlander's observations, or the Southern rural poetry of Gowin's early vision. The images speak of regard, the camera a sort of bridge with power shared on both sides of the film. Bebe Nixon seems often to be looking back at the lens just as intently as we suppose the photographer might be looking at her, and so by extension, our own gaze

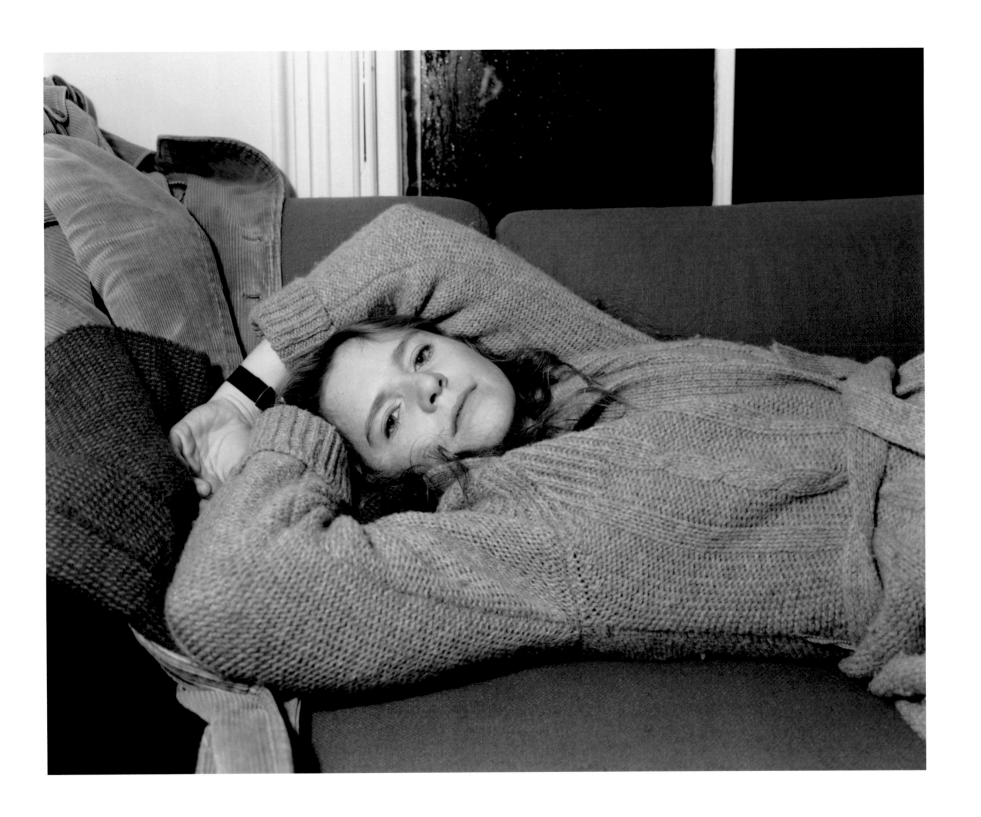

Nicholas Nixon, *Bebe, Cambridge,* 1978

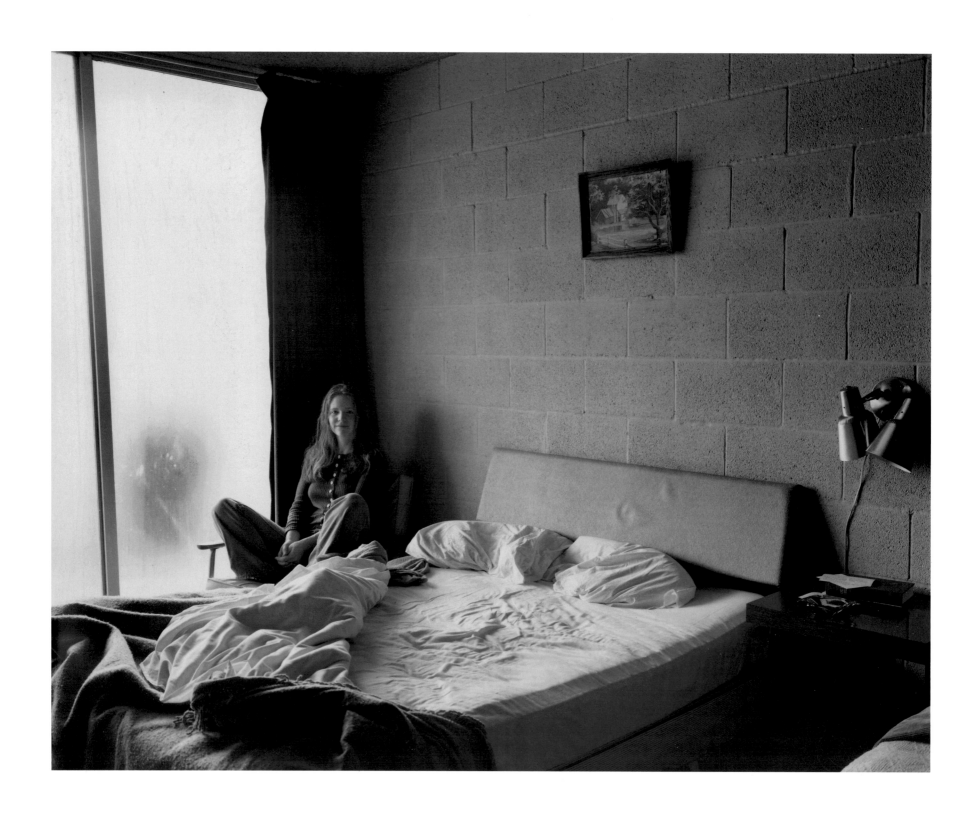

Nicholas Nixon, *Hogdenville, Kentucky*, 1972

is properly serious. Ms. Nixon is not, like O'Keeffe and Charis Wilson, decades younger than her spouse. She is not flamboyant like Yoko Fukase, nor is she openly willing to expose her body or its functioning to any audience. One feels that would unsettle both the artist and the model. This is a couple with a powerful sense of propriety. As Bebe Nixon states, "Photography is so common that people feel they understand what they see. They presume to bring a vocabulary to the viewing as though they have a relationship to the pictures, and the content, as though they know more about what they are seeing than they do."[5]

Bebe Nixon is a documentary filmmaker. For fifteen years she worked on and eventually produced Public Broadcasting's *Nova* series for WGBH in Boston; since 1985 she has worked on nonbroadcast documentary educational films. She too has a life lived through the lens. It would be hard to identify a couple more attuned to images on film. Far from being intrusive in their life, the camera provides a mode of understanding and of sharing insight.

In his 1988 introduction to *Pictures of People,* the catalog of the Museum of Modern Art's exhibition, Peter Galassi states of Nixon: "The self-evident mastery of craft, the flourishes of style, have dissolved into lucid unembellished description. If Nixon began with the most basic artistic motive — to make something clear and beautiful and new —that motive has transformed itself. Making pictures has become a way of finding a path to the heart."[6]

Nick Nixon shows genuine affection for the textures of his wife's skin, freckled and lined. He fills the entire frame with a part of her or fragments of their children. With such exactitude and precision one might expect an analytical flavor from his photographs, yet instead, one senses a long, languorous, and even voluptuous caressing of a beloved topography. His wife's surface is savored in great detail. That skin is a home to him — a place for solace, play, and also for honor and respect. No one since Stieglitz has so intimately placed his lens in relation to his wife. These intimacies identify Bebe Nixon's trust in her husband as much as they point to Nick Nixon's responsibility. Placing a huge view camera so close to anyone triggers a sense of invasion and necessitates some form of agreement. In the end we know her both on the microcosmic level and as the whole person who stands beside Nick Nixon the photographer. "It is generally her 'force' that I see of her. I'm mostly looking at the person who is my equal, moving along in life with me."[7]

Early pictures of Bebe Nixon feature eye-to-eye communication. Artist looks at model, model looks at artist. Love, curiosity, and even adoration, are shown from a distance — ten to twelve feet. Some context

is included: a couch, a chair, a corner, a bookshelf, or a bed. But always they are face-to-face. After a few years the images seem more intimate. The expressions somehow dearer, more knowing, declarative rather than curious.

Then the children arrive, and the pictures are very close indeed. The world of children is physically tactile, and these pictures are filled with the texture and context of raising infants: a tiny fist waved toward a huge chin; a freckled shoulder with an arm and elbow cradling part of a baby, a string of baby drool glazing an adult arm. There are enough images of the children to describe their growth and the occupations of childhood. We see Bebe tending to their needs, scolding them, and lying too wide awake next to them as they sleep. Their kids seem innocent, and vulnerable. Nick projects his wife as a powerful, protective, and very involved mother.

Nixon is still as enthralled as he was when newly in love, nearly thirty years ago. Yet the pictures with the children are statements, not questions. The artist is not the only focus of Bebe's life at this time and he seems to accept that. The balance of the family's affections has shifted. Fathers often find themselves feeling vestigial or unnecessary. Nick finds his place, and it is that of an involved father and an intimate witness. These refreshingly unique images of an evolving family during child rearing mix humor, pathos, poignancy, and sensuous poetry. The lustrous skin of a baby, the moist pools of their eyes, the voluptuous tuck and roll of their pudgy limbs are described with amazement. One senses that Nixon photographs to interrogate and preserve that which he can scarcely believe. In a 1985 image, Bebe's sweet smile, neck, shoulder, and upper chest provide a freckled backdrop to a single upraised newborn fist. In stunning simplicity Nixon identifies the ludicrous, undeniable infant proclamation "I am here," while the amused mother looks on, knowing both how inevitable his independence is and also how necessary is her provision for it.

Nick Nixon photographs his family in real activity, including the discordant and the disruptive. Bebe Nixon snarls angrily at a genuinely frightened and chastised youngster. It's not a staged moment, but such spontaneity is unexpected from large-format equipment. We expect the combat photographer to use 35mm. Nixon is a master at working with a huge camera without letting it call attention to itself. For years he did very close work with strangers. The entrée his subjects provided him is a rare and precious commodity, given only to one who can evoke trust in others. In most hands, the view camera can turn flesh to stone and annihilate a fleeting expression. Nixon captures quick gestures and sponta-

neous juxtapositions and brings them back alive. In his home the large camera and tripod have become just another piece of furniture. They are always around and therefore become invisible. They cease to be intrusive. Their operation is expected, like any other tool, say, a grandfather clock or a VCR.

Nixon is nothing if not earnest and frank. These characteristics are often thought of as passé, nearly comical. Yet, of course, they are still hard to earn, and they are essential to navigating a moral and useful course through life. This is the source of the veracity in his work.

He is famous for his continuing monumental portrait of his wife and her sisters, which has been released as a series (one image per year) since 1975. Each is a photograph of four women in the same lineup, each attentive and each looking at us. Confronting this imposing wall of apparently strong wills for more than twenty years, we feel not only acquainted with them but intimate. The great photographer Lisette Model often said, "The more specific the image, the more universal the meaning." As the sisters age and evolve in their own particular ways, we each see ourselves, our families, our era transforming over time. The sisters are growing older with us, providing a sort of public baseline on which to gauge our own progress. One can only imagine the complexity of the lives of this family of four women over these decades. And that is exactly what these images have prompted us to do. The family unit, its complexity, its profundity, propelled Nick's scrutiny. Bebe emphasizes, "The family has been a unit for a long time; a unit which drew the photographs to them, not the other way around. The family was there first. We are a group of aging women going through life together. The pictures still thrill me to look at them."[8]

In the early 1980s Nick Nixon photographed the elderly in a nursing home where he was a part-time volunteer. The images are rarely environmental; they are intense interrogations into aging. He made close-up studies of ancient, translucent skin ready to leave the bone, eyes wide with wonderment, terror, or simple muscular atrophy, and many other evidences of erosive aging. Nixon, at the same time, began his intimate pictures of his children, Sam and Clementine, born in 1983 and 1985, respectively. Using related ideas of composition, he examined newborn dimpled fingers and gnarled, shrunken, bony centenarian hands that seem covered in parchment.

In 1987 he began a series of pictures of people with AIDS. The subjects were repeatedly photographed through the last year or two of their lives. The progressions of images show relentless deterioration, familial care, and heroic perseverance. Some of the portraits are contextual, others are concentrated facial close-ups, allowing us no room in the frame for respite or escape. Aging and mortality are Nixon's motifs again. The images of the Brown sisters, the elderly, the children, and the AIDS patients all confront the passage of time. They are sophisticated referents to common family pictures. Nixon is not trying to invent a new sort of photograph. He is, however, trying to seize the tradition and express in a more aware way what we all hope our family pictures show — just how profound bonds of family are. If one studies random, anonymous, family albums, as many curators have done, one becomes accustomed to seeing the occasional inexplicably elegant, poetic photograph. A moment in which the film mysteriously exposes deep into the subject as well as the photographer.

Honor, trust, obligation, fit well with a man who wants to carefully bring his viewers into his life. We, in turn, feel honored, trusted, and obliged to carefully address his vision. There seems no scrutiny that is too close, no rendition too honest. Bebe Nixon is monumental, even heroic in her depiction. The photographs from 1997 and 1998 are so close that context is no longer an element in them. Half of a face now makes an entire image. Nixon himself is seen entering the frame with his wife. He looks back at the camera as though it was being operated by another. He has crossed over to her side to identify himself where his heart is. He has managed to find a relaxed and natural way to slip into the picture alongside his wife. It is appropriate to images which purport to record a relationship that both members be present. Bebe states, "To a degree, his pictures reflect what he thinks the world is made up of. Now he is in the frame. He seeks order and connection. And in our life that is partially how it looks."[9]

In the traditional triad of art, an artist, a model, and a viewer, each has an assignment. In Nixon's newest works, the audience may begin to feel the discomfort of being left out. The frame has absorbed two of the three participants, leaving us alone on the outside. Or is Nicholas Nixon simply more comfortable at his wife's side and has he found a more direct way to show it? Perhaps he is illustrating what each of these portfolios identifies; that the bonds between such couples are, in the end, invisible, discernible only through metaphor and symbol. The two partners, in a single frame, collaboratively form their own image, in their own space and time. As Nixon's own self-portrait migrates through the camera to join his wife, he seems to be climbing inside his own process, to find from the inside out an even closer and more intimate understanding of his wife.

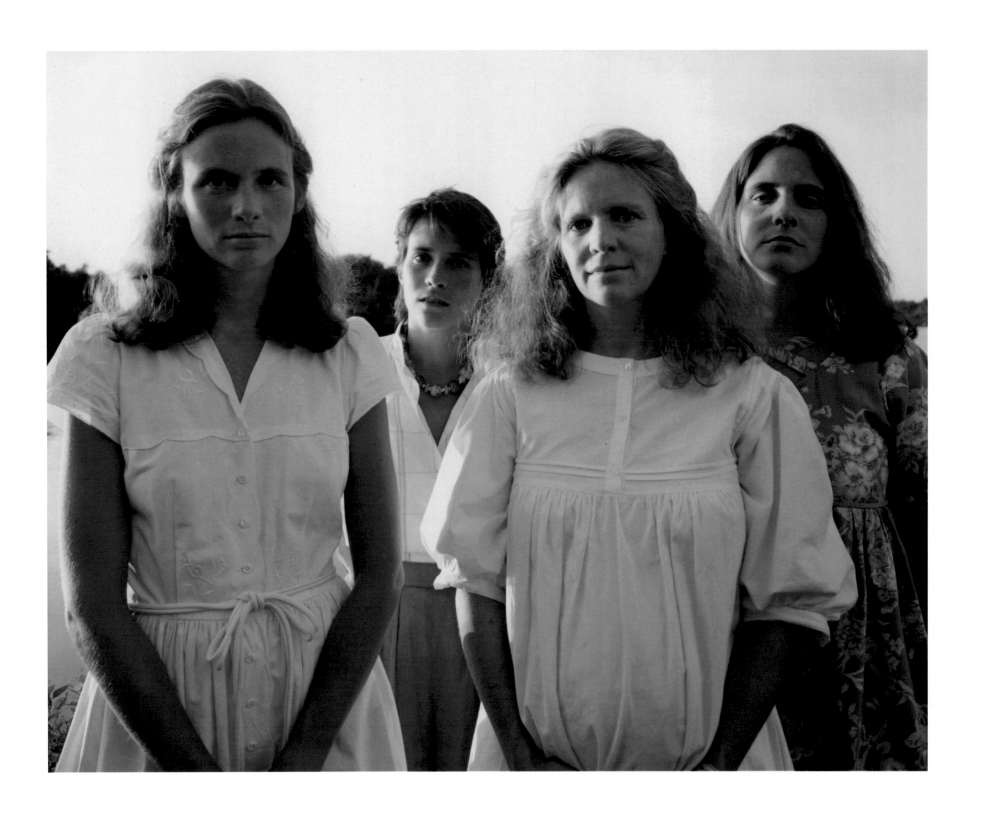

Nicholas Nixon, *Brown Sisters*, 1983

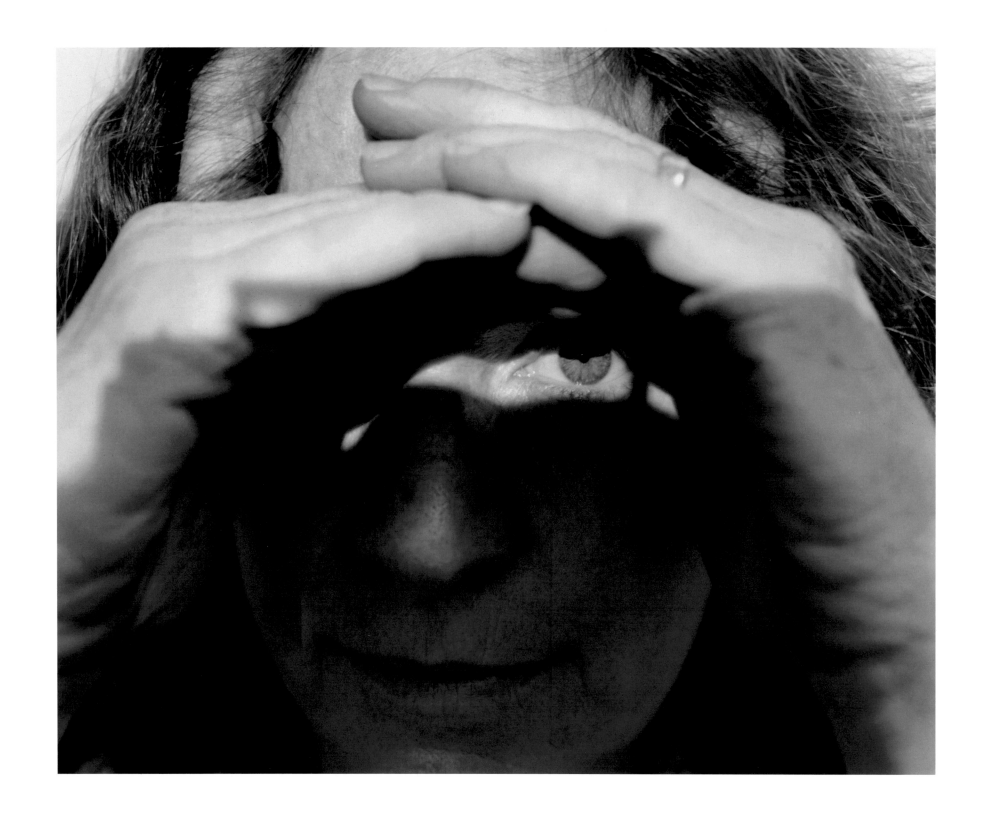

Nicholas Nixon, *Untitled*, 1996

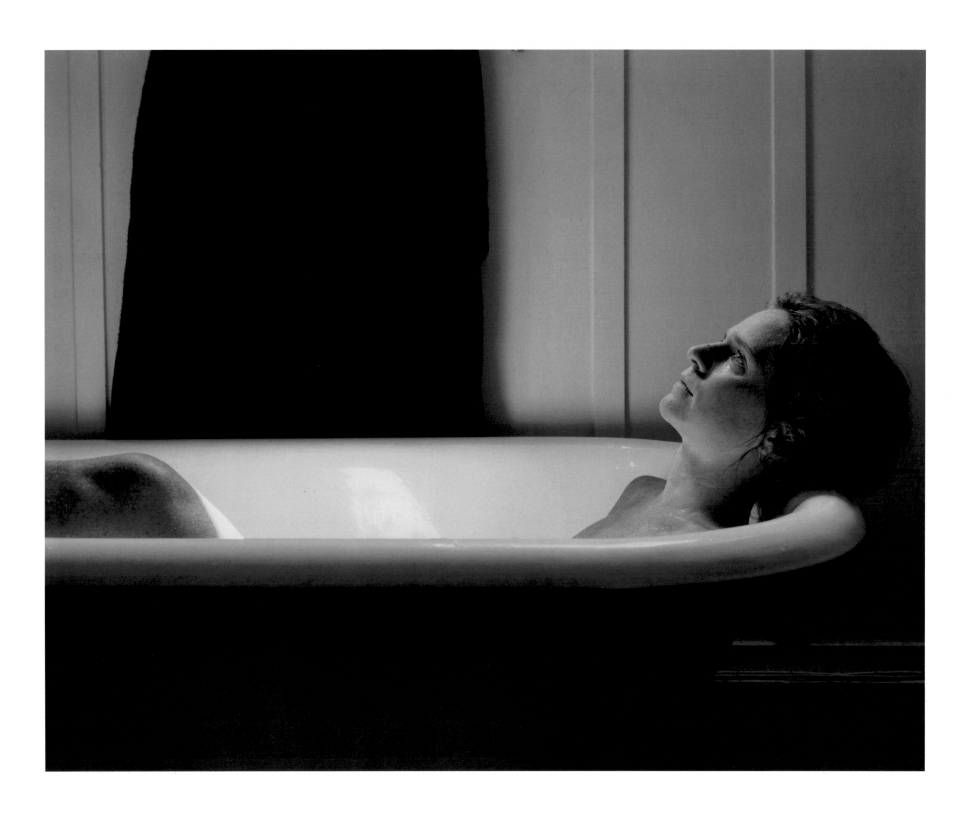

Nicholas Nixon, *Bebe, Cambridge,* 1980

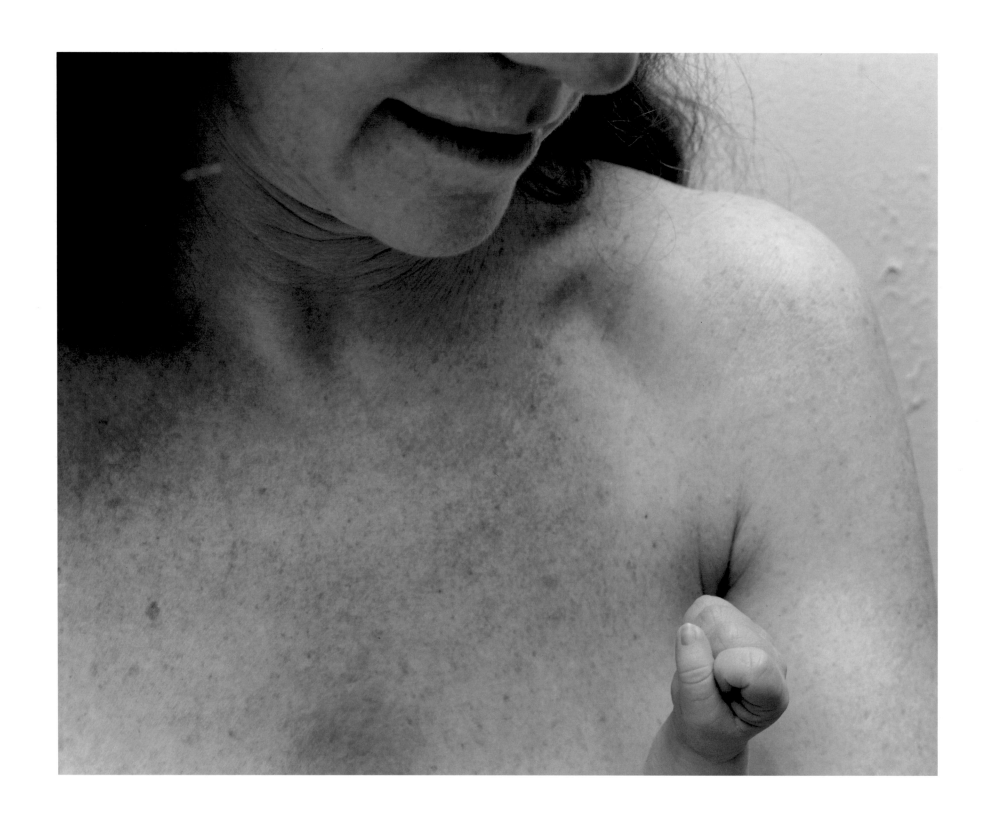

Nicholas Nixon, *Bebe and Clementine, Cambridge,* 1985

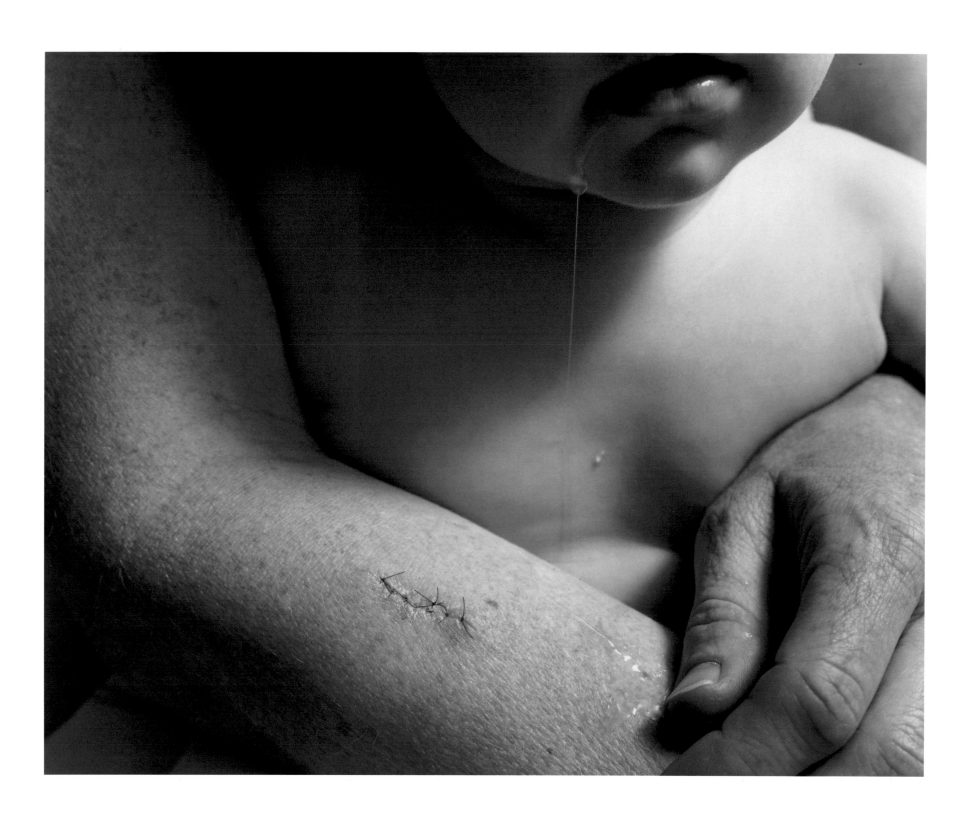

Nicholas Nixon, *Cambridge*, 1986

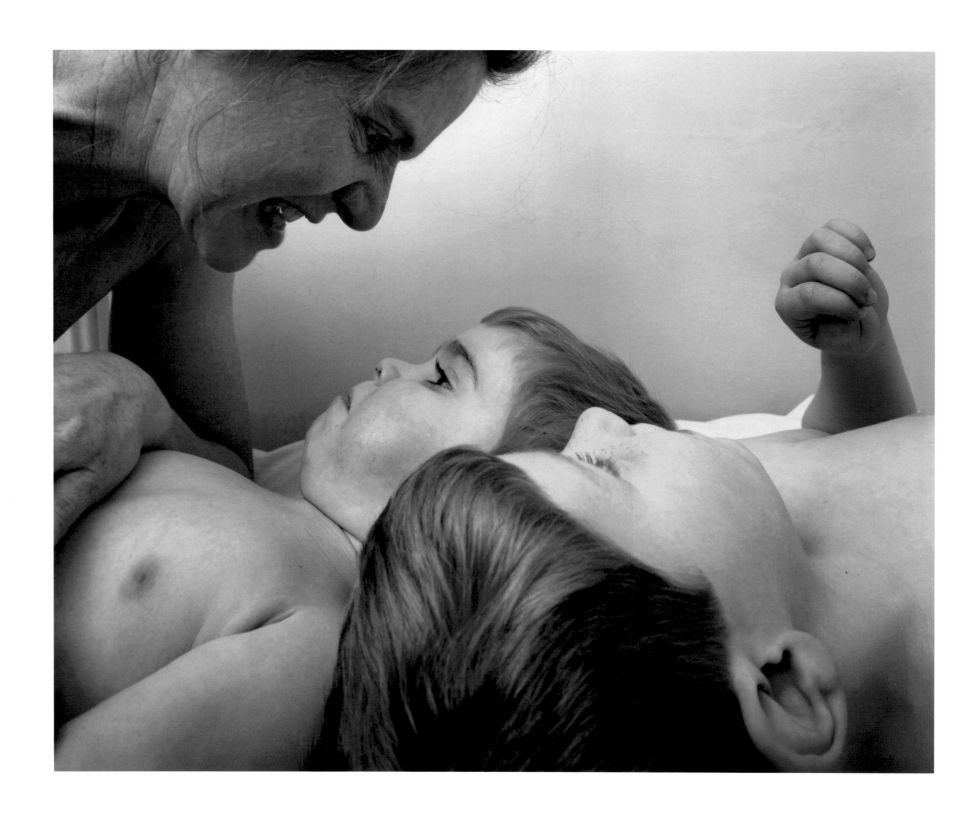

Nicholas Nixon, *Bebe, Clementine and Sam, Cambridge,* 1988

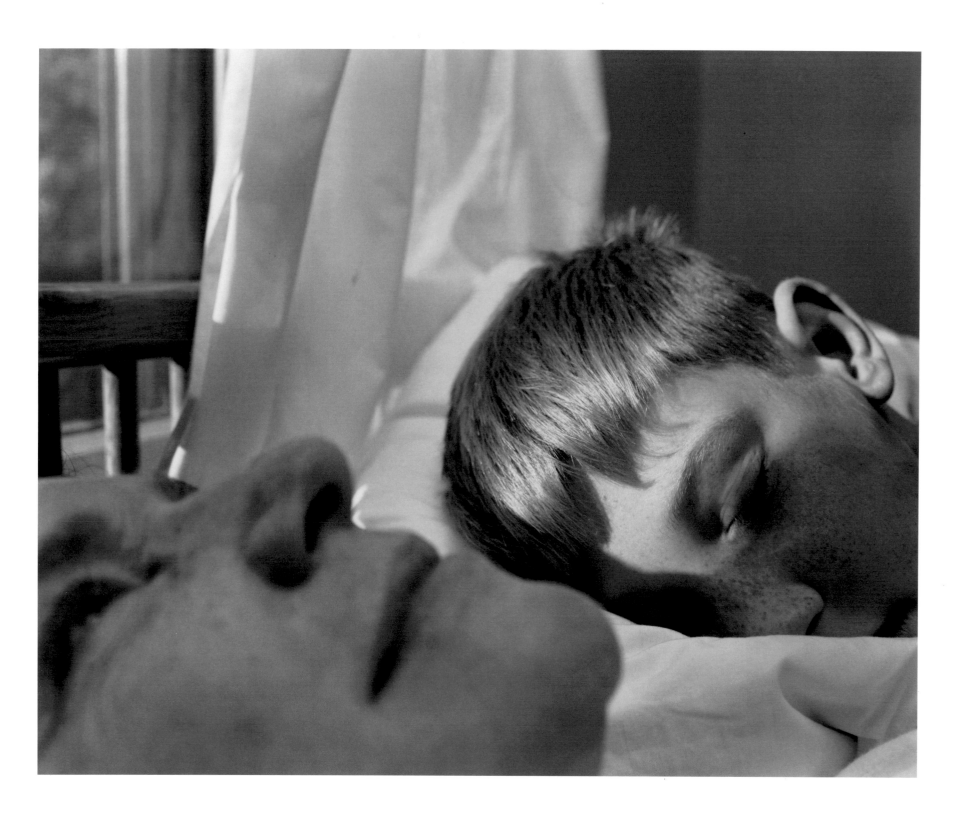

Nicholas Nixon, *Bebe and Sam, Lexington*, 1995

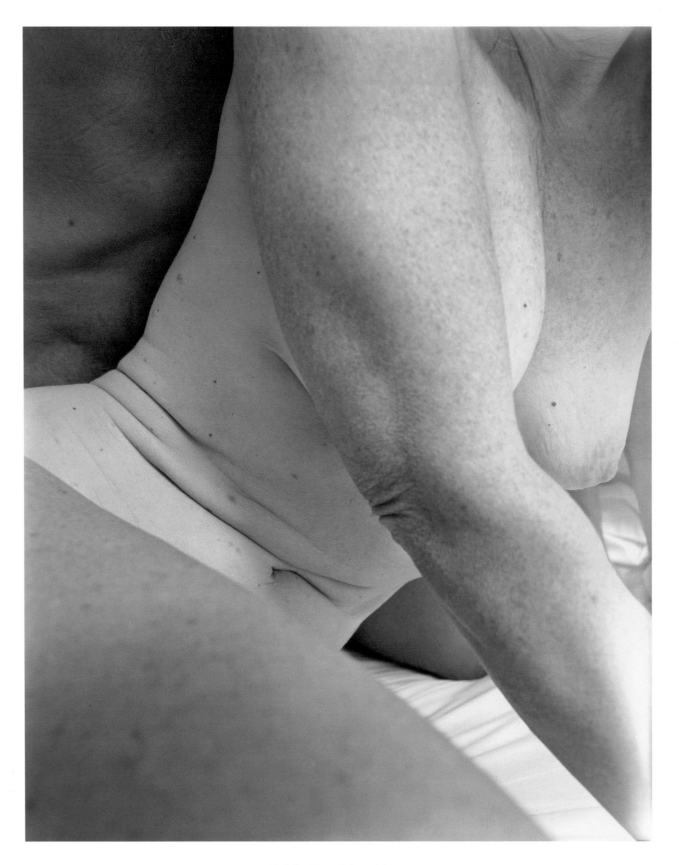

Nicholas Nixon, *Bebe and I,* 1998

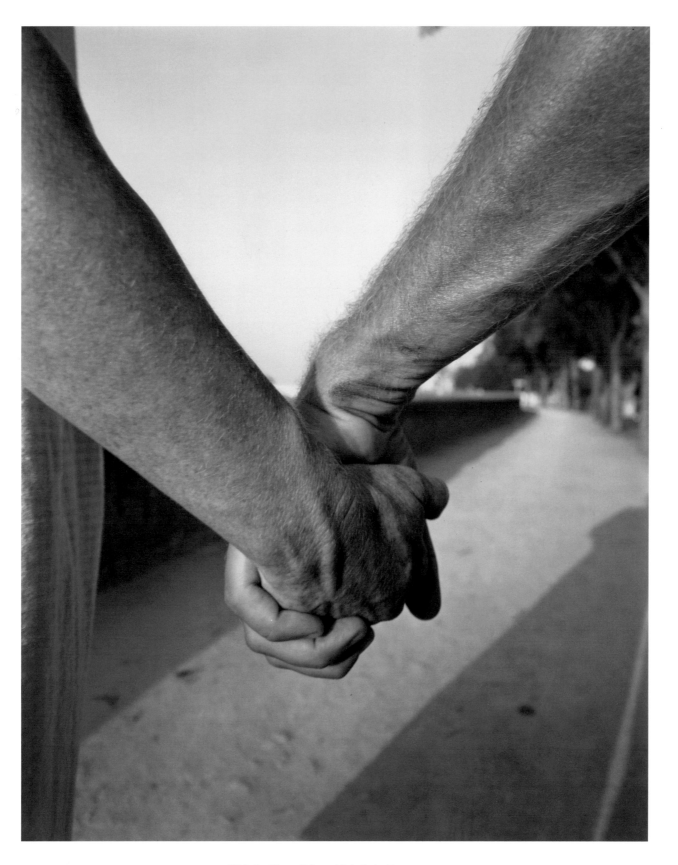

Nicholas Nixon, *Bebe and I, Amboise, France*, 1997

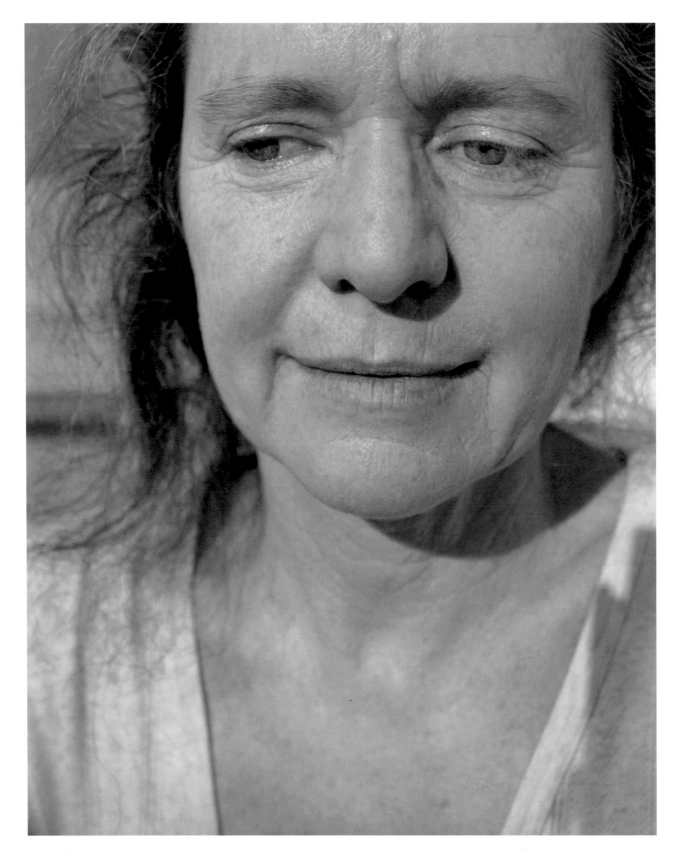

Nicholas Nixon, *Bebe, Lexington*, 1998

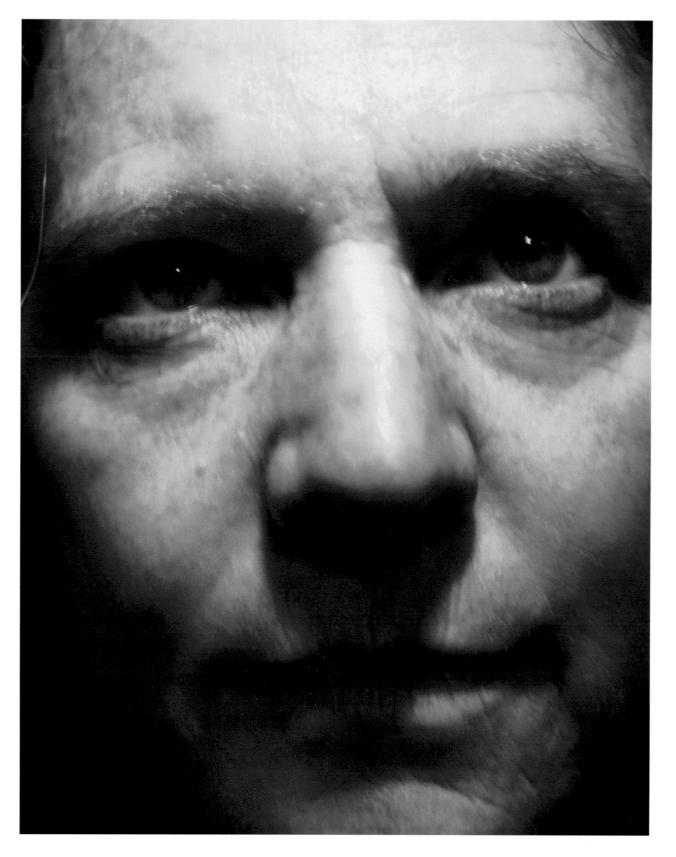

Nicholas Nixon, *Bebe, Lexington,* 1997

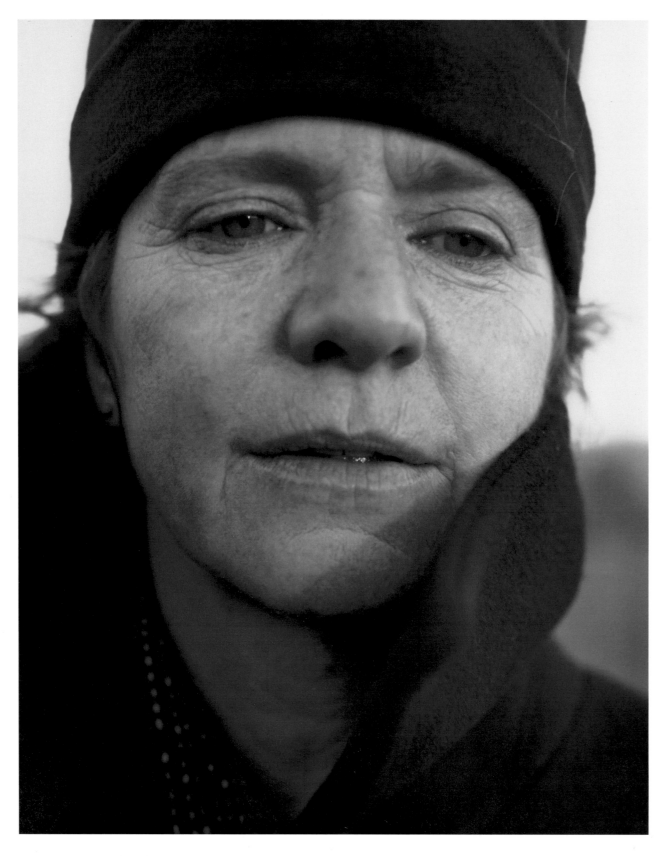

Nicholas Nixon, *Bebe, Lexington*, 1996

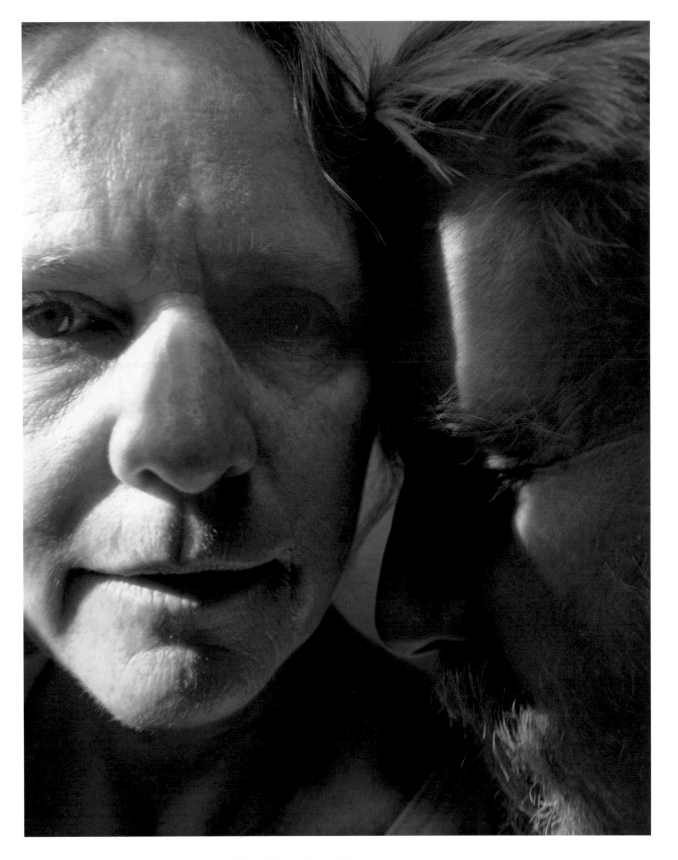

Nicholas Nixon, *Bebe and I, Resest des Brosses*, 1997

NOTES

Introduction

1. *In the American West: Photographs by Richard Avedon* (Fort Worth, Texas: Arron Carter Museum), 1985, n.p.

2. Vicki Goldberg, "In the Game of Portraiture, the Photographer Almost Always Wins," *New York Times,* March 13, 1994.

3. Linda Nochlin, "Cezanne: Studies in Contrast," *Art in America* (June 1996), p. 56.

4. Alf Erdmann Ziegler, "Despised Pleasures," *Art in America* (January 1996).

5. Donald Bachardy, *The Last Drawings of Christopher Isherwood* (London and Boston: Faber and Faber), 1990, p. xviii.

6. Nancy Dine, "Sitting," in *Nancy Outside in July: Etchings by Jim Dine* (West Islip, New York: ULAE), 1982, n.p.

7. Roberta McGrath, "Re-Reading Edward Weston: Feminism, Photography and Psychoanalysis," *Ten-8* 27 (1987), p. 30.

8. Arlene Croce, "Onward and Upward with the Arts: Is the Muse Dead?," *New Yorker* (February 26 and March 4, 1996).

9. Ibid.

10. Ibid.

11. Bebe Nixon, telephone interview with the author, August 5, 1998.

12. Ibid.

13. Eleanor Callahan, interview with the author, Atlanta, Georgia, February 28, 1997.

14. Maria Friedlander, interview with the author, New City, N.Y., August 8, 1997.

15. Charis Wilson, *Edward Weston Nudes* (Millerton, New York: Aperture), 1977, p. 8.

16. Susan Sontag, *On Photography* (New York: Farrar, Straus and Giroux), 1973, p. 15.

17. *Georgia O'Keeffe: A Portrait by Alfred Stieglitz* (New York: Metropolitan Museum of Art), 1978, n.p.

Adolph de Meyer

1. Anne Ehrenkranz, *A Singular Elegance: The Photographs of Baron Adolph de Meyer* (San Francisco: Chronicle Books and the International Center for Photography, New York), 1994, p. 14.

2. Ibid., p. 21.

3. Ibid., p. 22.

4. Alexandra Anderson-Spivy, *Of Passions and Tenderness: Portraits of Olga by Baron de Meyer* (Marina del Rey, California: Graystone Books), 1992, p. 19.

5. Ibid., p. 96.

6. Baron Adolph de Meyer, letter to Alfred Stieglitz, February 15, 1940, in Ehrenkranz, p. 48. The letter is housed in the Stieglitz Archive, Yale Collection of American Literature, Beinecke Library, Yale University.

7. Ehrenkranz, p. 13.

Alfred Stieglitz

1. Anita Pollitzer, letter to Georgia O'Keeffe, January 1, 1916. Stieglitz Archive, Beinecke Library, Yale University.

2. Richard Whelan, *Alfred Stieglitz: A Biography* (New York: Da Capo Press), 1997, p. 396.

3. John Szarkowski, *Alfred Stieglitz at Lake George* (New York: Museum of Modern Art), 1995, p. 23.

4. Whelan, p. 400.

5. Ibid., p. 403.

6. Ibid.

7. Paul Rosenfeld, "Stieglitz," *Dial* 70 (April 1921), p. 398.

8. Barbara Buhler Lynes, *O'Keeffe, Stieglitz and the Critics: 1916-1929* (Chicago and London: University of Chicago Press), 1989, p. 16.

9. Georgia O'Keeffe, letter to Anita Pollitzer, 1921, Stieglitz Archive, Beinecke Library, Yale University. Also reprinted in Anna Pollitzer, *A Woman on Paper: Georgia O'Keeffe* (New York: Simon and Schuster), 1938.

10. Bram Dijkstra, *Georgia O'Keeffe and the Eros of Place* (Princeton: Princeton University Press), 1998, pp. 184–186.

11. Whelan, p. 462.

12. A. D. Coleman, "Letter from New York," no. 82, *photo metro* 16:148, 1998, p. 26.

Edward Weston

1. Gilles Mora, et al. *Edward Weston: Forms of Passion* (New York: Harry N. Abrams), 1995, p. 15.

2. Edward Weston, *The Daybooks of Edward Weston: California* (New York: Horizon Press in collaboration with George Eastman House, Rochester, New York), 1966, entry December 9, 1934, p. 283.

3. Charis Wilson, *Edward Weston: Nudes* (Millerton, New York: Aperture), 1977, p. 6.

4. Wilson, p. 8.

5. Ibid.

6. Weston, entry April 20, 1934, p. 281.

7. Theodore E. Stebbins, Jr., *Weston's Westons: Portraits and Nudes* (Boston: Museum of Fine Arts), 1989, p. 28.

8. Wilson, p. 11.

9. Weston, entry December 9, 1934, p. 283.

10. Amy Conger, *Edward Weston: Photographs*, figure 836/1934 (Tucson, Arizona: Center for Creative Photography), 1992, n.p.

11. Charis Wilson, videotaped conversation with Theodore E. Stebbins, Jr., made at the Museum of Fine Arts, Boston, February 14, 1990.

12. Ibid.

13. Charis Wilson and Wendy Madar, *Through Another Lens: My Years with Edward Weston* (New York: North Point Press/Farrar, Straus and Giroux), 1998, p. 33.

14. Wilson, videotaped conversation.

15. Charis Wilson, audiotaped interview with the author, Santa Cruz, California, January 27, 1994.

HARRY CALLAHAN

1. Kieth F. Davis, *Harry Callahan Photographs*, exhibition catalogue (Kansas City, Mo., Hallmark Cards), 1981, p. 56.

2. Davis, p. 49.

3. Ibid., p. 55.

4. Ibid.

5. John Pultz, *Art Journal* (Winter 1996), pp. 103–105.

6. Barbaralee Diamondstein, ed., *Visions and Images: American Photographers on Photography* (New York: Rizzoli), 1981, pp. 11–12.

7. Vicki Goldberg, "The Inner Life of an Outward-Gazing Eye," *New York Times*, Sunday, March 24, 1996, p. 39.

8. Eleanor Callahan, in Jain Kelly, ed., *Nude: Theory* (New York: Lustrum Press), 1979, pp. 27–47.

9. *Callahan in New England*, exhibition catalogue (Providence, R.I.: David Winton Bell Gallery, List Art Center, Brown University), 1994, interview with Diana L. Johnson, p. 11.

EMMET GOWIN

1. Emmet Gowin, telephone interview with the author, April 2, 1998.

2. Philadelphia Museum of Art, *Emmet Gowin: Photographs* (Philadelphia: Philadelphia Museum of Art/Bulfinch Press), 1990, p. 7.

3. Gowin, telephone interview.

4. *Emmet Gowin, Photographs 1966-1983*, exhibition catalog (Washington, D.C.: Corcoran Gallery of Art), 1983, n.p.

5. Emmet Gowin, interview with the author, San Diego, California, December 4, 1994.

6. Gowin, telephone interview.

LEE FRIEDLANDER

1. Maria Friedlander, interview with the author, New City, New York, August 8, 1997.

2. Lee Friedlander, *Nudes* (London: Jonathan Cape), 1991, p. 89.

3. Maria Friedlander, interview with the author.

SEIICHI FURUYA

Notes 1-8, interview with the author, New York, August 9, 1997.

NICHOLAS NIXON

1. Nicholas Nixon, telephone interview with the author, May 11, 1998.

2. Ibid.

3. *Nicholas Nixon: New Topographics*, exhibition catalog (Rochester, N.Y.: George Eastman House), 1975, p. 5.

4. Robert Adams, introduction to *Nicholas Nixon: Photographs from One Year*, Untitled 31, The Friends of Photography, Carmel, in association with the Institute of Contemporary Art, Boston, 1983, p. 5.

5. Bebe Nixon, telephone interview with the author, August 5, 1998.

6. Peter Galassi, introduction to *Nicholas Nixon: Pictures of People*, exhibition catalog (New York: Museum of Modern Art), 1988, p. 28.

7. Nicholas Nixon, telephone interview.

8. Bebe Nixon, telephone interview.

9. Ibid.

LIST OF PLATES AND CREDITS

All measurements are height by width. Numbers refer to page numbers.

INTRODUCTION

23 (left)
Don Bachardy, *Christopher Isherwood*, 1957
Gelatin silver, 8 x 10 in.
Courtesy of the artist
Copyright © Don Bachardy

23 (right)
Don Bachardy, *Christopher Isherwood*, 1986
Acrylic on paper, 30 x 22 in.
Courtesy of the artist and Mulligan Shanoski Gallery, San
 Francisco
Copyright © Don Bachardy

27 (left)
Doris Ulmann, *John Jacob Niles Seated Cross-Legged on Table
 with Dulcimer*, ca. 1927–1934
Platinum, 7⅞ x 6 in.
Courtesy of the J. Paul Getty Museum, Los Angeles

27 (right)
Doris Ulmann, *John Jacob Niles in Hat and Overcoat*,
 ca. 1927–1934
Platinum, 7¹⁵/₁₆ x 6¹/₁₆ in.
Courtesy of the J. Paul Getty Museum, Los Angeles

28
Sally Mann, *Untitled*, 1997
Gelatin silver, 8 x 10 in.
Courtesy of the artist
Copyright © Sally Mann

ADOLPH DE MEYER

Except as noted, the following photographs are courtesy of
G. Ray Hawkins of the G. Ray Hawkins Gallery, Los Angeles.
Copyright © G. Ray Hawkins Gallery, Los Angeles.

3
Olga de Meyer, ca. 1898
Platinum/palladium, 7 x 7 in.

18
Adolph and Olga de Meyer, ca. 1900
Platinum, 7½ x 5¾ in.

34, 40
Olga de Meyer on a Cane Settee, ca. 1905
Platinum/palladium, 10¼ x 8¼ in.

37
Olga de Meyer, ca. 1896
Platinum, 14 x 11 in.

41
Olga de Meyer, ca. 1910
Platinum, 5¼ x 3½ in.

43
Olga de Meyer, ca. 1898
Platinum/palladium, 5¼ x 4 in.

44
Olga de Meyer, ca. 1910
Platinum/palladium, 13 x 9½ in.

45
Olga de Meyer, ca. 1898
Platinum/palladium, 7¾ x 4¼ in.

46
Olga de Meyer, 1910
Platinum/palladium, 8½ x 5 in.

47
Olga de Meyer in a Garden, ca. 1910
Gelatin silver, 6 x 7¹⁵/₁₆ in.
Courtesy of the J. Paul Getty Museum, Los Angeles

48
Olga de Meyer, 1915
Platinum/palladium, 10½ x 4½ in.

49
Olga de Meyer, 1920
Gelatin silver, 9½ x 7½ in.
Collection of Joyce and Michael Axelrod

50
Olga de Meyer, ca. 1915
Platinum, 9 x 5 in.

51
Olga de Meyer, ca. 1925
Gelatin silver, 9 x 7 in.

52
Olga de Meyer, ca. 1912
Platinum/palladium, 9 x 6 in.

53
Olga de Meyer, ca. 1916
Platinum, 8⅜ x 5⅜ in.

ALFRED STIEGLITZ

The following photographs are courtesy of the J. Paul Getty
Museum, Los Angeles. Copyright © by the Estate of Georgia
O'Keeffe.

4
Georgia O'Keeffe: A Portrait, 1923
Gelatin silver, 3½ x 4⅝ in.

34, 55
Georgia O'Keeffe: A Portrait, 1920
Palladium, 4⅝ x 3⅝ in.

57
Georgia O'Keeffe: A Portrait, 1918
Gelatin silver, 2 x 1½ in.

60
Georgia O'Keeffe: A Portrait, 1918
Gelatin silver, 3½ x 4 9/16 in.

61
Georgia O'Keeffe: A Portrait, 1918
Palladium, 9¾ x 7⅞ in.

62
Georgia O'Keeffe: A Portrait, 1918
Palladium, 6½ x 6 in.

63
Georgia O'Keeffe: A Portrait, 1918
Palladium, 9⅜ x 6⅝ in.

64
Georgia O'Keeffe: A Portrait, 1924
Gelatin silver, 4⅝ x 3⅝ in.

65
Georgia O'Keeffe: A Portrait, 1921
Gelatin silver, 4⅝ x 3⅝ in.

66
Georgia O'Keeffe: A Portrait, 1930
Gelatin silver, 7½ x 6 in.

67
Georgia O'Keeffe: A Portrait, 1932
Gelatin silver, 9½ x 7⅜ in

69
Georgia O'Keeffe: A Portrait, 1932
Palladium, 4½ x 9⅜ in.

70
Georgia O'Keeffe: A Portrait, 1933
Gelatin silver, 9⅜ x 7⅜ in.

71
Georgia O'Keeffe: A Portrait, 1933
Gelatin silver, 3½ x 4½ in.

72
Georgia O'Keeffe: A Portrait, 1933
Gelatin silver, 9½ x 7½ in.

73
Georgia O'Keeffe: A Portrait, 1932 or 1933
Gelatin silver, 7¾ x 9½ in.

EDWARD WESTON

Except as noted, the following photographs are courtesy of
the Collection of the Center for Creative Photography, the
University of Arizona, Tucson. Copyright © 1981 by the Center
for Creative Photography, Arizona Board of Regents.

5
Charis Weston, 1935
Gelatin silver, 11.8 x 9.3 cm.

34, 78
Charis, New Mexico, 1941
Gelatin silver, 11.6 x 9.0 cm.

75
Nude, 1934
11.6 x 9.0 cm.

80, front jacket (slightly cropped)
Nude, 1934
Gelatin silver, 9.2 x 11.7 cm.

81
Nude, 1935
Gelatin silver, 11.6 x 9.1 cm.

82
Nude, 1936
Gelatin silver, 19.1 x 24.0 cm.

83
Nude, 1936
Gelatin silver, 19.0 x 24.0 cm.
Courtesy of Susan Herzig and Paul Hertzmann, Paul M.
 Hertzmann, Inc., San Francisco

84
Nude, 1935
Gelatin silver (posthumous research print), 19.2 x 24.5 cm.

85
Nude, New Mexico, 1937
Gelatin silver, 19.0 x 24.2 cm.

86
Charis, Lake Ediza, 1937
Gelatin silver, 24.1 x 19.1 cm.

87
Charis, New Mexico, 1942
Gelatin silver, 24.3 x 19.2 cm.

89
Nude Floating, 1939
Gelatin silver, 19.1 x 24.4 cm.

91
7 A.M. Pacific War Time, Carmel, 1945
Gelatin silver, 19.0 x 24.1 cm.

92
Heimy, 1945
Gelatin silver, 19.1 x 24.3 cm.

93
Nude, New York, 1941
Gelatin silver, 24.5 x 19.3 cm.

94
Charis, 1945
Gelatin silver (posthumous research print), 8 x 10 in.

95
Charis, 1945
Gelatin silver (posthumous research print), 8 x 10 in.

HARRY CALLAHAN

Except as noted, the following photographs are courtesy of
the artist, the Collection of the Center for Creative
Photography, the University of Arizona, Tucson, and Pace
Wildenstein MacGill Gallery, New York. Copyright © by the
Estate of Harry Callahan.

6
Eleanor, New York, 1945
Gelatin silver, 8⁵⁄₁₆ x 6½ in.
Courtesy of the J. Paul Getty Museum, Los Angeles

34, 115
Eleanor, Chicago, 1949
Gelatin silver, 24.4 x 23.3 cm.

97
Detroit, ca. 1941
Gelatin silver, 11.2 x 8.2 cm.

98, back jacket
Eleanor, 1947
Gelatin silver, 11.5 x 8.2 cm.

101
Eleanor, 1949
Gelatin silver, 18.3 x 18.0 cm.

102
Chicago, ca. 1949
Gelatin silver, 8.4 x 11.3 cm.

103
Chicago, ca. 1949
Gelatin silver, 11.9 x 11.5 cm.

104
Contact Sheet 12, 10/w, 2/w, ca. 1953
Gelatin silver, 24.0 x 18.2 cm. (approx.)

105
Chicago, 1953
Gelatin silver 19.1 x 18.6 cm.

106
Chicago, ca. 1953
Gelatin silver. 13.6 x 17.3 cm.

107
Chicago, ca. 1952
Gelatin silver, 19.2 x 24.3 cm.

108
Chicago, ca. 1953
Gelatin silver, 19.4 x 24.6 cm.

109
Lake Michigan, 1953
Gelatin silver 19.4 x 24.5 cm.

110
Untitled, 1954
Gelatin silver, 17. x 16.8 cm.

111
Chicago, ca. 1955
Gelatin silver, 18.0 x 17.8 cm.

112
Chicago, 1952
Gelatin silver, contact sheet, 9¾ x 7 in. on 10-x-8-in. paper

113
Eleanor and Barbara, n.d.
Gelatin silver, 7¹³⁄₁₆ x 7¾ in. on 8-x-10-in. paper

116
Chicago, ca. 1960
Gelatin silver, 12.0 x 11.5 cm.

117
Aix-en-Provence, 1958
Gelatin silver, 16.3 x 13.0 cm.

EMMET GOWIN

The following photographs are courtesy of the artist and Pace Wildenstein MacGill Gallery, New York. Copyright © Emmet Gowin.

7
Edith, Danville, Virginia, 1969
Gelatin silver, 5 x 6½ in. on 8-x-10-in. paper

34, 120
Edith, Danville, Virginia, 1978
Toned gelatin silver, 6½ x 6½ in. on 8-x-10-in. paper

119
Contact Print, 1961
Gelatin silver, 8 x 10 in.

123
Edith, Chincoteague, Virginia, 1967
Toned gelatin silver, 6½ x 6½ in. on 8-x-10-in. paper

124
Edith, Ruth and Mae, Danville, Virginia, 1967
Gelatin silver, 5 x 6½ in. on 8-x-10-in. paper

125
Edith and Dwayne, Danville, Virginia, 1969
Gelatin silver, 5 x 6½ in. on 8-x-10-in. paper

126
Edith and Rennie Booher, Danville, Virginia, 1970
Gelatin silver, 5¼ x 6¼ in. on 8-x-10-in. paper

127
Edith and Elijah, Danville, Virginia, 1969
Gelatin silver, 5½ x 7 in. on 8-x-10-in. paper

128
Edith, Danville, Virginia, 1970
Gelatin silver, 7½ x 9½ in. on 8-x-10-in. paper

129
Edith, Christmas, Danville, Virginia, 1971
Gelatin silver, 7½ x 9½ in. on 8-x-10-in. paper

130
Edith, Danville, Virginia, 1971
Gelatin silver, 6 x 6 in. on 8-x-10-in. paper

131
Edith, Danville, Virginia, 1971
Gelatin silver, 6 x 6 in. on 8-x-10-in. paper

132
Edith, Danville, Virginia, 1980
Toned gelatin silver, 6 x 6 in. on 8-x-10-in. paper

133
Edith, 1986
Toned gelatin silver, 6¾ x 6¾ in. on 8-x-10-in. paper

134
Reva and Edith, 1986
Gelatin silver, 6¼ x 6¼ in. on 8-x-10-in. paper

135
Edith, Newtown, Pennsylvania, 1980
Gelatin silver, 4⅝ x 4⅝ in. on 5½-x-7-in. paper

137
Edith, 1996
Gelatin silver, 5⅝ x 5⅝ in. on 8-x-10-in. paper

LEE FRIEDLANDER

The following photographs are courtesy of the Fraenkel Gallery, San Francisco. Copyright © Lee Friedlander.

8
Maria, 1970
Gelatin silver, 11 x 14 in.

34, 139
Maria, 1959
Gelatin silver, 14 x 11 in.

140
New City, N.Y., 1962
Gelatin silver, 14 x 11 in.

143
New City, N.Y., 1971
Gelatin silver, 11 x 14 in.

144
Maria, 1961
Gelatin silver, 14 x 11 in.

145
New City, N.Y., 1963
Gelatin silver, 14 x 11 in.

146
Ft. Lee, N.J., 1972
Gelatin silver, 11 x 14 in.

147
New City, N.Y., 1972
Gelatin silver, 11 x 14 in.

148
Ft. Lee, N.J., 1971
Gelatin silver, 11 x 14 in.

149
Stone Ridge, 1971
Gelatin silver, 11 x 14 in.

151
Arches, N.P., Utah, 1972
Gelatin silver, 14 x 11 in.

152
Chicago, 1974
Gelatin silver, 11 x 14 in.

153
Las Vegas, 1978
Gelatin silver, 11 x 14 in.

154
Copake, N.Y., 1987
Gelatin silver, 11 x 14 in.

155
Arizona, 1989
Gelatin silver, 11 x 14 in.

157
Wales, 1992
Gelatin silver, 14 x 11 in.

MASAHISA FUKASE

The following photographs are courtesy of Koko Yamagishi, executor for the estate of Masahisa Fukase. Copyright © Masahisa Fukase.

9
Matsubara Apartment, 1968
Gelatin silver, 20 x 16 in.

34, 163
Matsubara Apartment, 1968
Gelatin silver, 13½ x 19 in.

159
Kudan Church, 1964
Gelatin silver, 10 x 8 in.

161
Tokyo, 1970
Gelatin silver, 19 x 13½ in.

165
Bifuka, Hokkaido, 1975
Gelatin silver

166
On a Plane to Hokkaido, 1971
Gelatin silver, 13½ x 19 in.

167
Bifuka, Hokkaido, 1971
Gelatin silver, 13½ x 19 in.

168
Bifuka, Hokkaido, 1971
Gelatin silver, 13½ x 19 in.

169
Sarobetsu, Hokkaido, 1971
Gelatin silver, 13½ x 19 in.

170
Izu, 1973
Gelatin silver, 19 x 13½ in.

171
Izu, 1973
Gelatin silver, 19 x 13½ in.

172
New York, 1974
Gelatin silver, 13½ x 19 in.

173
New York, 1974
Gelatin silver, 13½ x 19 in.

174
Kanazawa, 1977
Gelatin silver, 13½ x 19 in.

175
Kanazawa, 1977
Gelatin silver, 13½ x 19 in.

177
Kyoto, 1977
Gelatin silver, 13½ x 19 in.

Seiichi Furuya

The following photographs are courtesy of the artist and the Robert Miller Gallery, New York. Copyright © Seiichi Furuya.

10
78/8, 1978
Gelatin silver, 37.5 x 25 cm.

34, 185
79/79, 1979
Gelatin silver, 37.5 x 25 cm.

179
Izu, 1978
Color, 37.5 x 30.8 cm.

180
82/8, 1982
Gelatin silver, 37.5 x 25 cm.

184
78/32, 1978
Gelatin silver, 37.5 x 25 cm.

186
80/97, 1980
Gelatin silver, 37.5 x 25 cm.

187
80/10, 1980
Gelatin silver, 37.5 x 25 cm.

189
81/27, 1981
Gelatin silver, 37.5 x 25 cm.

190
81/61, 1981
Gelatin silver, 37.5 x 25 cm.

191
83/97, 1983
Gelatin silver, 37.5 x 25 cm.

192
82/31, 1982
Gelatin silver, 37.5 x 25 cm.

193
83/76, 1983
Gelatin silver, 25 x 37.5 cm.

194
Untitled, 1985
Color, 25 x 37.5 cm.

195
Untitled, 1985
Color, 37.5 x 25 cm.

196
Untitled, 1985
Color 46.7 x 27.3 cm.

197
Untitled, 1985
Color, 25 x 37.5 cm.

Nicholas Nixon

The following photographs are courtesy of the artist and the Fraenkel Gallery, San Francisco. Copyright © Nicholas Nixon.

11
Aspen, 1970
Gelatin silver, 10 x 8 in.

34, 204
Untitled, 1996
Gelatin silver, 8 x 10 in.

199
Bebe, Cambridge, 1978
Gelatin silver, 8 x 10 in.

200
Hogdenville, Kentucky, 1972
Gelatin silver, 8 x 10 in.

203
Brown Sisters, 1983
Gelatin silver, 8 x 10 in.

205
Bebe, Cambridge, 1980
Gelatin silver, 8 x 10 in.

206
Bebe and Clementine, Cambridge, 1985
Gelatin silver, 8 x 10 in.

207
Cambridge, 1986
Gelatin silver, 8 x 10 in.

208
Bebe, Clementine, and Sam, Cambridge, 1988
Gelatin silver, 8 x 10 in.

209
Bebe and Sam, Lexington, 1995
Gelatin silver, 8 x 10 in.

210
Bebe and I, 1998
Gelatin silver, 10 x 8 in.

211
Bebe and I, Amboise, France, 1997
Gelatin silver, 10 x 8 in.

212
Bebe, Lexington, 1998
Gelatin silver, 10 x 8 in.

213
Bebe, Lexington, 1997
Gelatin silver, 10 x 8 in.

214
Bebe, Lexington, 1996
Gelatin silver, 10 x 8 in.

215
Bebe and I, Resest des Brosses, 1997
Gelatin silver, 10 x 8 in.

ACKNOWLEDGMENTS

These acknowledgments are among perhaps the most important pages of this book. Far more than an obligatory listing of those who have my gratitude, they enumerate a group of dedicated scholars and artists who cumulatively hold the knowledge and wisdom of the field. They represent volumes written, and many more to come, anecdotes far beyond recording, libraries of observations, and the pulsing heart of a living medium in its fullest reach into twentieth-century life. It is my privilege to share their time and to knit their ideas into the fabric of my own. It is they who provide much of the beauty and strength that fabric may display.

The families and individuals whose lives were invaded by my inquiries knew that I could never be more than a tourist in their private lives. They invited me graciously, and I have tried to honor their trust. My depiction of them is based on my interpretation and is guided by respect. All were welcoming, and I have tried to understand their perspectives.

This project began with a single idea. I was fortunate that the idea did not survive intact, but altered in form and content to a more accurate series of observations. A book provides the opportunity to let some of that thinking rest, but naturally ideas continue to transform, mutate, and expand. If these ideas ignite, it is the following people who have provided the fuel and occasionally the heat.

Thanks to David C. Copley, Judith Harris, the Rockefeller Foundation, and Tomas Ybarra Frausto for their willingness to fund this effort and their belief that these ideas were worthy of their support. Interviews, advice, suggestions, and the lending of photographs were at the core of my work. These were provided by Charis Wilson, Harry Callahan, Eleanor Callahan, Emmet Gowin, Edith Gowin, Yoko Wanibe Fukase, Lee Friedlander, Maria Friedlander, Seiichi Furuya, Nicholas Nixon, and Bebe Nixon. Those who made prints available to me for study and for exhibition and reproduction were G. Ray Hawkins of the G. Ray Hawkins Gallery, Weston Naef, Gordon Baldwin, Kate Ware of the J. Paul Getty Museum, Terrence Pitts, Amy Rule, Diane Nilsen of the Center for Creative Photography, Peter MacGill of the Pace-MacGill Gallery, Koko Yamagishi of the Masahisa Fukase Estate, Olivier Renaud-Clement of the Robert Miller Gallery, Jeffrey Fraenkel and Frish Brandt of the Fraenkel Gallery. Merry Foresta of the National Museum of American Art, an early partner in this project, suggested its name and much of its trajectory. Eugenia Parry was an intermittent advisor of great clarity. Heath Fox, Kate Fletcher, Gaidi Finnie, Penny Taylor, Gayle Benn, Diana Gaston, Shannon Carroll, Milton Yi, Barbara Pope, Tomoko Maruyama, Jane Fantel, Julius Edoh, Michelle Lacsamana, Jill Jones Mason, Melissa Whitcomb, An Nguyen, and Hetty Tye, all of the Museum of Photographic Arts, kept the institutional ship on course when this project distracted me. Joyce and Michael Axelrod, Howard Greenberg, Marla Westover of the Howard Greenberg Gallery, Sally Mann, Donald Bachardy, Michael Shanoski of the Mulligan-Shanoski Gallery, Leon Wilson, Cliff Ackley of the Museum of Fine Arts, Boston, Jeff Rosenheim of the Metropolitan Museum of Art, Peter Galassi of the Museum of Modern Art, Sarah Greenough of the National Gallery of Art, David Travis, Colin Westerbeck, Sylvia Wolf of the Art Institute of Chicago, Tom Bamberger of the Milwaukee Art Museum, Peter Bunnell of the Art Museum of Princeton University, Keith Davis, Amy Conger, Robert Kirschenbaum of Pacific Press Service, Nancy Dubois, Eikoh Hosoe, Yuko Yamaji, Vicki Goldberg, and Cathy Silvern all offered insights, and occasionally the tempering blows of difficult questions well asked. Kathleen Stoughton's students Laura Lisle, Daniel Foster, and Anne Hoehn Garrison provided research assistance. Kaori Hashimoto generously translated Japanese texts for me.

The extraordinary family at Bulfinch Press/Little, Brown: Janet Swan Bush, who decided that these ideas held merit, Terry Reece Hackford, who generously and expertly edited this text, Tiffany Reed, who gave valued assistance, Sandra Klimt, who led the production team, thorough copyeditor Betty Power, elegant designer Alex Castro, and brilliant platemaker Robert Hennessey; these remarkable people seem able to take the roughest formulations and make from them a delicious and seductive product. For this, and for the alternate handholding and prodding, I am grateful.

Arthur Porras, Eric Blau, and Michael Breslauer were steadfast friends throughout, and wisely kept my outbursts to a minimum. I thank my family for encouraging me and allowing me to be absent in mind and body as this work evolved. They, more than anything besides deadlines, inspire me.